U0225774

à Paris

À PARIS

巴黎美人

我是我自己

20 Women on Life in the City of Light

[法]珍妮·达玛斯 劳伦·巴斯蒂德 —— 著 米梨 —— 译

中信出版集团 | 北京

图书在版编目（CIP）数据

巴黎美人：我是我自己/（法）珍妮·达玛斯，
（法）劳伦·巴斯蒂德著；米梨译. -- 北京：中信出版
社，2019.6（2024.4重印）
ISBN 978-7-5217-0368-9

Ⅰ.①巴… Ⅱ.①珍… ②劳… ③米… Ⅲ.①女性—
服饰美学—法国—通俗读物 Ⅳ.①TS941.11-49

中国版本图书馆CIP数据核字(2019)第061997号

À PARIS by Jeanne Damas with Lauren Bastide © Éditions Grasset et Fasquelle, 2017
Simplified Chinese language edition published by special arrangement with Éditions Grasset et
Fasquelle in conjunction with their duly appointed agent 2 Seas Literary Agency and co-agent The
Artemis Agency.
Simplified Chinese translation copyright © 2019 by CITIC Press Corporation
ALL RIGHTS RESERVED
本书仅限中国大陆地区发行销售

巴黎美人：我是我自己

著　者：[法]珍妮·达玛斯　[法]劳伦·巴斯蒂德
译　者：米梨
出版发行：中信出版集团股份有限公司
　　　　　（北京市朝阳区东三环北路27号嘉铭中心　邮编　100020）
承 印 者：北京利丰雅高长城印刷有限公司

开　　本：880mm×1230mm　1/32　　印　张：7　　　　字　数：150千字
版　　次：2019年6月第1版　　　　印　次：2024年4月第11次印刷
京权图字：01-2019-2207
书　　号：ISBN 978-7-5217-0368-9
定　　价：88.00元

图书策划　小满工作室
总 策 划：卢自强　　　　策划编辑：陈明希　　责任编辑：吕娣
营销编辑：任俊颖　　　　整体设计：尚燕平　　内文制作：常亭

怀着无限爱意，
向我们挚爱的城市致敬。

目录

前言

关于这本书的构想第一次出现在 2016 年 4 月。我们俩都梦想着能畅游整个巴黎，遇见城中最鼓舞人心的女子。正如歌手埃拉·菲茨杰拉德和路易斯·阿姆斯特朗在《巴黎四月》(*April in Paris*) 里所唱的那样：街道两旁的栗花正在怒放，塞纳河上泛着点点金光，巴黎女子身着柔软轻盈的针织衫在乍暖还寒的早春微风中微微颤抖，她们坐在位于奥贝尔康夫路（Oberkampf）的两个朋友咖啡馆，手袋放在桌子下方。这就是典型的巴黎之春。但是，如今这一切可能和以往不太一样了，因为巴黎仍处于动荡不安之中。大约半年前，2015 年 11 月，一场足以摧毁全城的枪击事件，发生在巴黎人用来跳舞和举办庆祝活动的场所，许多年轻且毫无戒备的生命就这样消失了。在接下来的冬日时光里，虽然巴黎人仍在饮酒、交谈、相爱，在做这些他们最喜欢做的事，但我们还是能窥见他们内心深处的焦虑。每个人都在以自己的方式表达悲伤，不过令人庆幸的是，巴黎现在又重新振作起来，虽然伤痕累累，但仍然充满骄傲。关于这一点，我们当天完全能够从两个朋友咖啡馆外的一切感受到。

在初次相谈后，我们便开启了巴黎之旅。从 2016 年 4 月到 12 月，

我们相约在城中漫游，但让我们感到奇怪的是，丝毫感受不到这座城市的忧伤或苦涩，她带给我们的反而是快乐。我们想要拥抱坐在酒吧和餐厅外的人们，也想要亲吻在地铁站里的旅人。我们总是近乎疯狂地热爱这座城市，特别是 2015 年 11 月发生惨剧之后，这种感觉变得更加强烈。我们热爱她的傲慢，她的不完美，她的质朴，更深爱住在这里的法国女人们……正如杰克·凯鲁亚克所说："巴黎就是个女人！"

下面，让我们再次回到两个朋友咖啡馆的露天餐桌旁吧。我们在那里一边吞云吐雾，一边尽情享受着普依·芙美葡萄酒。我们俩都近乎荒谬地执着于巴黎女子的法式风情，而她们也的确拥有能把任何服饰都打造出法式风格的魔力：比如用破洞牛仔裤搭配羊绒衫、在风衣里搭上飘逸的连衣裙、挽起上衣的衣袖、穿着破旧的芭蕾舞鞋去跳舞等。这一切特点已经基本上能完美地勾勒出传说中充满魅力的巴黎女子形象。在我们之前，也曾有其他人探索过巴黎女子那迷人又善变的情绪，她们的自信，或是古怪之处：比如，她们中的某些人会拒绝沿着斑马线过马路，还会冲着按喇叭的司机竖起中指；有时候，她们为等一通电话翘首期盼了 15 个月，却在电话铃响起时选择忽略。简而言之，她们有时是冷漠无情的。

我们时常觉得，找寻现代女性的特质真是一大乐事。但是，我们也经常会说，巴黎女子并不只是描绘中的那种理想女性。巴黎女子，不仅仅是有漂亮外表和炙热感情的女孩，她们的风格可不止于此。正如那天讨论的那样，我们认识太多不同类型的巴黎女子了。有人在奥贝维埃[1]开创自己的事业；有人在巴士底广场附近抚养三个孩子；有人会前往共和国广场参与抗议，高举拳头；还有人会跑去意大利广场跳嘻

1 奥贝维埃（Aubervilliers），位于巴黎北郊，是许多服装业界人士的"必经之地"。这里店铺林立，店主大多都是中国人，有"成衣唐人街"之称。——译者注

哈街舞，去美丽城收集小饰物，在"蔬菜城"（Paradis）开办餐厅，到卢森堡公园执导电影。大家刻板印象中的巴黎女子可能会和自己的猫住在圣日耳曼大道，一整天都赖在沙发上看西蒙娜·波伏娃的短篇小说，但在现实生活中，我们还从未遇见过这样的女人。我们无意改变过往的印象，也不想否认典型巴黎女子的存在。之所以知道这样的女人是存在的，是因为我们为了写这本书，会见了 20 位巴黎女人。但是，如果要用一件事情、一个超越了穿着和言谈方式的共同点来定义巴黎女子的话，那首要的，必然是她在巴黎的生活方式。

走出去结识那些拥有不同背景和生活的真实女子，是写作这本书的初衷。我们想要发现她们的不同特质，想要创造出全新的"巴黎女子图鉴"。我们没有打算丢弃原先的刻板印象，但也坚持自己的想法，我们想要通过访问 20 位女性，了解并记录她们在巴黎的生活方式以及她们与这座城市的关系，以此来解开人们对巴黎女人的迷思。

珍妮生长于巴黎第十一区，现在依然住在那里，从她公寓的顶层能俯瞰整个莫里斯·加德特公园。在描述自己的时候，她首先自称是当地著名餐厅"特鲁索广场"老板的女儿，喜欢在周六日拎着购物篮去阿丽格市集淘回深爱的陶瓷罐，再往里面随意地插上几束野花。我是写下这些文字的劳伦，刚刚庆祝了自己在巴黎第九区度过了第 12 个年头。我会开着颇有艺术感的古董车驶过殉道者街，在周末的时候，我还会买下几斤重的左翼报纸和杂志开着车把它们运回家，然后到出售健康食品的咖啡馆里享用有机沙拉。如果有些东西让我们成为巴黎女子，那主要应该就是——我们在这座城市里度过日常生活的方式。在 4 月的某个傍晚，我们在两个朋友咖啡馆灵机一动产生了写这本书的想法，并且决定要以最巴黎的方式来实现这个想法：漫游整座城市。

于是，我们拿起笔记本，肩上挎着奥林巴斯相机，出发去偶遇我们的巴黎女子们。我们完全是凭直觉选择被采访者，也没有什么隐秘

的动机。我们可能在 Instagram（照片墙）上偶然浏览到某位女子，也可能某晚在酒吧喜欢上一起喝酒的另一个女人。我们也会询问朋友的朋友、朋友的母亲、朋友的祖母，去和那些我们崇拜的女人们对话。

我们不是人类学家，也不是社会学家，更无意创作一个面面俱到的巴黎女人样本群。这本书中记录的巴黎女子和我们俩一样，她们大部分来自时尚、媒体、文化和艺术领域。归根结底，她们都只是巴黎女人而已，是在撰写这本书的九个月里，我们很幸运地结识到的一群人。

每一次和她们进行会面，我们都会从她们身上习得某些新的东西，当然也会获得意外的惊喜。这群巴黎女人帮助我们了解到在巴黎生活的女人们有哪些个人特征，而我们也从中受到启发，在章节之间添加了更多关于这座城市的"私房话"。巴黎女子挑战了我们的很多固有想法，也证实了我们曾经的一些怀疑。她们可能住在阁楼里，驳船上，在一座高楼的第十四层，又或者会隐匿在一个小院子里；她们来自各行各业，拥有不同的社会背景，代表着各种文化。但是，有一种精神能够把她们结合到一起：她们全都怀有一种坚定地成为自己的自信。我们之所以选择记录这些个性各异的巴黎女人，是因为她们拥有珍妮老挂在嘴边的"无可替代的风情"，这可能就是"It girl"（时髦女孩）中的"It"所代表的意义吧。我们访问过的每一位女子，都会邀请我们深入了解她们的生活和思想，她们也在向我们展示：巴黎女人与这座城市是融为一体的。在这一段壮阔的旅程结束时，我们才意识到，原来在不经意间，我们已经描绘出一幅巴黎的肖像画。不过，这也没什么好惊讶的。因为，真正的巴黎女人本来就代表着巴黎这座城市。

珍妮·达玛斯和劳伦·巴斯蒂德

2017 年 5 月 30 日写于巴黎

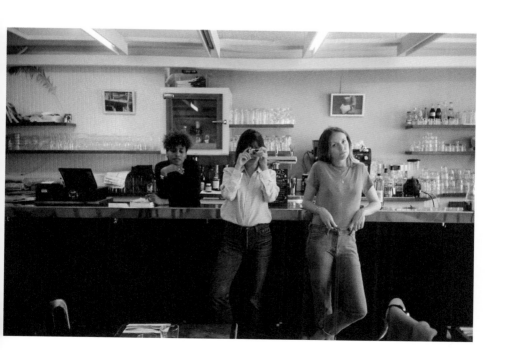

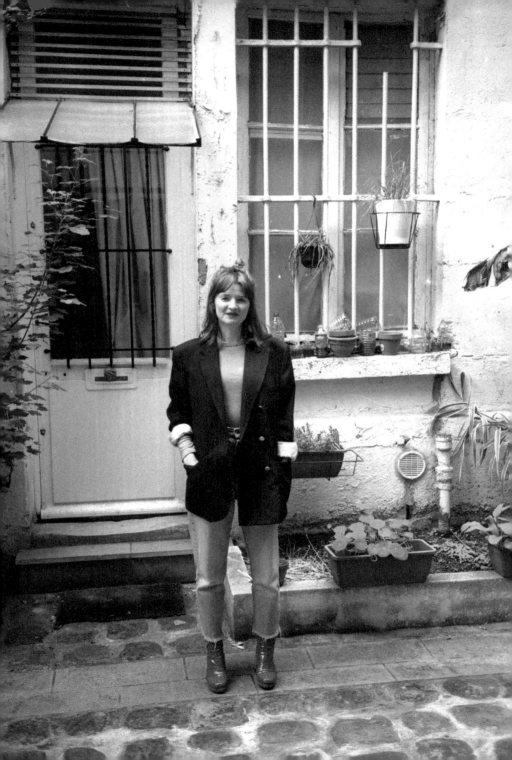

1 在拉普街

邂逅艾米丽·皮沙尔

家庭菜园
两只猫咪
帕米拉·安德森
一把奇亚籽

　　大多数巴黎女子和时尚爱好者都认识艾米丽·皮沙尔（Amélie Pichard）。自从 2010 年创立同名时尚品牌以来，她的品牌和名气就一飞冲天——先是凭借粉红糖果色的羊羔绒半高跟鞋奠定了品牌的声誉，接着与帕米拉·安德森合作的闪光流苏拖鞋也大获成功，随后品牌广告里红发模特漫步于乡间小道的画面更是让她和她的品牌名声大噪。艾米丽·皮沙尔创造的一切看起来都很美，所以我们很想到她的公寓里进行拜访。在 6 月的某个清晨，我们来到一个颇有巴黎特色的街区，这里的鹅卵石后街如迷宫一般地围绕着巴士底广场。艾米丽的家就在这迷宫之中，整栋建筑里有半木质结构的走廊和左右摇晃的楼梯井。我们沿着阶梯走上三楼，她正在隐蔽的寓所门口热情地朝我们打招呼。她身穿一件复古 T 恤，并把它塞进非常纤细贴身的李维斯 501 牛仔裤里，一头红发随意地披散在身上，整个装扮看上去可谓恰到好处。

　　有一种艺术会显得特别"巴黎化"，那就是借由衣着或公寓的装饰风格来彰显个人品位的艺术。在形容大部分巴黎人改造房屋时，"装饰"算不上一个很好的词。通常来说，巴黎人会连续数年每天花掉超过两小时的时间努力把他们的家打造成一个舒适又独特的隐室。艾米

丽就是这方面的专家。不用问她任何问题，只要悄悄打量一下她公寓里的每个角落，我们就可以很轻易地在脑海中描绘出她的形象。她的客厅里摆放着很多物件，让人不禁联想起20世纪60年代的美国——那个时代也的确为她提供了很多创作灵感。在靠近前门墙壁居中的位置，放着非常老旧的人体假肢，这会让她回想起在巴黎第十二区的勒德吕·罗林街区跟从一位真正的矫形医师学习制鞋艺术的时光。

此外，艾米丽·皮沙尔还深谙待客之道，即便是在早上10点钟，她也能轻松而热情地招呼客人参观她的家。进入家门几分钟后，我们俩就开始光着脚蜷缩在她的天鹅绒沙发上，任由两只大波斯猫在我们的小腿间蹭来蹭去。艾米丽和猫咪们的父亲享有"共同监护权"，两只猫有一半的时间会住在这里。这位设计师用自信和活力掌管自己的家居世界，而这个小世界还延伸到屋外布满青苔的鹅卵石小庭院。"我刚刚在外面建造了一个家庭菜园，在那里种了西红柿、各种香草和草莓，不久还要建一个堆肥箱，"她骄傲地告诉我们，"十年前，那里只有一只山羊和一只鸡。"这栋带庭院的复式公寓以前是公寓管理员的家，但后来某天开始对外出租。艾米丽决定租下这个地方，并把它改造成为一间工作坊，如此一来，她就能把原来小公寓里的大量鞋盒转移到这里存放。几个月后，她在那里遇到了自己的男朋友——一位来为她公司拍摄影片的导演。"我当时就像一头熊一样躺在小窝里，然后就有一些东西找上我了。"她有点自夸地说道。

如果说艾米丽总会有一些美好际遇，那是因为她成功地找到了一种安排生活的方式，让一切事情都发生在她家周遭。例如，她最近在拉普街的拐角处开设了自己的第一家精品店；又比如两年前，也就是还没租下复式公寓以前，她把自己公寓的一个房间当作设计鞋履原型的工作坊，而现在她也把那里当成办公室和创作空间。她把大卫·林奇、盖·伯丁的照片，以及贝蒂·佩吉的肖像画等图片都钉在一块灵感板上，

然后从那些图片中为下一个系列寻找创作源泉。虽然艾米丽学的就是服装设计，但当她意识到自己更喜欢创作偏"男性化"的作品时，才真正找到了属于自己的设计之路。艾米丽·皮沙尔不去顺应快时尚的浪潮，反其道而行之，以一种非常巴黎化的方式，成了一名成功的设计师。

她面露微笑，一根接一根地抽着烟，然后开始向我们讲述她的生活。和大多数巴黎女子一样，她并非从小在巴黎长大，而是在距离巴黎几小时路程的沙特尔。在父亲过世以前，她在每个星期三和学校假期都会去他的农场。父亲过世的时候，她还只是一个小女孩。后来，她和母亲及妹妹生活在一起。她讨厌学校，经常在练习本的空白处勾勒女人的轮廓。到了14岁，她开始崇拜法国流行歌手欧菲丽·温特和帕米拉·安德森。后来，她还真的和帕米拉·安德森一起创作了著名的"素食鞋"（不用动物真皮，而是用由塑料、人造革等材料制成的鞋子）。和我们大多数人一样，她也经历过青春期的焦虑和冲动，这些情绪驱使她把自己的头发染成白金色，后来为了安抚母亲，她不得不把头发剪到很短。"当我二十岁来到巴黎的时候，感觉自己从此变得开心起来。"她说。

当我们让身为巴黎女子的她透露一下自己最珍视的物品时，她提到了自己的地址簿。艾米丽本人从来都不曾离开过这片界限清晰的小区域——位于巴士底、夏洪尼路和勒德吕·罗林大道之间的这片区域。她每天清晨吃完早餐（通常是加入杏仁露、猕猴桃、香蕉和奇亚籽的燕麦粥）后，都会去一趟这个区域里的花店、文具店和报刊亭，然后还会去当地的咖啡馆买一杯黑咖啡。她略带羞怯地笑着说："这是我比较守旧的一面。"实际上，把自己居住的街区当作小镇一样，这就是最典型的巴黎式生活。另外，还有一些事例也能显示出一个人非常巴黎化，比如因为常去的药店关门了而不得不多走一个街区时会叹气；又比如除了在自家街角的面包坊买面包以外，不会光顾其他店铺；再比如，能够讲出离自己最近的十条街上所有店铺的名字。

不过，就像艾米丽自己所说的那样，她之所以如此离不开居住的街区，也可能是因为她本身就是一个少于走动的人。对她而言，过塞纳河、走到"河对岸"仿佛就已经是一次探险了。所以，这说明什么呢？

巴黎人（至少是我们认识的那些人）最中意的，或许就是在朋友家中围着唱片机或音响跳舞，然后七八个人挤在露台上抽会儿烟休息片刻，又或是聊聊哲学。艾米丽坦言，如今很享受窝在家中的时光，总是喜欢让别人到家里来找自己。她会买来一箱又一箱的香槟款待客人，让来自各个领域的朋友共度一段美妙时光。在她家里举办的夜间派对已在整个街区小有名气，而且被认为是最有趣、最疯狂的聚会。但令人惊讶的是，她的邻居们从来都不会投诉派对发出的噪声——对于租住公寓的巴黎人来说，这一点简直就和从住处能饱览塞纳河上的风景一样重要。如此一来，她公寓里的音响里就能不断传出海滩男孩、金发女郎乐队和碧昂斯的歌声，而且一直持续到凌晨。

我们的巴黎

城市中的乡村生活

　　我们俩和那些受访的巴黎女人有一个很大的共同点，那就是我们会用居住的场所（城区、街区和公寓）来定义自我。

　　我们相信，无论是住在一套豪华公寓里，还是窝在一间小阁楼上，把自己的家打理得极其舒适且具有自己的特色，是一件极其重要的事情。无论是为了在周五和周六的晚上工作，做做白日梦，还是偶尔犯一下拖延症，又或是和朋友找找乐子，我们都会为家里添置蜡烛、垫子、旧书和松软的沙发。要知道，当有人来造访的时候，这样的家庭氛围会很不错。说到"街区"这个词，我们所提到的"街区"指的是自家附近的那些建筑物，包括一家本地咖啡馆——一家能让我们在清晨时分夺门而入，不用任何言语，仅仅倚靠在吧台就能端走一杯美式咖啡的咖啡馆；当然，也包括一间我们最爱的面包坊，而且是那种永远都不会有游客聒噪（排队真是一件很痛苦的事情），只花 1 欧元左右就能买到美味的火腿沙拉蛋黄酱三明治的传统老店。以珍妮为例，就能说明我们有多么离不开自己的街区：她总是在筹划搬去第九区，却只关注现在所居住的街区地产广告。

十间私房面包坊以及我们深爱的理由：

i.　Terroirs d'Avenir
推荐理由：乡村面包、番茄佛卡恰
地址：尼罗河街（Nil）1 号
邮编：75002

ii.　Le Moulin de la Vierge
推荐理由：巧克力闪电泡芙
地址：圣多米尼克街（Saint-Dominique）64 号
邮编：75007

iii.　La Boulangerie Verte
推荐理由：牛角包、让人难以拒绝的法式小泡
地址：殉道者街（Martyrs）60 号
邮编：75009

iv.　Du Pain et des Idées
推荐理由：橙花布里欧修面包、酥皮面包
地址：伊夫·托迪克街（Yves Toudic）34 号
邮编：75010

v.　Julhès Paris
推荐理由：马卡龙、熟食
地址：圣丹尼郊区街（Faubourg-Saint-Denis）56
邮编：75010

vi.　Boulangerie Utopie
推荐理由：令人销魂的苹果翻转蛋糕
地址：让-皮埃尔·坦博街（Jean-Pierre Timbat）20 号
邮编：75011

vii.　Moisan Le Pain au Naturel（在阿丽格市集里）
推荐理由：用传统方式烘焙的有机面包
地址：阿丽格广场（place d'Aligre）5 号
邮编：75012

viii.　Le Blé Sucré
推荐理由：巧克力夹心面包、迷你草莓蛋糕
地址：安托万·沃隆街（Antoine Vollon）7 号
邮编：75012

ix.　Boulangerie Boris
推荐理由：迷你三明治、法棍面包
地点：考茵库特街（Caulaincourt）48 号
邮编：75018

x.　Boulangerie Alexine
推荐理由：巴黎最美味的蛋挞、酥脆面包棒（得趁热吃）
地点：莱皮克街（Lepic）40 号
邮编：75018

巴黎十大咖啡馆：

i. Le Saint-Gervais
推荐理由：位于马莱区（Marais）的露天咖啡馆，
提供高品质的食物
地址：圣殿老妇街（Vieille-du-Temple）96 号
邮编：75003

ii. L'Escale
推荐理由：提供美味的咖啡和牛角包，能看到塞
纳河
地址：双甲板街（Deux-Ponts）1 号
邮编：75004

iii. Le Pick Clops
推荐理由：可以一边畅饮啤酒，一边观察过往的人群
地址：圣殿老妇街 16 号
邮编：75004

iv. Le Rouquet
推荐理由：位于圣日耳曼德佩区中心地段，提供
正宗的法式午餐
地址：圣日耳曼大道 188 号
邮编：75007

v. Le Mansart
推荐理由：位于皮加勒区，适合在夏日傍晚到这
里享用一杯桃红葡萄酒
地址：芒萨尔街（Mansart）1 号
邮编：75009

vi. Le Petit Château d'Eau
推荐理由：适合午后到这里来，懒洋洋地享用一
杯咖啡
地址：水塔街（Château d'Eau）34 号
邮编：75010

vii. Le Carillon
推荐理由：适合到户外阳台饮酒和社交
地址：阿利贝尔街（Alibert）18 号
邮编：75010

viii. 两个朋友咖啡馆
推荐理由：有自然葡萄酒和出色的西班牙小菜
地址：奥贝尔康夫街 45 号
邮编：75011

x. Le Penty
推荐理由：店主是一位乐观向上的女孩，出售 2
欧元的新鲜薄荷茶
地址：科特街（Cotte）11 号
邮编：75012

. Le Folies
推荐理由：不妨在夏日傍晚来这里喝上一杯，四
周都是美丽城的年轻人
地址：美丽城 8 号
邮编：75020

　　她生长在第十一区，也用赚取的第一桶金在
这里买了一个小型公寓，算是已经稳定地在这一
区扎根了。在社交媒体上，她的粉丝见过她家的
大理石壁炉，也知道她那只叫查理的猫咪会趴在
书架附近休息。看来，要把一个人从如此温馨的
家庭环境中剥离开来，真是相当困难的事情呢。

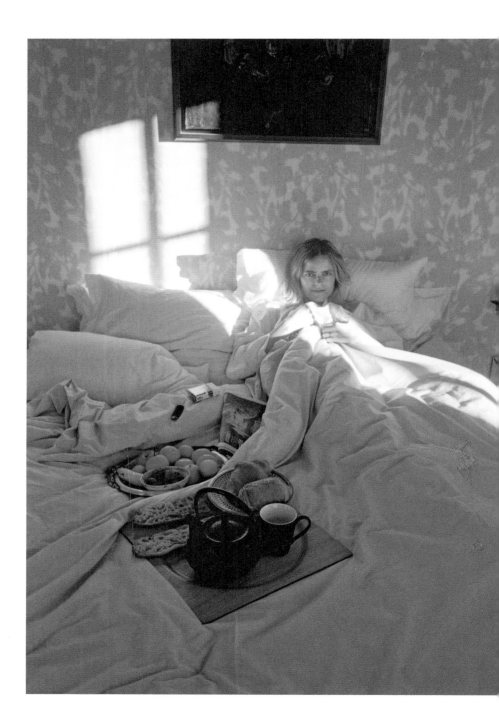

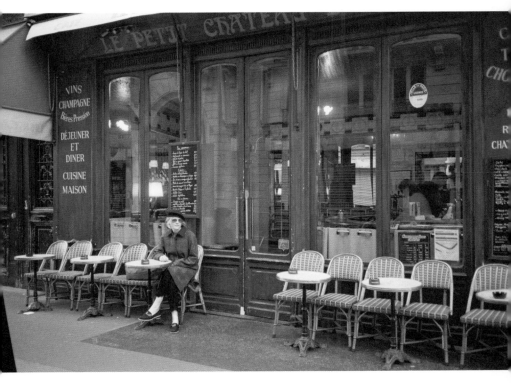

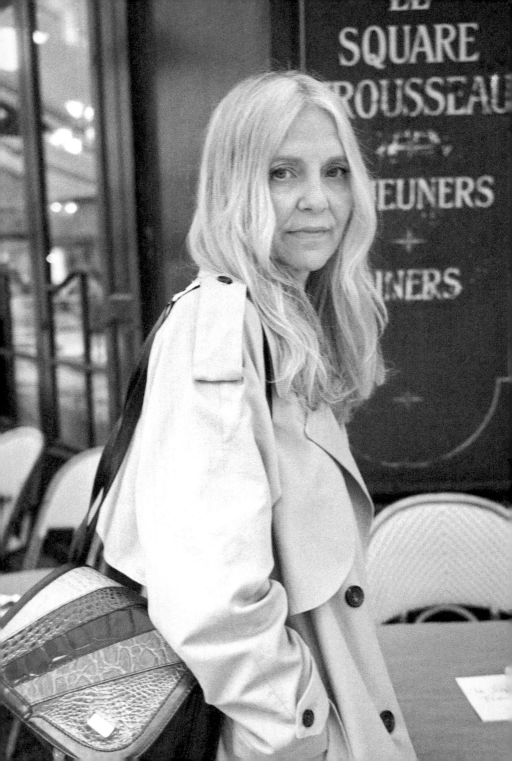

在特鲁索广场餐厅
和**纳萨莉 · 迪梅**聊人生哲学

螺纹高领毛衣
炒蛋和煎烧土豆
小木屐
盖 · 伯丁

从我们开始为这本书梳理巴黎女子名单的那一刻起，纳萨莉 · 迪梅（Nathalie Dumeix）的名字就出现在珍妮的名单上，并且还名列前茅。作为一位造型师，纳萨莉创立了自己的品牌，在过去 20 年里，她一直在珍妮父母开办的特鲁索广场餐厅附近经营时装精品店。店里出售的衣服都来自这位巴黎丽人的完美品位——国外杂志总是会报道她的穿衣打扮，比方说，某本杂志想捕捉从 1 月到 12 月都能穿的典型风衣搭配等。在她的店铺，你会发现有不少混搭，比如高腰裤搭配一件质地精良的灯芯绒螺纹高领毛衣，再配上极其精致的黄金首饰和坡跟拖鞋。简而言之，舒适又别致的装扮就是巴黎女子的特色，而珍妮的穿衣搭配就很符合这个要求。事实上，珍妮也发现，她的时尚触觉在一定程度上要归功于纳萨莉的时装精品店：因为她从十几岁就开始在放学后光顾这间店，还喜欢在店里和纳萨莉谈论服装和男孩。

我们和纳萨莉约在第十二区的特鲁索广场餐厅（距离巴士底广场不远）见面，然后坐在露天茶座里聊天。那一天，蓝天白云相映成趣，而纳萨莉的装扮更是惊艳：她理所当然地穿着风衣，看似没有做过造型的亚麻色金发披散着。虽然几乎是素颜，但岁月没有在她的完美肌

肤上留下任何痕迹，反倒是随着时光推移，她的脸庞变得更加美丽。她的身材可以说是极度瘦削，但她在中午时分点了一份高热量的火腿炒蛋配煎烧土豆。那么，就让我们面对这样的现实吧。当你遇见纳萨莉时，你希望她能袒露所有的关于美丽的秘密，因为她就是那种让你想模仿她的穿着和一颦一笑的女人，甚至你还想和她拥有一样的年纪。而这种感觉，也许就是全世界对巴黎女人的观感吧。

她那令人称赞的时装风格得益于母亲的真传。在她还小的时候，母亲就会让她穿着"可爱的大衣和从瑞典买来的小木屐"。她在勃艮第的塞纳河畔沙蒂永长大，而不是在巴黎。当地静静流淌的河流，对她来说就像一条通往首都的线索。对于自己的命运，纳萨莉一直很坚定。在你决定"出发去巴黎"的时候，你一定要笃定，在那迷宫般的城区

里一定有一些东西在等待你去发掘。事实上，大多数人都会搬到巴黎去实现某一个专业领域的梦想，当然，有时候也是为了爱情。就我个人而言，因为想成为一名记者，所以在 23 岁时来到了巴黎，而在那时候，自己的心智也相对成熟了。试想，你能在巴黎以外的其他地方成为下一个弗朗索瓦丝·吉鲁[1]吗？而对于纳萨莉而言，她在九岁的时候就梦想成为可可·香奈儿或玛丽·居里。事实上，她也确实拥有前者的优雅和后者的严谨态度。她的命运故事，也似乎只能在巴黎才能展开。

对于纳萨莉而言，这座城市就像一块巨大的拼布工艺毯，上面绣满了她的生活碎片。她七岁时来到巴黎，之后就读于著名的法国高级时装学院（ESMOD）——学院致力于培养未来的时装之星，从里面走出了许多设计大师。每到晚上，她都会出现在 Le Palace、Les Bains Douches 等传奇夜店。那是 20 世纪 80 年代，时尚界和娱乐圈的人物都喜欢光顾这些夜店，也正是在那个时候，她遇到了摄影师盖·伯丁、设计师多罗蒂·比斯和皮埃尔·达乐比——这两人就相当于今天的菲比·菲洛和拉夫·西蒙斯。不仅如此，她还遇到过来自巴黎政治学院的"粪便俱乐部"[2]。只有在巴黎，俱乐部里的成员才有可能一边阅读，一边饮酒。"我是一个失眠者，几乎不需要睡觉。所以，我一直都是完美的夜间活动者。我从不酗酒，偶尔会喝一两杯，但从不沾染毒品；我还可以很长时间都不碰酒。"听到此番话，看来我们现在已经触碰到纳萨莉的秘密了，这也许也是巴黎女子最令人羡慕的一种品质：自我平衡。这并不是由适度和约束形成的平衡，而是一种特殊的方式，能够调节疯狂与理智，也能够中和奢侈与简单。

我们请她聊一聊自己的偶像，她毫不犹豫说出了一个人的名字。"弗

1　弗朗索瓦丝·吉鲁（Françoise Giroud），法国首任妇女部长，世界著名女权斗士。——译者注
2　粪便俱乐部（Caca's Club），直译为"白痴但窝心的文盲俱乐部"，由法国广告人、作家弗雷德里克·贝格伯德和朋友创立。——译者注

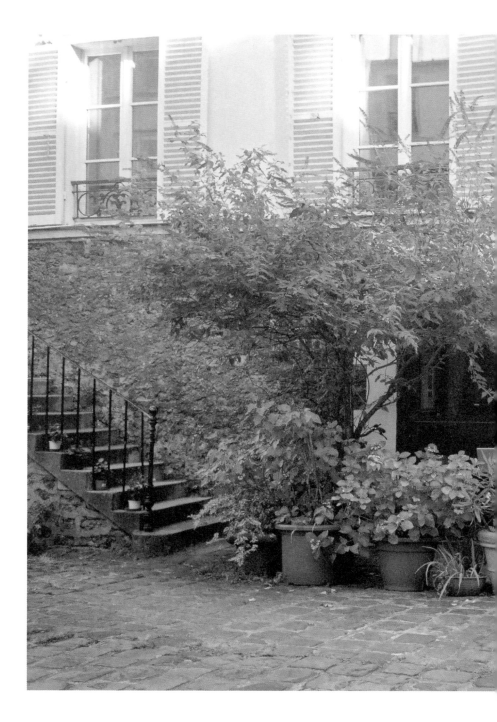

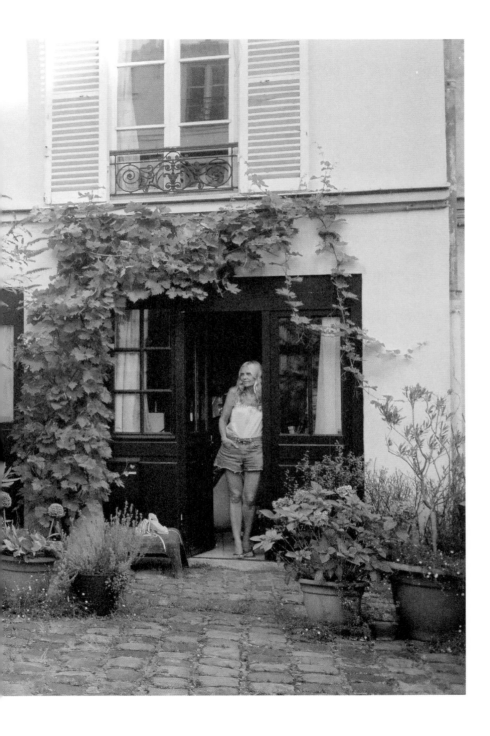

朗索瓦丝·萨冈[1]，因为她有艳丽出挑的一面，"顿了一下她又补充说，"也有忧郁伤感的一面。"这真是一个典型的巴黎式悖论。她还透露了自己的美容秘诀，她漫不经心地向我们保证：几乎不用任何保养品来护理她娇嫩的皮肤和高高的颧骨。"我每天用温水洗脸，会使用 *ELLE* 杂志上介绍的日霜新品。"她接着讲述了自己完成晨间"素颜妆"的日常指定步骤："先用欧莱雅的 CC 霜打底，然后用 & Other Stories 品牌的遮瑕膏隐藏眼部以下的瑕疵，还有抹平脸上的小洞。接下来，我会用少量的魅可品牌的珍珠白蜜粉让脸部轮廓更明显，特别是让眉毛、颧骨和上唇曲线显得更加突出，最后再用白色的眉笔在眉毛下面轻轻画上一笔。"我们问，还有其他的例子吗？她说，还有一个关于她自己的悖论：她完全不会限制自己享用任何食物。在她吞下鸡蛋和土豆后，又享用了特鲁索广场餐厅服务员推荐的迷你蛋白酥。不过，她还是会遵守一些自己订下的严格规定：不喝咖啡，不喝茶，不吃奶制品，不吃含麸质的食物。在体育运动方面，她也有自己的原则："我不做任何运动。"谁知话音刚落，她就脸红了。然后她才承认："我喜欢步行到新桥去看看过往的行人，还有那些坐在露天酒吧和餐馆外的人们，或是去逛一逛某些历史性地标建筑。"可是，从第十二区到新桥，必须得步行 50 分钟以上，想必这应该就是属于她的运动方式吧。和许多巴黎人一样，纳萨莉只会步行或骑自行车，这样一来，她每天都能很轻易地走上12 000 步。这充满魔力的运动方式或许也可以解释她为什么能保持苗条的身材，以及她为什么不需要每周去健身房大汗淋漓地踩三次脚踏车。稍后的时间里，太阳在乌云后面变得忽隐忽现，就像纳萨莉坐在特鲁索广场餐厅外谈论关于巴黎的话题一样，充满辩证的哲学意味。我们问她："想要找到一种中间立场吗？""不了，谢谢！"她或许觉得，把"太多"和"太少"、精力充沛和疲倦嗜睡、过度和禁欲这些词放在一起谈论，是一件多么美好的事情。正因如此，巴黎女人才得以享受、品味和拥抱更多的生活。

1　弗朗索瓦丝·萨冈（Francoise Sagan），法国著名的才女作家，个性鲜明，行为有些离经叛道。——译者注

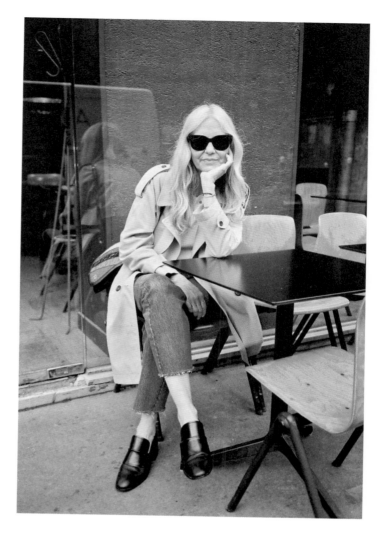

我们的巴黎

反自拍系列

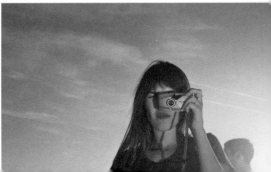

从理论上来说，巴黎女人是从不自拍的。难道要在你面前挥舞着相机，寻找合适的角度和恰到好处的光线，然后在公共场合对着相机一遍又一遍地傻笑着自拍？绝对没门儿。但再说一遍，这只是从理论上来说。

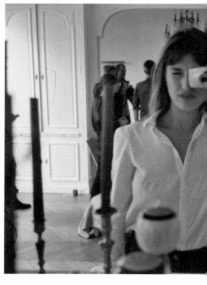

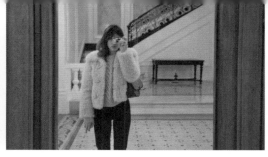
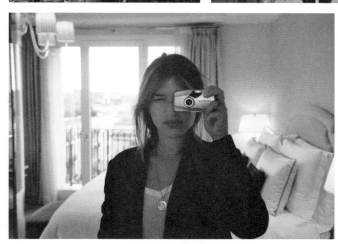
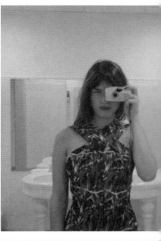

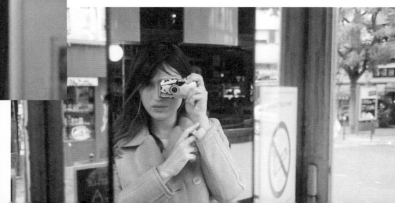

在唐人街

和**帕特里夏 · 巴丹**聊午夜巴黎

屋顶公寓
珠子
巫师
洛神花汁

在巴黎，总会遇到一些令人极度兴奋的小型夜店，它们的入口处通常很狭窄，让人很难挤进去，但夜猫子们喜欢聚集在这些地方把酒言欢，甚至无所不谈。一旦他们的意识和身体经过了"热身"，还会随着音乐起舞。Le Palace、Le Pulp、Le Baron、Le Montana 以及最近流行的 La Mano 都属于这样的夜店——后者位于第九区，是一家散发着墨西哥气息的小夜店。当我们着手写这本书的时候，La Mano 外面早已排起了长龙，通常会持续到凌晨一点左右。珍妮和我更喜欢在星期四晚上 11 点左右前往那里，这样就可以避开周末拥挤的人潮。我们喜欢从这家店的音响里流淌出来的有节奏感的音乐，比如萨尔萨舞曲、伦巴、古巴爵士乐，正如我们喜欢这家店的梅斯卡尔鸡尾酒和友好的气氛一样。

通常，夜店的风格即能体现店主的性格，而让 La Mano 变得如此温暖和宾客盈门的店主名叫帕特里夏。她的到来，不仅为俱乐部注入了令人意想不到的乐趣，还为这里带来了勾花背心的风潮和喧闹的笑声。可以说，La Mano 就是帕特里夏本人。她负责俱乐部的传讯和公关工作，并在有人光临时上前迎接问好。但最重要的是，她会一路小

跑着跳上舞台，一连跳上几个小时会催眠人的桑巴舞。当夜晚结束时，她能够让所有的派对参与者都投入其中，让你想和她一起舞蹈，像她一样挥洒汗水，沉浸在节奏之中。她的吸引力和超凡魅力仿佛再现了玛塔·哈里、格蕾丝·琼斯或法国音乐厅舞蹈演员米斯坦盖等明星的感染力——这些明星都擅长将诱惑和神秘感巧妙地结合在一起并展现在自己的舞蹈之中，他们在巴黎的历史中有着举足轻重的地位。而帕特里夏，就是巴黎夜生活中典型的女中豪杰。

某个清晨，珍妮和我在帕特里夏位于第四区的店外碰面。珍妮头一天晚上喝得酩酊大醉，起得很晚，所以我们先走进一间小小的时髦咖啡馆（Bob's Juice）坐一坐——店内的新鲜果昔和拿铁非常美味。帕特里夏的家位于以前的女佣街区——上马莱街区的一栋狭窄独特的大楼顶层，这让我们必须爬很多级楼梯才能来到她家。透过她家客厅的牛眼窗，可以窥见屋外的石板瓦房顶和呈现出吉塔涅斯 [1] 蓝的天空。帕特里夏跳了一整晚舞，也是刚刚起床。她剃了光头，没有化妆，穿着黑色紧身棉质连衣裙，看起来像个十几岁的孩子。她让我们坐在铺着垫子和复古织物的沙发上，自己则跑去小厨房里做了一杯洛神花汁，说能缓解珍妮宿醉后的头痛。"我已经告诉自己二十多次了，我应该搬家，找个更大的地方，但这是我的小小避难所，我在这里过得很好。"她的公寓精美得让人惊叹，所有的小角落和缝隙都摆放着独特的物品，其中大部分都是可以用来穿戴的，其中就包括她在巴尔贝斯大街和皮加勒区的情趣用品店淘到的珠串头饰。刚来到这间公寓时，她还曾经从一块旧厨房窗帘上把珠子取下来，用来装饰她的渔网连体衣和牛仔短裤。

一种明目张胆的狂野与自由气息就像微风一样在她家里飘荡。她的座右铭是：永不道歉，以及要去做每一件事和拥抱每一件事。她在

1　吉塔涅斯（Gitanes），一种法国卷烟品牌，其包装是蓝色。——译者注

晚上工作，这样白天就可以自由地发展个人项目。她也确实刚刚成立了一个名为"B'Attitude"的机构，通过该组织，她能把一切让她兴奋不已的事物分享给其他人，包括舞蹈、调酒术、造型、女权主义、天然化妆品和艺术等。她最为精通的艺术就是如何勇敢地做自己，以及不断重塑自我——这种态度让她大半辈子都游走在这座光之城中，接受人生的种种历练。"我几乎去过巴黎的每一个区，除了第十六区以外，我居住过每个城区。在我看来，巴黎就是自由的化身。我从来都不想离开这座城市，因为在这里，你可以成为你想成为的人，可以做你想做的事。"

　　帕特里夏在第七区长大，距离传说中的韦尔讷伊大街上的赛日·甘斯布故居不远。她小时候，每天早上都会经过他家。"在我们上学的路上，他常常向我和妹妹挥手。我们是这个区里仅有的黑人孩子。" 帕特里夏在 14 岁时开始迷上夜巴黎，也发现了自己最喜欢的东西——自由。"我会在晚上偷偷溜出去，告诉妈妈我在做照看幼儿的工作，但其实我会跑去 Folies Pigalle 夜店过夜。"在她 17 岁时，母亲决定搬回瓜德罗普，但她拒绝一同前往。"我已经和巴黎建立起联系了，不能眼见着自己搬去别的地方住。这里就像是自己的家，我希望这种感觉能永远持续下去。"所以，她后来就在巴黎独自生活，直到长大成人，而这种

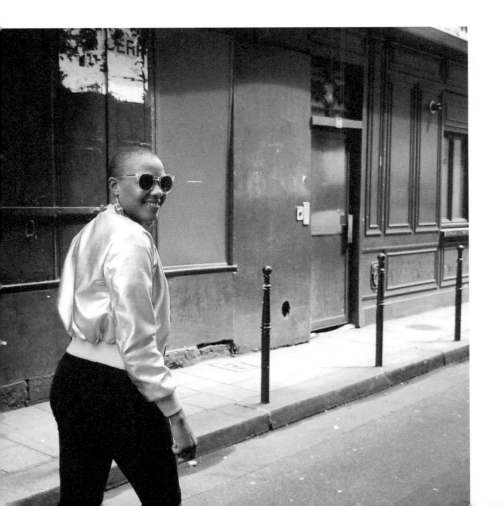

经历也塑造了她如今乐天派的性格。她告诉我们，她曾在中央市场度过无数个下午，也曾到无罪者街的广场上和一群滑板爱好者和说唱歌手跳舞。"我们这群女孩子开始一个接一个地征服 Le Palace、Les Bains Douches 等夜店。我们很可爱，但也很瘦弱。我们整晚整晚地在这些地方跳舞，别人会给我们一杯橙汁当作回报。"后来，她回到大学里继续学习日语，并在当年 1 月遇到了后来的丈夫，然后在 7 月出嫁，次年 3 月儿子便出生了。如今，她的儿子已经 16 岁了，一家人住在莫里斯·加德特公园附近，就在珍妮家对面。

若是你在巴黎成长，把杜乐丽花园当作你的游乐场，熟知香榭丽舍大道的美景，你就会用一种更宽广的视角来审视事物。至少，帕特里夏就是这样。正因为如此，她似乎还不满足于只待在巴黎，而喜欢经常四处旅行，以此实现自己想要看到更多事物的愿望。事实上，她刚刚完成了在巴西的长途旅行。她一边喝着洛神花汁，一边告诉我们她在巴西到处游逛时发生的趣事：她和爵士芭蕾舞团的舞者混在一起，到普拉亚格兰德海滩上疯狂跳舞，还去巴西利亚郊区的一个慈善中心聆听当地宗教的传奇故事。她从巴黎出发时，只带着平时惯用的基础款背包，里面装着两件棉质连衣裤、一条短裤和一件绣花夹克，这样就组成了一套"适合跳舞的表演服"。

帕特里夏拥有从零开始打造全套行头的本领。她从皮加勒区的商店或巴尔贝斯大街的古着店买回所需要的材料，用它们制作衣服。她还用服装、头饰和鞋子来装饰公寓，而这些服饰也恰恰拼凑出完整的帕特里夏。它们似乎在诉说着她的旅程，她的才华，以及她每天晚上在 La Mano 的舞池中扮演的角色：总是在鼓励参加派对的人都来加入她的行列，盛情邀请所有人一起舞蹈。

我们的巴黎
尽情享受一杯开胃酒

请忘掉运动、刺绣和园艺，甚至也忘掉厨房吧；对于巴黎女人而言，懂得如何甄别美酒才是最重要的技能，这可是关乎自尊的重要问题呢！我们在餐厅里手握菜单点餐的时候，会趁机向侍酒师坚定而大声地说出自己心仪的美酒。随后在一阵觥筹交错中，我们还会凝视着杯里的红酒，露出一种若有所思的表情。在某个夏日夜晚，甚至是一瓶简单的桃红葡萄酒，也会让我们和朋友在露天酒吧里开怀畅饮。在巴黎，美酒就是生活。有人偏爱红酒，有人则喜爱白葡萄酒；有人中意勃艮第，有人却离不开波尔多。我们俩都爱好饮红酒；珍妮对波尔多地区的所有酒类都情有独钟，而我则更爱勃艮第的，但同时也痴迷来自罗蒂丘的良酒。我们都喜欢生活中冒出的各种惊喜，但在选择葡萄酒方面则显得长情而守旧。

我们最爱的五大巴黎酒商：

i. Cave Augé
推荐理由：巴黎历史最悠久的酒窖
地址：奥斯曼大道（Haussmann）116号
邮编：75008

ii. La Cave de l'Insolite
推荐理由：主打自然葡萄酒
地址：美丽谷街（Folie Méricourt）30号
邮编：75011

iii. Lavinia
推荐理由：从全世界搜罗自然发酵的年份酒
地址：玛德莲大道（Madeleine）3号
邮编：75001

iv. Le Verre Volé
推荐理由：第一个被命名为 cave à manger（酒吧兼餐厅）的地方
地址：朗克里街（Lancry）67号
邮编：75010

v. Le Baron Rouge
推荐理由：如果自备酒瓶的话，可直接买木里的酒
地址：泰奥菲尔·鲁塞尔街（Théophile Roussel）
邮编：75012

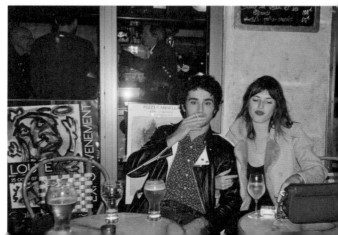

五款能彰显你是葡萄酒行家的葡萄酒：

i. 开胃红酒：马赛尔和马蒂厄拉皮尔（Marcel and Matthieu Lapierre）墨贡红酒，散发果香，口感如水一般轻盈和清爽

ii. 佐餐红酒：勃艮第菲力普帕卡雷酒庄红葡萄酒、精致有特色的黑皮诺红葡萄酒

iii. 佐肉红酒：教皇新堡维勒朱丽安酒庄红葡萄酒，闻起来有土壤和南法的味道；米歇尔法瓦圣埃美隆红葡萄酒

iv. 开胃桃红葡萄酒：雷－让（Ray-Jane）酒庄邦多勒桃红葡萄酒，加入冰块后风味更佳

v. 佐海鲜的白酒：宾纳（Binner）酒庄雷司令葡萄酒，口感干爽，散发果香和阿尔萨斯区的矿物味道，适合搭配奶酪

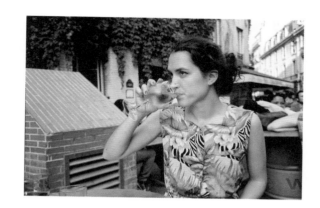

在波平考特村

和**夏洛特·莫雷尔**

聊三十岁巴黎女人的感情生活

一扇摇摇欲坠的门
格子薄毯
一位催眠师
三位朋友

　　一个三十岁的单身巴黎女人会如何谈论自己呢？当然会把她的爱情生活作为切入点啦。这事说起来有点太疯狂了，我们和夏洛特一开始并不熟络，但很快我们就跑到她的可爱公寓里盘腿而坐，在扶手椅上听她大谈她的爱情故事。在某个周六早上，珍妮在两个朋友咖啡馆里迷上了夏洛特的外表（既优雅又带着波希米亚风格的造型），夏洛特和珍妮都爱来这间咖啡馆——现在它也快成为这本书的采写总部了。她们还约定，要在几天后去拜访夏洛特。夏洛特住在波平考特市集附近的一间一居室公寓里。那个区域里有不少二手店和本地酒吧，刚刚被正式命名为"波平考特村"。没想到，夏洛特的公寓比她别致的外表更有巴黎人的风格。整个房间里弥漫着一种令人销魂的香气（几乎到处都摆放着意大利香水制造品牌圣塔玛莉亚诺维拉出品的石榴香水，香水瓶里面还浸泡着红色的石榴）。她家里的所有装饰都很有品位：又大又明亮的白色卧室里，有黑色大理石壁炉、窗帘盒，还摆放着一些艺术作品，其中夹杂着一些略带烟火气的二手货。不过，房间的墙壁有大大的裂痕，甚至连门也显得摇摇欲坠。"这栋楼正在缓慢塌陷，但

这个区域还是很受欢迎的。总有一天，我肯定能以一个好价钱卖掉它！"夏洛特大声说道，此刻她正为我们端来热气腾腾的绿茶和无麸质曲奇。她还说自己不喜欢照相，但在珍妮的镜头前却表现得相当轻松。她盘坐在深灰色的沙发上，双手握着 20 世纪 70 年代的陶瓷杯，脚慢慢滑到一张格子薄毯下，随意的举止中透露出一种平和与自信——这很像巴黎人的作风。总之，这位年轻的女士看起来很有巴黎范儿。她询问我们是否介意她抽支烟，我们表示毫不介意。然后，她娓娓道出自己的故事。

夏洛特在巴黎长大，她的童年在一个被称为"巴黎乡村"的独特街区里度过——街区位于第二十区，是元帅大道附近一块地势较高的区域。她曾就读于著名的马西雍中学——这间学校的校舍以前是塞纳河岸边的一家酒店，校内的建筑美轮美奂。如今，第十一区已经成了她的另一个家和故乡，但当年产生搬家念头时，曾着实让她陷入严重的恐慌。在交谈了短短一刻钟后，珍妮和夏洛特就很快意识到，她们有许多共同的熟人。

夏洛特直截了当地告诉我们，她的爱情生活就像弗朗索瓦·特吕弗导演的电影剧情一样。是的，她说得没错。她告诉我们，自己曾爱上一个男人，还讲述了这段关系的所有细节。但她让我们发誓，无论何种情况，书里都不能提及这个故事的任何内容。她曾想尽一切办法要忘记他，甚至还去寻求催眠师的帮助。"我的妇科医生向我推荐了这位催眠师，但他自己最后也成了我的心理医生。"她叹了口气，又点上一支烟，用略带戏剧性的语气补充道，"显然啊，我还是想要个孩子。"

夏洛特觉得自己最像巴黎人的时候，就是在外面待了一晚上后搭出租车回家的一刻。在那一刻，她会摇下车窗，让脑海里充盈着音乐，也让双眼沉浸在车窗外不断晃过的城市风景中。"在那个瞬间，我会意识到自己是多么幸运。"她疯狂地爱着巴黎，还出人意料地喜欢法

国摄影师克里斯蒂安·米洛万诺夫在 20 世纪 80 年代拍摄的"办公室"（bureaux）主题影集。她每天都要洗头发，但喜欢让头发自然阴干，她也爱使用雅漾（一种在法国药妆店常见的美容品牌）的产品。不过她也承认，自己不太喜欢化妆或穿内衣。"我在纽约住过几个月，也经常去东京旅行，我很欣赏巴黎女人享有的自由度。巴黎女人可以不做发型、不修指甲，坐着的时候也不用交叉双腿。要是在别的地方，我们这种慵懒的态度是不可能存在的！"

这种态度不仅决定了她的生活方式，也支配着她的日常生活。"我

从来没有计划过什么，也从未在日历上记录过任何事项。"她向我们保证说。她这一代人普遍都有两份工作，夏洛特也不例外。她在通信公司兼职，薪水用来支付各种账单；另外，她和她在学习艺术史时结识的两位女性朋友在一起经营自己的事业。她们的公司叫"我们可不是孤军奋战"（We Do Not Work Alone），致力于艺术品营销。每天早上，她都会喝一杯橙汁、一杯黑咖啡，吃一块法式吐司，然后通过短信与合伙人谈工作，通常要持续到他们午餐相见的时候。

到了下午，她们会到朋友与同事路易丝合住的公寓里工作，这间公寓位于理查－勒努瓦大道一栋建于 20 世纪 60 年代的大楼顶部。"这

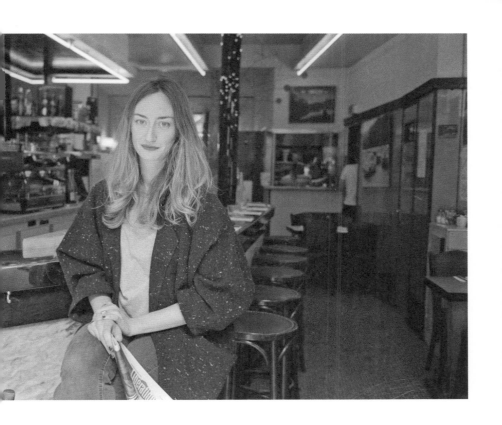

里就像一个大家庭，我们全部都是路易丝女儿的教母，我们和大部分做推广的艺术家也都是朋友。事实上，我们的工作日常常常都会以喝一杯作为结束！"这就是巴黎赋予人们的自由吧。

我们的巴黎
爱网络，憎网络

巴黎女人从不发到 Instagram 上的
十种事物：

i.　她的猫咪

ii.　她的书

iii.　她的男友

iv.　她的小孩

v.　她的闺蜜

vi.　日间巴黎的明信片

vii.　巴黎之夜的明信片

viii.　她的购物篮

ix.　正在享用的食物

x.　简·柏金的照片

巴黎女人喜欢发到 Instagram 上的十种事物：

i. 她的猫咪

ii. 她的书

iii. 她的男友

iv. 她的小孩

v. 她的闺蜜

vi. 日间巴黎的明信片

vii. 巴黎之夜的明信片

viii.她的购物篮

ix. 正在享用的食物

x. 简·柏金的照片

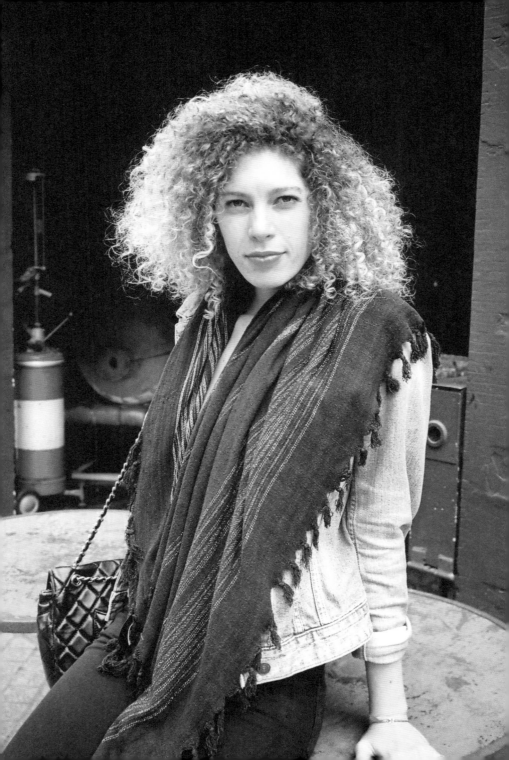

在圣旺

听**范妮·克莱维尔**
讲述在巴黎奋斗的故事

圣旺跳蚤市场
精品女士内衣
优异的法国中学毕业会考成绩
大蒜和韭黄

在如今这个年代，如果你连巴黎环城大道都没去过就说自己了解巴黎，那简直是在说疯话。环城大道就好比一堵墙，把巴黎城与郊区分隔开，它也似乎在提醒人们，市中心与郊外之间存在着显而易见的社会隔离现象。不过每到星期天，我们就会去城市周边地区散步，比如到蒙特勒伊参观工作坊，造访圣丹尼的单间公寓，又或者是拜访隐匿在圣旺区某栋美丽砖楼里的一间小公寓。我们的受访者范妮就居住在其中一间公寓里。她很喜欢自己漂亮的一居室公寓，其位置距离克利尼昂库尔门的著名跳蚤市场仅有几步之遥——这座跳蚤市场是巴黎复古爱好者的周末热门去处。

范妮是一个身材高挑、天生就拥有一头靓丽卷发的女人。她以前老盘算着要赶在 30 岁前用积蓄在这里买一套公寓，经过几年努力，一个月前她终于有了属于自己的家。她为新家添置了很多可爱的家居用品，无论是粉红糖果色的冰箱，还是桌上的白玫瑰，通通都经过了精心挑选，而这也是她长久以来的梦想。

范妮在巴黎圣佩雷斯大街打理一家名为"巴黎之石"的珠宝店，

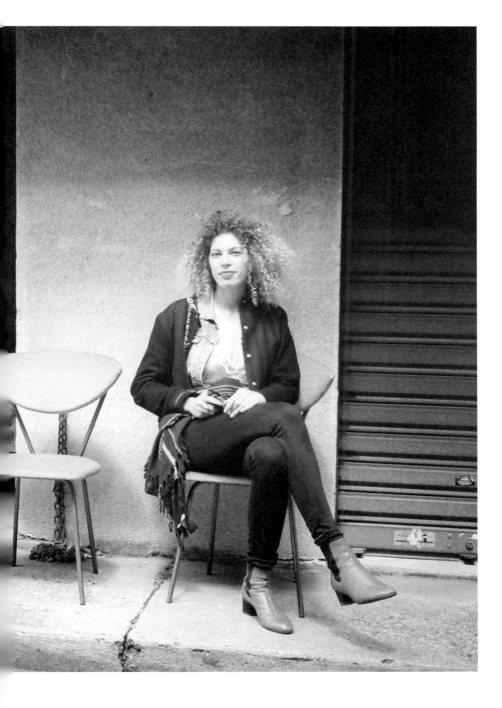

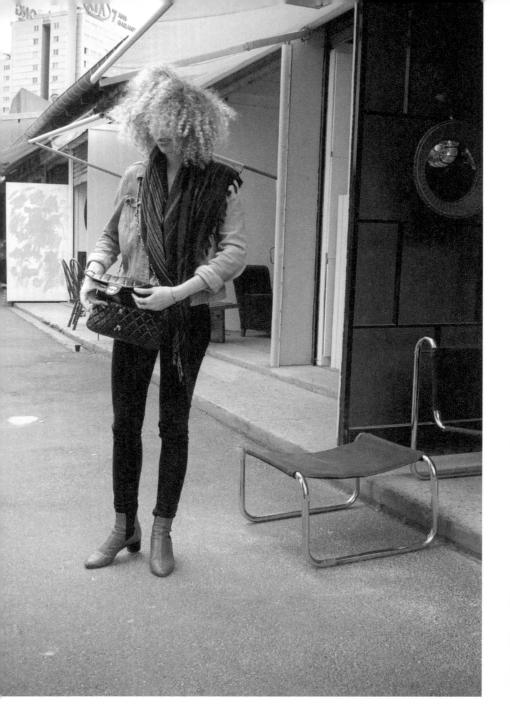

距离出版此书法语版的格拉塞出版社的总部只有很短一段路程。珍妮经常去那里购物，因为那间店能满足她对精致耳环的痴迷，而这也正是这一品牌成功的原因。我们最先被范妮出众的外表所吸引，打算把她的故事收入这本书里。但让我们没想到的是，接下来会听到一位 21 世纪巴尔扎克式女汉子的逸闻趣事：一个出生在外省，但从小就被征服首都的决心所激励的年轻女子的奋斗故事。

范妮出生在波尔多，母亲是当地人，父亲是瓜德罗普人。她的童年不是在圣马丁岛的瓜德罗普度过，就是住在诺曼底的一所寄宿学校里。在她还很小的时候，跟随着在音乐行业工作的母亲搬到了巴黎第十三区。就像我们遇到的每一个巴黎女子一样，范妮清晰又动情地讲述了自己探索首都的故事。她回忆道："那时我 13 岁，平时在寄宿学校，周末就会去我母亲在巴黎的住处。"说着她点了一支烟，往精致的酒杯里倒上了第二杯番石榴汁。"我常常是一个人。我会去舒瓦西大街买越南河粉汤，去 MK2 图书馆看电影，或者去陈氏商场购物——因为他家会出售来自西印度的商品。我记得，在巴黎散步是让我欢欣鼓舞的事情。其实现在我也经常回那个街区，这样会让自己感觉又变成了一个十几岁的孩子。"

那么，是儿时经历激发了她想长住巴黎的愿望吗？"我意识到，巴黎是一座包罗万象的城市，集合了伴随我童年时光的种种不同的文化。这里的一切东西都混杂在一起。"为了要留在巴黎的梦想，她在 15 岁的夏天去瓜德罗普一家购物中心报名参加了精英模特公司的世界精英模特大赛。当得知自己赢得评审团大奖时，她着实震惊了。随后，她休学一年投身模特界，但很快意识到，现实情况比她预期的要复杂得多。"在那个年代，很少有黑人或混血女性能够在模特界功成名就。我的经纪人一直想把我的自然卷发弄直，他们还认为我的身体'适合展示内衣'，所以经常让我为内衣品牌做展示模特和走秀。在我的职业生

涯里，曾遇到过连 3 欧元都掏不出来的东欧女孩。她们抱有在模特界出人头地的决心，而我却没有。我很快就意识到，自己不可能成为下一个娜奥米·坎贝尔。"于是，这位模特菜鸟后来修读了商业学位，之后辗转于巴黎蒙田大道和摩纳哥等地的奢华精品店，然后在 2013 年遇到了"巴黎之石"珠宝店创始人玛丽·波尼亚托夫斯基，开始在这家店工作。从这份工作中，范妮看到了一个"能够安顿下来"的机会，并重新找回了自己的爱好。她特别喜欢唱歌，每个月都要去上几个小时的演唱课。

范妮最喜欢邀请一小撮朋友来家里做客。她仿佛有一种魔力，每次都能让朋友们心甘情愿地坐地铁来到 4 号线的终点站。她会不断往橱柜里补充大蒜、韭黄、西红柿、柠檬和印度香米，从来不会被突如其来的朋友杀个措手不及。"只需要往这些原料里加上一点扇贝或去骨鱼片，就能搞定一顿美味佳肴。"所以，她的朋友们也都知道，无论何时来到范妮的家，她家的炉子上总会有一道美食在等着自己。"我搬到这里才一个月，但已经和当地的杂货店老板混得脸熟了。我经常到那里询问一些很难找到的东西！"她的这一席话，想必只能从一个忠实诚恳的巴黎女子口中说出来吧！

我们的巴黎

做这些事，能让你看起来更像巴黎女人

一个人的出生地并不重要：一旦来到巴黎，就会被这座城市所改造，成为真正的巴黎女子。巴黎是一座国际化都市，来自世界各地的人们把这座城市变得丰富多彩，也把这里当成了他们的家。归根结底，能够把生活在巴黎的每个人联结起来的，是一种特殊的生活方式——巴黎人的那些"恶趣味"。

i. 在没有地铁票时，顺着前一个人一起挤地铁闸门。

ii. 从第九区的特鲁丁大街租一辆共享单车骑行 32 分钟后停放在第十六区的东京宫。

iii. 有一种对巴黎人的刻板印象是真的：在家的路上，巴黎人一边走路，一边趁热啃掉半根法棍面包。

iv. 晚上 7 点半在酒吧聚会时巴黎人会说："今天我有事，只能喝一杯哟！"但到凌晨两点时已经干掉了六瓶桑塞尔白葡萄酒。

v. 从 Monoprix 超市花 12.99 欧元买一盒妙巴腮红，在接下来的六年里每天都在用它化妆。

vi. 在你进食的时候，会和你谈论食物（等上了咖啡，话题会转换到政治或是性方面）。

vii. 计划重读作家玛格丽特·尤瑟纳尔的所著作，却在每个周日都在网飞看网络电视。

viii. 看完时装秀后，会跑去古着店，看有没有在秀场上看到的"一模一样的服饰"。

ix. 买下当天所有的报纸和杂志，而坐在咖馆外却只读《巴黎人报》的星座占卜文章。

x. 无论天气温暖、下雨或是下雪，总是会怨天气不好……这个，你懂的。

xi. 就算电脑里有 25 张精彩歌单，也会选择厨房里听怀旧电台的节目。

xii. 把迟到 15 分钟当作准时。

xiii. 在市集里买有机蔬菜计划着为自己做大餐，最后却到本地的法式餐馆吃法式三明治。

xiv. 一旦气温上升到 18 摄氏度，就会去公园享受野餐。

xv. 购买尺码极小的复古鞋，但只穿一次。

在杜乐丽花园旁

听**索菲·丰塔内尔**
讲述自然变老的美丽故事

一排房间
玄米茶
尚蒂伊奶油咖啡
自然到白头

在六楼的镀锌屋顶下，有六扇大窗户和六个小阳台，淡蓝色的窗帘在六月温柔的微风中轻轻飘动，透过薄薄的窗帘，可以看到杜伊勒里宫绿意盎然的花园、大摩天轮，还有欢快肆意的巴黎风光。索菲·丰塔内尔（Sophie Fontanel）的 Instagram 粉丝（现在粉丝数已有约 17 万）对她家窗外美妙绝伦的景色可谓已经了如指掌。索菲每天都会在社交网络上分享雅致的图片和充满幽默感的想法，而她也承认对此相当上瘾。她的遣词造句丰富多变，还有自成一格的美衣哲学，不过最吸引粉丝的，还要属她那让别人无法仿效的巴黎式生活——这也是我们今天去拜访她的原因。

"有一种女人只存在于巴黎。"她说，"她们身上有一种模棱两可又自相矛盾的感觉。她不化妆，但当她直勾勾地盯着你时，你发现她就好像涂了睫毛膏一样。她在讨论性话题时显露出一丝狡黠，上床时却又拘谨到难以置信。她会狼吞虎咽吃下一个巨无霸三明治，但在第二天之前却忍着不再吃任何东西。身为一个巴黎女人，就得有我行我素的样子。"索菲显然在遵循这一生活哲学。她写过一本书，里面讲述了

自己曾经一段既激烈又备受折磨的经历，这个关于情欲的故事远销美国，而且销量不俗。

索菲曾为 *ELLE* 杂志撰稿，还担任过该杂志的时尚总监。现在，她习惯利用 Instagram 和《新观察家》杂志的每周专栏来抒发自己对于时尚圈的见解，她发表的文章总是让读者看得欲罢不能。索菲觉得自己完全不可能避而不谈内心的看法，也无法抑制讲俏皮话的冲动。"巴黎女人一直都有完全的言论自由，"索菲特别强调了这一点，随后她还一针见血地总结出巴黎女人的典型特征，"比方说，我早上不会设置闹钟，还喜欢赖床，但这并不意味着我不工作。事实上，喜爱享受放松惬意的生活，是巴黎女人身上一种非常典型的特质。"

轻松自在的生活方式也许更像是南法城市奥瑟戈尔那些冲浪者所专属的，但实际上索菲说得也没错，巴黎女人之所以很酷，并不是因为她们成天无所事事，而是因为她们享受自己的生活。

露露·德拉法蕾斯、伊娜·德拉弗拉桑热、卡洛琳·德·麦格雷等著名模特、设计师和缪斯都享有"巴黎酷女人"的称号。在法语中，一个人的名字里若带有"de"，那就说明此人是贵族后裔，而几乎所有出身高贵且散发贵族气质的巴黎女人通常看上去都既冷酷，又玩世不恭，还带有某种不拘小节的成熟感。

索菲·丰塔内尔就拥有这样的气质。她出身于贵族气息浓厚的第十六区葡萄园街，生活在该街区的大都是条件优渥的中产家庭。但是，她的家庭却并不富裕；母亲是亚美尼亚难民，早年间一手拿着 *Vogue* 杂志，一手拉着索菲的父亲来到了马赛。"我生活的地方仍然有食品储藏室和后楼梯。小时候，我经常在公寓外遇到像杰姬·肯尼迪[1]那样裹着头巾的贵妇，也常看到别人全家去参加弥撒或去犹太教堂。从小我就觉得，我们家是中了彩票才能住到第十六区吧。不过，其实我更想住在圣日耳曼德佩区，因为只需步行就可以到花神咖啡馆。当然，父母对我的想法感到诧异极了。"事实上，索菲长大以后就自己搬到了韦尔讷伊街的一套一居室公寓里，离圣日耳曼德佩区只有一步之遥。她在花神咖啡馆开过很多会议，下午时分，她总会点一杯干白葡萄酒小酌，再配一小碟粗红肠。我之所以知道索菲有这个习惯，是因为曾和她在 *ELLE* 共事过。不过，那时的我太年轻，还无法像她一样享受如此完美的巴黎时光。她以前是我的导师，后来我们成了亲密无间的朋友。

尽管索菲对花神咖啡馆如此痴迷，她却告诉我们，这间咖啡馆远远算不上巴黎最具标志性的地方。实际上，她对巴黎的咖啡馆自有一套详尽的理论。"我从小就知道自己是巴黎人，身边也总有朋友想去新潮的 Costes 餐厅或波堡（Beaubourg）咖啡馆。但是，我更喜欢去本地

1 杰姬·肯尼迪（Jackie Kennedy），杰奎琳·肯尼迪的昵称，是美国第 35 任总统约翰·肯尼迪的夫人。——译者注

酒吧。巴黎人有一种本领：总能把本地酒吧里让人难以忍受的服务生变得友好待人。他们会让服务生慢慢了解自己，喜欢自己，最后欣然为自己奉上一杯加了尚蒂伊奶油的咖啡。"

在我们和索菲碰面的那天，她正在践行一项长期计划：不染头发（就像她多年以来一直所做的那样），让白发慢慢取代黑发。索菲喜欢在 Instagram 上和粉丝分享生活点滴，她目前正在写一本小说，粉丝们很快就有机会了解她的更多经历——每当机遇来临的时候，她就会用文字记录生活的一切，而她的书也总是能引发世界各地女性的共鸣。她为我们的印花瓷杯（在她家里一排房间的尽头，我们发现有一张大床上的床单图案和茶杯的图案非常相似）里斟了一杯玄米茶，说她刚刚和美国版 *Vogue* 杂志的一名记者兼粉丝通话。基本上，索菲在谈话过程中一直都在向我们强调一种具有巴黎特色的论断：一个女人的生命力并不局限于年轻的岁月，在变老的过程中，不依靠整容，她依然可以活得很摩登且充满吸引力。"要普及这一想法，还需要做不少艰巨的工作。但是，这并非一项脑力工作，而需要身体力行。"面对这个过程需要相当大的勇气，也需要有一种自信又从容的态度，就像索菲之前提到的那样。

她告诉我们，要想最终拥有一头白发，就必须忍受从黑发到白发的各个阶段，还要应付来自时尚界人士七嘴八舌的议论。有一位时装周的造型师曾评论说："你知道的，男人永远都不喜欢白发。"索菲立刻回敬道："男人什么时候知道他们喜欢什么呢？"由此看来，索菲只做自己喜欢做的事，尤其是服饰方面。每次拜访她的时候，她起码会带我们去一次更衣室，让我们欣赏她的最新战利品。这一次，她展示的是设计师凡妮莎·苏厄德定制的高腰牛仔裙。她把更衣室视为自己的梦想之地。在这里，她有专门放手提包的隔间，有满是围巾的帽盒，还有摆放整齐的棉质 T 恤和折叠规整的毛衣。但是，这个空间远远不

到"爆仓"的程度：我们看到在横杆上只挂着几件衣物，而且只看到两双靴子——如果看过索菲发布在 Instagram 上的不同造型的话，一定会对这么少的衣物感到大吃一惊。她不愿长期保存任何东西，定期清理淘汰衣物是她的法则。

"我在花时间购买一些不会过时、但会让自己厌倦的东西，"她笑说，"我只保存从古着店里淘来的东西，或是会让我触景生情的物品，比如这张母亲重新整理过的沙发，还有姑妈阿娜赫德的家具。我甚至把书扔掉，因为我不需要靠那些书来证明自己都读过什么。"是什么让索菲成为时尚偶像呢？看来就是这种深刻却轻盈的生活方式吧。

我们的巴黎
欣赏一切自然事物

珍妮在试图说明自己所理解的"自然"时是这么说的："如果你爱自己的伴侣，会爱他坏掉的牙齿和轻微的斜视。喜欢时装设计师索尼亚·里基尔，是因为她有迷人的红发；喜欢凡妮莎·帕拉迪斯[1]，是因为她牙齿间的细缝；而对于演员朱丽特·格蕾科，喜欢的是她的罗马鼻。"要知道，"缺陷"这个词可是真会激怒我们的。只有当一个人假定世上存在"完美"的微笑、头发或眼睛时，才会出现"缺陷"一说。我们都讨厌那些严格又肤浅的"美"之定义，让人变得优雅和更有女人味儿的方式有上千种。女权主义运动提到"自我照顾"（self-care），这一说法来自天生好战的盎格鲁—撒克逊的部落文化，意思是每个人都有爱自己的权利，并且要在没有负罪感的情况下照顾自己。无论生理还是心理，无论长处或短处，人们都拥有深爱自己的一切的基本权利。这本书里的所有女人都散发着"自然"之光。换言之，她们觉得完全没有必要去变得"完美"，或是改善自己的外貌，因为她们只想全然地做自己。

1　凡妮莎·帕拉迪斯（Vanessa Paradis），法国女演员、歌手。——译者注

在圣马丁近郊

听**吉泽斯·博格**

聊文学、爱情以及激情燃烧的岁月

亚马孙蝴蝶
Favela Chic 餐吧
工作服
埃里克·侯麦

　　虽然世事难料，但我们与吉泽斯的相遇应该是命中注定。某天晚上，珍妮在一家酒吧里夜游时偶然撞见了她，于是就无可救药地"拜倒"在这位穿着天蓝色工作服的女孩子面前，后来还说要拉我一起去和这位年轻女孩聊天。吉泽斯在巴黎第十区马歇拱廊街经营一间名为耶稣天堂的新潮餐吧，招牌菜蟹肉贝奈特饼[1]、香橙鸡和出色的卡比罗斯卡鸡尾酒让这家店名气不小。几天后，本书的编辑克洛依也打电话来和我们说，她刚刚在耶稣天堂开完会，发现餐馆老板娘不仅举止优雅，还热爱文学。为了这本书，看来我们真的必须去拜访一下她！

　　其实呢，不把吉泽斯放进这本书也是不可能的。单单一看"吉泽斯[2]"的大名，就足以吸引人们的眼球。她来自佛得角，今年44岁，已经在巴黎生活了25个年头。她拥有一套四面是淡蓝色墙壁的公寓，墙上贴着电影海报，家里还有从艾玛于斯慈善商店买回来的蝴蝶标本。

1　贝奈特饼（beignet），在油酥面团表面撒上一层薄薄的细砂糖做成的一种法式无孔甜甜圈，口感类似于油条。——译者注
2　吉泽斯（Jesus），在英文中与"耶稣"的拼写相同。——译者注

在一个秋日下午，我和珍妮终于有幸来到吉泽斯家里和她闲聊，听她讲述一个女人如何靠自己打拼事业的故事。

吉泽斯并非一开始就决定要成为一名备受艺术家和作家所崇拜的餐馆老板。在她的过往经历里，也没有任何迹象表明她将在第十区一个小小的拱廊街开办一家隐秘的餐馆——常客们担心人们蜂拥而至会让这家店失去特色，因此从不大肆宣传，只在小圈子里提及餐厅的地址。吉泽斯梦想有一天在店里举办文学颁奖礼来鼓励年轻的巴黎作家们，她还聘请了一位写过四部小说的主厨安娜·迪博斯克。

虽然举办文学颁奖礼是个梦想，但吉泽斯必须时刻为她的巴黎梦而战。她的坚韧不拔和远见卓识，让我们想起了可可·香奈儿和记者艾莲娜·拉札雷芙。那些在巴黎留下印记的商界女性和她一样，都是在逆境中一路披荆斩棘，不断成长。"1992年，我坐长途汽车来到巴黎的加列尼汽车站，"她回忆说，"我当时十九岁，在这之前和父亲住在里斯本。我们抵达巴黎的时候正好是火热的八月，而我一句法语也不会讲。"

如果想了解吉泽斯，就应该听她是如何谈论文化的。她的书架都快承受不住藏书的重量了。她为我们朗读了一大段2015年诺贝尔文学奖得主、白俄罗斯作家斯韦特兰娜·阿列克谢耶维奇的作品，还承认自己经常重读路易-费迪南·塞利纳的著作。除此以外，她也会去剧院看戏剧和芭蕾舞。她向我们提到皮娜·鲍什[1]，说自己最近在沙特莱剧院看到了她以前的编舞作品。吉泽斯说，近来也去过巴黎爱乐文化中心，在那里听了一场菲利普·格拉斯[2]的室内音乐会，去奥德翁剧院看

[1] 皮娜·鲍什（Pina Bausch），德国最著名的现代舞编导家，被誉为"德国现代舞第一夫人"。——译者注

[2] 菲利普·格拉斯（Philip Glass），美国作曲家，作品经常重复简短的旋律和节奏模式，同时加以缓慢渐进的变奏，被称为简约音乐。——译者注

了最新一场莎士比亚的《亨利四世》。她向我们介绍了自己的一些艺术家朋友，比如为耶稣天堂设计品牌标志的马达加斯加艺术家乔埃尔·安德里奥梅里索亚。

吉泽斯每周至少都会去一次 La Cinémathèque、Le Champo、Le Reflet Médicis 这些位于拉丁区的电影院，去欣赏最爱的电影导演埃里克·侯麦拍的老电影。她把他执导的电影《狮子星座》反复看过不下20次。"我喜欢下午去看电影——那个时候，会有几个老人大声评论演员的表演，看完电影，我还喜欢去老酒吧坐一坐喝杯茶。"她用极轻微的佛得角口音提到"vieux rade"——"本地老酒吧"的口语说法，从她口中听到法国导演让－吕克·戈达尔的这句俚语，还蛮有诗意的。

我和珍妮对吉泽斯拥有如此渊博的学识感到非常诧异，也惊叹她在巴黎的文化生活竟然如此丰富，要知道，大多数巴黎本地人都忘记了要去参与文化活动。她不仅专注于文化，也热爱时尚，并拥有独特的穿衣风格。她善于以极低的价格淘到令人惊艳的服饰，并把不同单品搭配在一起打造出优雅的造型。实际上，她有时也会为电影和其他摄影活动担任造型师。她全凭自己的努力，达到了目前的成就。"我来自一个什么都没有的地方，天生也没有任何优势，因此人们经常会质疑我的聪明才智，"她说，"他们会诧异我竟然懂得这么多东西。我一直都有求知的渴望。父亲曾告诉我：学习不会占用你太多的时间。"

正是由于长年孜孜不倦地努力工作，吉泽斯才能懂得和享受工作为心灵带来的滋养。"当时我的首要目标是说一口流利的法语，这也是一项基本要求。我不想像我的姐妹们那样侨居在与世隔绝的佛得角社区里，而想让自己从这一切中解脱出来，融入巴黎人的生活中。我看了很多电视，尝试去了解我刚到的这个国家，每当有人跟我说法语，我都会向他们表示感谢。三个月后，我就开始能流利地说这门语言了。"后来，吉泽斯生了一个小女孩，取名为莉萨。她起初在巴黎东南郊的

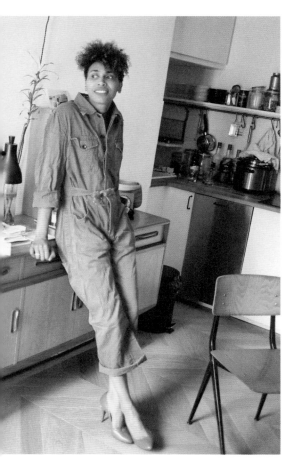

克雷泰尔为一对夫妻工作，随后到一家名为 Favela Chic 的巴西餐吧俱乐部当服务员——这家店相较以前的工作地点更靠近市中心，位于共和国广场和圣马丁运河之间，至今仍在营业。

当年，这家店可是巴黎年轻人心中的"宇宙中心"，是每个人都必去的地方，而那时候每个人都想去那里看一眼吉泽斯。"我只是有些漂亮而已，"她谦虚地笑着说，"但是，我可什么都不懂啊！我从来没有做过饭，也从来没调过鸡尾酒。我也不知道自己怎么就好像成了那里的招牌。人们会去那里看我，甚至现在我到巴塞罗那或纽约，有时候也有人跟我谈起当年在那里的工作，这实在太疯狂了。"说着她叹了口气，感觉她希望人们不要再提起这件事。

如今，她把全部热情都倾注在经营了两年的耶稣天堂餐吧上。当然，她还是一如既往地热爱着巴黎，以及在这里结识的亲朋好友，对她来说，他们就如同自己的家人一样。"这里是我的家，我不会再搬家了。"不过她也坦诚地说自己也曾经因为某个男人而想过搬到里斯本。爱情，算得上她的致命弱点。"恋爱关系为我的生活提供了一种韵律，"她承认这一点，"我可能会因为在街上撞见一见钟情的人就离开现在的爱人。浪漫的爱情总是让我神魂颠倒。每当在街头遇到一个人以后，我就会觉得，哎呀，好像立马就不能想象没有他的生活了。这样的遭遇也可能只会发生在巴黎街头吧。那些人会让你忍不住回头看，更会赢得你的心。那一刻，就像有什么东西在你的胃里翻江倒海一样，但是到了某一天，这样的感觉又会突然消失得无影无踪。我能够几小时不间断地谈论爱情呢。"从本质上来说，我们都觉得吉泽斯是激情的化身，也许是因为巴黎比其他任何地方都更能让她抒发自己的感情吧。

我们的巴黎

相爱在巴黎

在巴黎坠入爱河，本应是一件无比完美的事——但因为这座城市到处都充斥着关于浪漫的陈词滥调，这种说法也很容易因为太绝对而给情侣们带来巨大的压力。就像摄影师杜瓦诺拍摄的标志性作品《市政厅前之吻》，抑或伍迪·艾伦的电影里展现的那样，巴黎似乎理应从早到晚都充斥着各种浪漫。但是我们都知道，巴黎其实就像其他任何地方一样，这里有夫妻在经历一个糟糕之夜后分道扬镳或反目成仇，也有情侣不得不共同忍受日渐沉闷的生活，当然，这里还生活着许多"万年单身狗"。不过，就算我们本可以摒弃所有属于巴黎的多愁善感的浪漫主义，彻底粉碎爱情的神话，但我们还是决定不那样做。人们都说，巴黎是一座爱之城……虽然这个说法很老套，但我们仍然想守护它。

梦想中的巴黎亲吻圣地：

i. 在艺术桥的扶栏上挂上一把爱情锁，然后深情一吻。

ii. 站在埃菲尔铁塔的第二层，伴着夕阳西下相拥相吻。

iii. 在一个美好的夏日清晨，到协和广场的摩天轮上亲吻对方。

iv. 在位于肖蒙山丘公园的罗莎·博纳尔酒吧附近的垂柳下驻足拥吻。

v. 某个春日傍晚，到塞纳河游艇浮桥上热吻。

vi. 在十月的某个深夜，撑着一把大伞，站在圣日耳曼大道上拥吻。

际生活中的巴黎亲吻地点：

躲在里沃利街圣雅克塔公园里的灌木丛中
吻。

反锁在莫利托游泳池的私人更衣室里
吻。

凌晨 2:30，坐在开往尚佩雷门的深夜巴士
亲吻对方。

在皮加勒街的 Chez Moune 俱乐部外的垃圾
旁热吻。

在圣丹尼街的 Mauri7 酒吧柜台下面激吻。

在波堡街皮卡第冷冻食品超市里的海鲜区
吻。

站在人行道上轻轻一吻——当然，我们不
能告诉你具体位置。

外出吸烟后，在酒吧户外座席的暖炉旁瑟
发抖地亲吻对方。

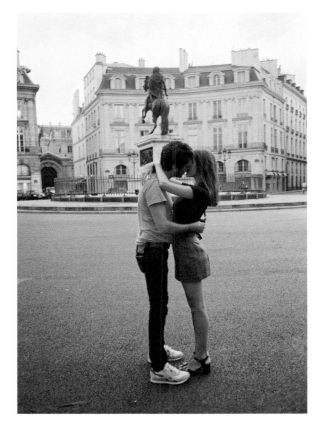

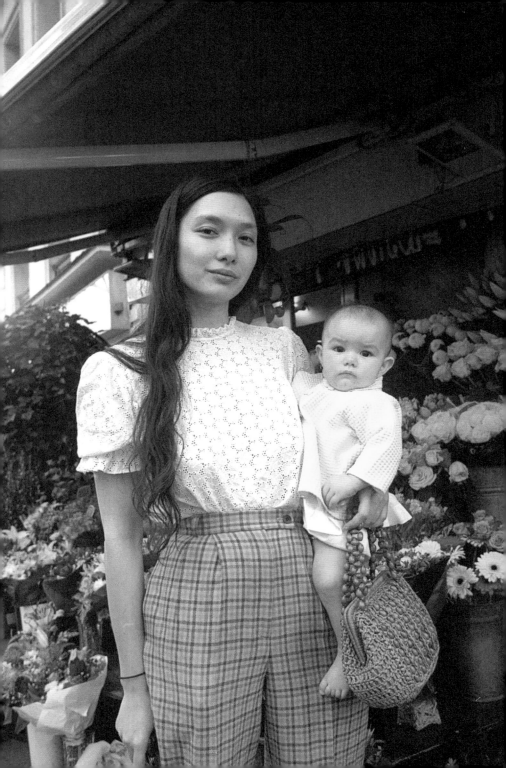

在圣马丁运河河畔

和女权主义者**诺埃米·费斯特**回忆惊魂一刻

法国文化
露台后
装饰艺术
Le Baron 夜店

　　在拜访诺埃米的时候，我们见到了她三个半月大的可爱小宝宝吉吉。她穿着棉质睡衣，为躺在摇篮里的宝宝做"声乐练习"。诺埃米仍在适应有孩子的生活，但如同典型的巴黎女人一样，她没有背负任何负罪感。"我会在晚上用母乳喂她，但我没有戒烟；不管是去办公室，还是参加晚宴或聚会，我到任何地方都会带着她，但不会在外面待到很晚才回家。"到访的那天，我们在诺埃米家听到厨房里传来法国文化节目的声音，看见她桌上的早餐还没来得及收拾好，一个波点花瓶里插着一束野花。她的唱片机和成堆的黑胶唱片，可谓是整个房间的画龙点睛之笔。屋里正晾着几件衣服，前门有一个引人注目的太阳形状的镜子，正反射着一缕迷人的阳光，好像在欢迎我们来到诺埃米之家。

　　你听过法国知名歌手查尔·阿兹纳弗演唱的歌曲《波希米亚人》吗？是的，诺埃米就像是这首歌的化身，她的生活也正好体现出歌曲里传达的波希米亚精神：梦想有一个更加公正和单纯的世界，在固定的时间用原本打算购买食物的钱来买诗集。顺便说一句，20 世纪初，巴黎第一次出现"波希米亚"的说法就是在蒙马特尔附近。诺埃米的丈夫是一位 DJ、艺术家兼企业家，他们一年前在印度完婚。他们居住的地

方离圣马丁运河只有咫尺之遥，也是一个深受"波波族"[1]追捧的街区。2015 年 11 月 13 日，这里不幸成为恐怖分子的袭击目标，但想必和街区的特色应该没什么关系。在采访诺埃米的时候，我们对恐怖袭击仍然记忆犹新，所以很快就谈论到这个话题。"我们搬到这里快一年了，"她一边倒牛奶一边回忆说，"我们之前很想逃离第九区，因为那里已经完全士绅化。你会发现，那里所有的咖啡馆现在都是木质装潢，全都出售不含麸质的蛋糕。但来到这个街区后，我们体验到巴黎更接地气的一面，这里有文化的交融……我开了一家小卖部，一间咖啡馆和一家花店。"发生恐怖袭击的时候，一名恐怖分子在诺埃米家外 La Casa Nostra 餐厅的露台座席区开枪。那天晚上她听到街角传来枪声，于是从窗户探出头来看，刚好目睹一名男子倒在花店前。"那时候我刚刚发现自己怀孕了。起初在事件发生后，我也想逃到郊外。后来，我们看到本地人在清理人行道上的血迹，而两个月以来，整个街区就像一座陵墓一样，空气中弥漫着一种无法形容的悲痛。最让我震惊的是，媒体和政府一直高度戒备，让恐慌的状态延续了很长时间。最后，我还是决定留下来战斗。"

诺埃米出生在洛杉矶，母亲有一半英国血统一半中国血统，父亲则是以色列裔波兰人。她先在香港住过一段时间，接着搬到了伦敦，后来再随家人到巴黎安家，到巴黎的时候她才七岁。"因为父母把我送到香港的法语学校读书，我在四岁的时候就学会了说法语。第一次看到巴黎时，我发现这座城市非常明亮，简直令人着迷，让我再也不想回到伦敦——那个寒冷潮湿的城市，每天下午四点天就黑了。"

诺埃米的愿望实现了。后来，她和父母搬到位于第十六区的一栋

1　波波族（bourgeois bohemian），布尔乔亚—波希米亚人，指拥有较高学历、收入丰厚、追求生活享受、崇尚自由解放、具有较强独立意识的人群。——译者注

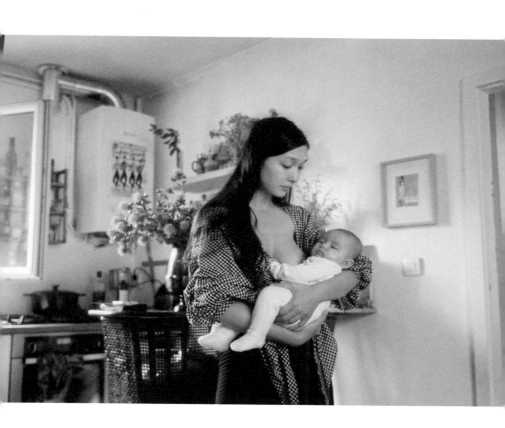

公寓大楼里，在那里度过了浪漫又富有创造力的童年时光。诺埃米从小就想成为一名艺术家，因此她拒绝接受传统的教育，也拒绝参加法国高中毕业会考，但她到法国著名的艺术和设计学院——国立高等装饰艺术学院参加了六年的工作坊学习。在那里，她学会了制作花卉式样的精美拼贴画。

当年在第八区的马索大街上有一间名叫 Le Baron 的小型夜店，每到晚上，巴黎的年轻人都喜欢成群结队地去那里参加聚会。我就是在那间夜店里第一次遇见了诺埃米。那时她才 17 岁，印象中的她好像穿着 20 世纪 40 年代的连衣裙，要不然就是胸前贴着装饰性的绒球。她是巴黎先锋时代的第一代女性 DJ（或被称为 "DJettes"），整个晚上都在打碟。诺埃米的公寓里充盈着无忧无虑的气氛，而她的生活方式，她拨开肩上的头发、把女儿吉吉紧抱在胸前的动作，让我回想起曾经在 Le Baron 感受过的那种飘飘欲仙的自由感。"当年度过的每个夜晚都很奇妙。那是一段毫无挂碍、轻松自在的时光，有各种各样的聚会，似乎拥有全部的自由。"如今，她的自我表达欲望依然不减，还成了坚定的女权主义者，想必女儿的出生对她产生了很大的影响吧。"我渐渐意识到，如果社会看待哺乳妇女的方式不对，那会让女性感到内疚。用那种方式看待她们，会让纯洁而自然的行为看起来很肮脏。我们不能容忍物化女性身体的行为，我们要解放乳头！为什么男人有权利袒胸露乳而我们就不行？有一天，我正坐在街边一条长凳上哺乳，一个男人竟然走过来侮辱我。这时候有一群年轻的柔道运动员和他们的母亲经过，把那个人给骂走了。这真是一次胜利。"

诺埃米还把她的"抗争"扩展到 Instagram 上，在上面发布了鲜花、孩子和她自己的全裸照片。在音乐方面，她最近和丈夫发起了一个名为 Radiooooo 的共享合作项目。那是一个很特别的网站，人们可以选择收听从 1910 年至今的世界各地歌曲。

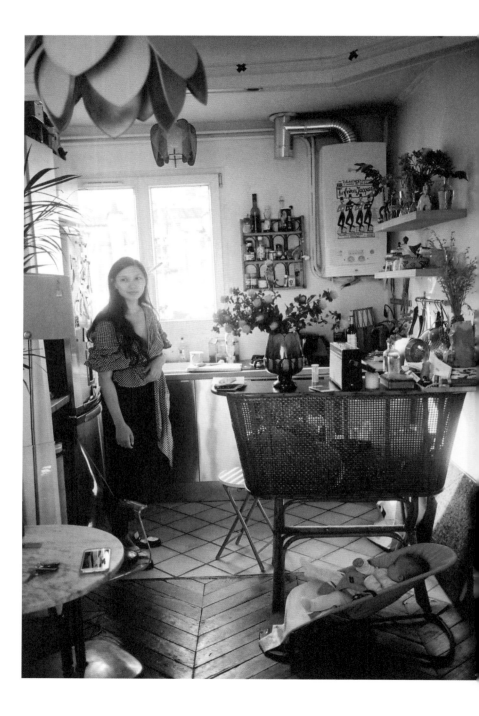

"我们的贡献者来自'世界的四个角落'[1]。最积极的一名贡献者生活在巴西海岸一个小岛上，此人收集了1978年的音乐。每一天，我们都会收到500多首歌曲，我们会精心挑选，保留最好的。每天早上，我们都会查看邮件，比如今天早上，有一位失明的电影人发来一条信息，说这个网站改变了他的生活，而我们也确实想通过这个项目，让世界变得更加开放，带给更多人快乐。"

1 "世界的四个角落"，这一说法出自莎士比亚的《威尼斯商人》，古时以为地球为方形，四个角落指的是世界的尽头或四面八方。——译者注

我们的巴黎
从小受过"良好"教育的孩子

若要讨论巴黎人如何抚养孩子，最常见的育儿方式就是随性而为。当然，巴黎也不乏"紧张过头的母亲"，孩子一出世，她们就立刻放弃了自己的生活。但是，从我们朋友圈里的故事，还有我们听到的关于巴黎女人的童年经历来看，巴黎的孩子似乎并没有"统治"着整个家庭。

十件巴黎儿童经常遇到的事情：

i. 因为父母在隔壁房间用餐，孩子半个晚上都睡在两堆衣服中间。

ii. 父母不懂雇佣保姆的重要性，即便在同层楼和邻居共进晚餐，在孩子睡着后也一直听着监视器。

iii. 八岁的时候就能独自步行去上学了。

iv. 五岁的时候去听演唱会，耳朵上戴着有保护听力作用的耳机。

v. 周日晚上，由于爸爸跑去街对面和朋友喝咖啡，连续坐了六次旋转木马。

vi. 由于妈妈要去上周六上午十一点的水中有氧运动课程，孩子们一整个上午都在公共游泳池里戏水。

vii. 从四岁就开始就明白士兵和共和国保安队员的区别：前者每天早上在学校周围带枪巡逻，后者则带着防暴盾牌出现在发生示威游行的时候。

viii. 在妈妈和朋友为墨贡酒贪杯的时候，孩子们在餐厅的纸桌布上涂满各种颜色。

ix. 爸爸在 Monoprix 超市里为接下来的一个星期囤货，孩子就在图书区坐了一个小时。

x. 在蒙梭公园里丢干面包给鸭子吃，觉得亲近大自然是件疯狂的事情。

世纪巴黎儿童最常见的 20 个历史悠久的名字：

诺雷（Honoré）
莉特（Colette）
朗索瓦丝（Françoise）
塞尔（Marcel）
尔纳贝（Barnabé）
波琳（Appoline）
尔萨泽（Balthazar）
莱斯蒂娜（Célestine）
希尔（Achille）
古斯丁（Augustine）
瑟夫（Joseph）
克（Jacques）
兰奇（Blanche）
尔纳黛特（Bernadette）
里厄斯（Marius）
珊娜（Suzanne）
奎琳（Jacqueline）
内斯特（Ernest）
方斯（Alphonse）
德琳（Madeleine）

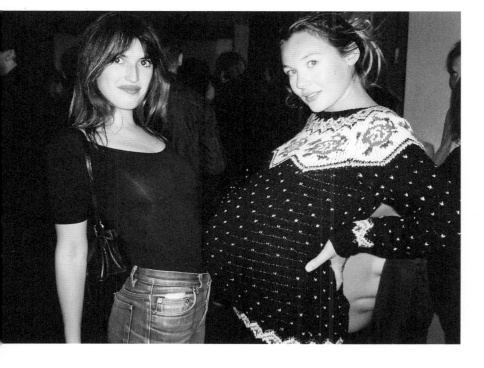

在伏尔泰大道
和**瓦伦丁·马约**
一起回首来时路

跳舞
行李箱
三个孩子
香奈儿快递

　　她曾经是一名舞蹈家，做过模特，也当过主编，还是一位母亲。但在今天，她优雅地吐着烟圈回答说："我不知道（Je ne sais pas）。"她就是瓦伦丁。为人情绪化，但有一种让人卸掉防备的魅力。同为巴黎女人的碧姬·芭铎、弗朗索瓦丝·萨冈和伊莎贝尔·于佩尔等偶像赢得了全世界的宠爱，她们从来都不会像美国明星一样露齿大笑。即使是在状态最好的时候，她们也带着一丝忧郁，而在状态不好的时候，甚至看起来有些恼怒。她们几乎得到了自己想要的一切，并征服了整个世界。瓦伦丁也是那种巴黎女人，她代表了那些既优雅又略带疲惫的巴黎女人，那些穿着香奈儿、为墙壁挂上当代摄影作品的巴黎女人，还有那些虽然穿着亮片服饰却仍旧没精打采的巴黎女人。

　　瓦伦丁的家在第十一区一条宽阔的林荫大道上。别人大概永远都不知道，就在繁华拥挤的人行道后面，有一个小小的庭院坐落在葱郁的树海之中。她居住的公寓看起来现代感十足，一共有两层楼，还带有一个私人的鹅卵石露台。在夏日的某一天，我们来到她家，坐在醒目的柚木桌旁，感觉就像坐在自己家里一样。瓦伦丁的孩子也是我们

　　的朋友，我们曾在这把遮阳伞下啜饮着桃红葡萄酒共度了许多个夜晚，这么说来，这里确实就像是我们的家。瓦伦丁也常常和我们一起聊天，虽然她的嗓音有点儿沙哑，但身材看上去很年轻，她穿着黑色牛仔裤，留着一头波浪形的深棕色短发。虽然她看上去老是有一种上文提到的轻微疲惫感，但待人慷慨大方，全身都散发着找寻乐趣的热情，她希望自己身边围绕着朋友、美酒、文化和幸福感。

　　瓦伦丁的个性具有两面性，而她在巴黎的生活也是如此。她既有法国著名演员凯瑟琳·德纳芙那样的保守，也有弗朗索瓦丝·朵列的奔放；她既有法国北方人的冷静，又自带南方人的热情。总之，她整个人都

融合了法国的两面性。她在比利时里尔长大，母亲来自马赛。她回忆说，母亲"是城里唯一会用橄榄油做饭的人"。13岁那年，她独自离开里尔前往尼斯，就读于当地一所著名的舞蹈学校。在某个夏天，她还有幸上过著名舞蹈家努里耶夫的课。在那里，她不仅学会了如何独立——一年只回家三次，自己洗衣服，还培养出将来成为首席舞蹈家的孤傲和毅然决然的个性。这位年轻的天才当时急于崭露头角，十六岁半就通过了法国高中毕业会考。随后，她搬到了纽约，住在西百老汇的一套公寓里，幸得奖学金补助，她顺利地加入了丹尼斯·韦恩的芭蕾舞团，从此开始加倍努力跳舞。

"我在世界各地都生活过，但我的根却在南法，不管走到哪里我都会种橄榄树，"她指着散落一地的昂迪兹花盆说，"我的祖父来自科西嘉岛，我喜欢地中海的颜色和温暖。"大约在十年前，瓦伦丁决定在巴黎安顿下来，从此结束了漂泊的生活。"我决定安定下来，因为我需要文化的滋养，也想继续茁壮成长，所以这个安居之地必然是巴黎！我的一个朋友偶然发现了这座房子和庭院，而我立刻就对这里产生了家的感觉，仿佛它一直在等着我的到来。我在这个街区结交了不少朋友，算是在巴黎过上了一种乡村生活，里里外外的所有东西都刚刚好。"

天色渐渐暗下来，可能会下雨，于是我们决定走去客厅。客厅的天花板很高，白色的墙壁上挂满了艺术品，中间挂着她和女儿在1987年为 ELLE 杂志拍摄的照片——摄影师是奥利维耶罗·托斯卡诺。瓦伦丁是20世纪80年代的顶级模特，也是彼得·林德伯格、理查德·阿维顿和史蒂文·梅塞等世界著名摄影师的缪斯女神。时至今日，她仍然与时尚界保持着很好的关系，即便现在已经55岁了，她独特的着装品位在"It girl"圈子里也依旧享有盛誉。

就在我们聊天的时候，突然响起了一阵门铃声，原来是香奈儿送来的快递。"我18岁在伦敦机场等行李的时候，被一位模特经纪看上

了。当时我忍不住大笑起来，觉得这种事怎么会发生在我身上呢！那个年代的杂志女孩可都是金发碧眼、身材高挑的瑞典人啊！"后来，瓦伦丁签约成为一名模特，接下来的几年里在全世界飞来飞去，但她说这就是她最喜欢做的事情。为了更好地证明自己的说法，她带我们参观了地下室。那里放着她的衣服、手袋、鞋和珠宝等物品，她还给我们看了几件珍藏的经典服饰，以及在私人售卖会淘来的小宝石。在这里，我们还发现有一大堆带轮子的设计师行李箱。"即使是现在，我也很喜欢收拾行李箱，就像知道有航班在等着我一样。去搭飞机的时候，我会穿上毛衣，披上披肩，带几本书和一件晚礼服，还会穿上古驰的拖鞋和柔软的裤子。每次我戴上大墨镜，拎着大手提包，感觉就可以随时起飞了。"

她一直过着这种随时候命的生活，喜欢以一种突然却又恰如其分的方式翻开生活的每一页。"模特真的是一份会消耗你生命的工作。就我个人而言，我需要剧院，孩子，看展览——我需要过生活。但我也必须承认的是，相比跳舞，做模特消耗的精力要少得多。"在当模特的时候，她遇到了自己的丈夫。他是一位有名的舞蹈指导，在广告牌上看到她的脸庞后，就疯狂地爱上了她。后来，他们搬到图尔，她在六年里一共生了三个孩子，而这也让她的模特生涯陷入了停滞。"那时我觉得自己很孤独。友谊是需要用时间来经营的，但在那段时间里，除了旅行，我什么也没有做。我好像随时都可以搬去任何地方。"随后，她的丈夫被调到摩纳哥，而她也搬到了尼斯，在那里寻回了自己和南法的羁绊。几年后，她在巴黎一家奢侈品杂志社找到了工作，生活也重新变得独立起来。这一切都像是宿命，仿佛只有巴黎才能满足她对美学的渴望，也只有巴黎才能安抚她的游子之心。不过她也承认，当下的境况要比当年艰难一些，这里主要指的是她的孩子。她说，她为他们生活的时代感到焦虑。

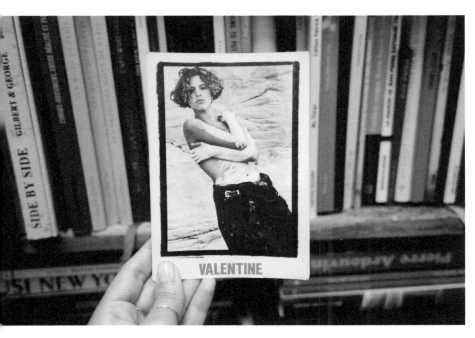

VALENTINE

　　"在 20 世纪 80 年代，人们不会问那么多问题，那个年代的后代不仅比他们的父母挣得更多，也在自力更生地创造自己的生活。"她的儿子今年 25 岁，在时尚界有一份很好的工作，但还是和她住在一起，就住在楼上。瓦伦丁环视着客厅，这里堆满了书籍、海报、照片、画作、艺术品和明信片。她钟爱这个专属于自己的空间，这里保存着过去所有经历的纪念物。"在这里，我过着与以往的游子生活完全相反的生活。我找到了自己的港湾，而这个港湾是巴黎。"

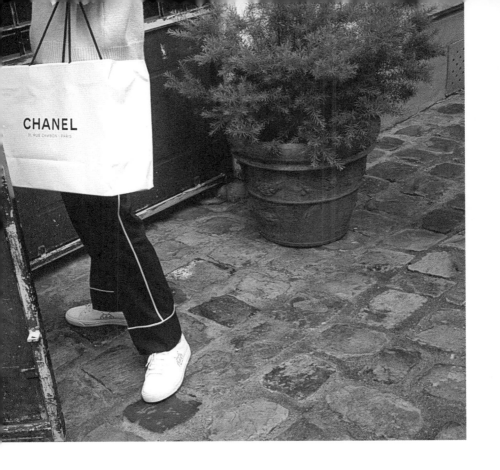

我们的巴黎

来我家晚餐吧？

我们继承了父母那代人的典型法式传统的待客之道：邀请朋友共进晚餐。

即使父母已经为晚宴制定了详细的计划，也总要预留一点即兴的成分。每一位客人都会为晚餐带来一些食材，所以我们曾在大快朵颐地吃掉一打牡蛎后，又吃了牛肉胡萝卜炖锅，也顾不得这两道菜是不是适合一起食用了。通常来说，奶酪盘和几瓶白葡萄酒搭配很不错，当然，桌上要有漂亮的桌布、优雅的酒杯、水果篮和烛光。最好的坦诚相待总是发生在午夜之后，所以这样的布置是为了能延长大家的雅兴。另外，喝完开胃酒的时间应该尽可能晚一点，以便从晚上十点半开始正式用餐，大家可以一边享受佳肴一边谈天说地，直到晚餐结束。

劳伦的普罗旺斯炖菜食谱：

a. 拿出一个大铸铁锅。

b. 把一个白洋葱切碎，和两瓣拍碎的大蒜一起炒成褐色，放进铸铁锅里备用。

c. 加入 1 千克绞碎的牛肉（让师傅事先把肉绞碎），并且炒至金棕色。

d. 将 1 千克胡萝卜去皮，切成条状，加入锅里。

e. 往锅里倒入 1 升红酒，最好用罗讷河红酒。

f. 加入一束百里香，一根迷迭香，两片月桂叶，一瓣蒜和一些夏季浆果。

g. 盖上锅盖，用最小火炖煮。

h. 至少炖煮四个小时。

i. 尽情享用吧。

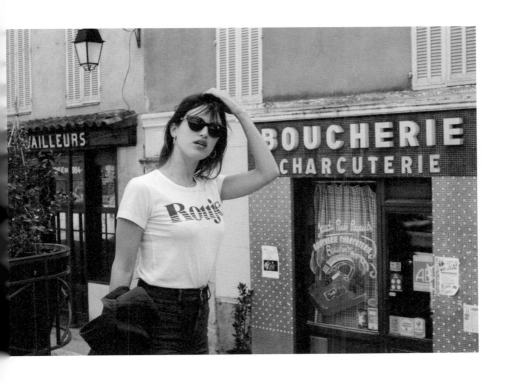

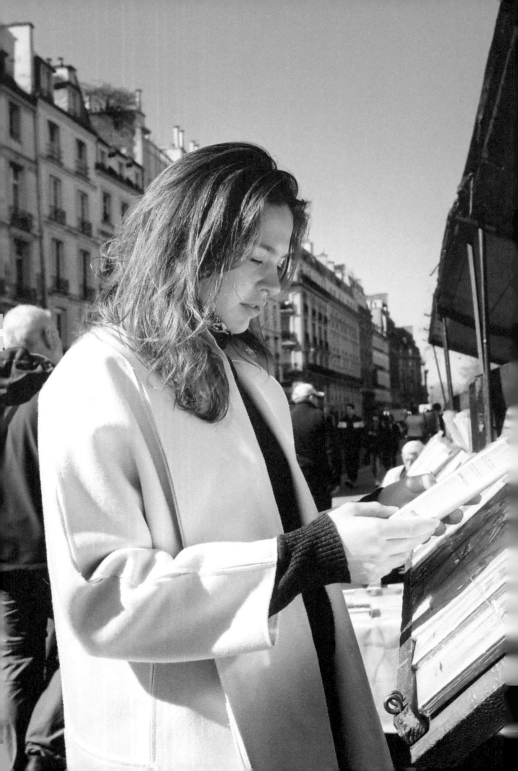

在圣路易岛

听**埃米莉·马朗**

聊她眼中的"小巴黎"

外带咖啡
平底鞋
富有传奇色彩的阿姨
塞纳河中央的小岛

 在埃米莉看来，巴黎真的很小。有时候，她在 24 小时内能在这座城市里来回穿梭六次。埃米莉对巴黎了如指掌，熟知城里所有的犄角旮旯，甚至是最隐秘的角落。她眼中的巴黎属于富裕家庭中的年轻女孩：这些巴黎女孩在十几岁骑着轻便摩托车在城里穿行，晚上则住在大人们无暇顾及的空荡大公寓里。

 采访埃米莉的那天，我们来到萦绕着慵懒浪漫气息的圣路易岛。这座位于巴黎市中心的风情小岛总是游客如织，经常有学校组织学生来这里旅行，游客比巴黎本地人还多。我们走到会面地点附近拐角处的咖啡店买了一杯外带咖啡。服务员稍稍扬了一下眉毛，却也似乎已经习惯了外带的要求，虽然通常只有美国人才这样做。埃米莉让我们到岛上一间装修时髦的公寓和她碰面——这是她家族旗下的单身公寓，里面的租客换了一波又一波。最初联系她的时候，由于不能邀请我们到她的家里做客（有一个朋友住在她位于马莱区的单间公寓里），她在电话里一直向我们道歉，还拜托我们到访的时候，给她捎上一杯意式浓缩咖啡。

 埃米莉的生活时刻都面临着很大的压力。作为一名年轻的女商人，

她的公寓既是工作大本营，也是朋友们路过此地的驿站。正因如此，她自己反而变得居无定所。行李散落在朋友的公寓、父亲的住处等各个角落，但只要她继续不停搬家，这对她来说似乎也并不是个大问题。见面的时候，她的头发看上去湿漉漉的，身上的 T 恤也有点皱，她踩着一双法国奢侈品鞋类公司 J. M. Weston 出品的克莱因蓝色平底鞋。她不停地查看手机，收到电邮时会回复一下，有短信跳出时会叹一口气。此刻的她和我们待在一起，但好像又身处别处，她一边迎接和招待我们，一边处理繁重的工作。一年前，埃米莉创立了马朗工作室，名字和祖父在奥斯曼大道开设的摄影工作室同名。20 世纪初，祖父的工作室是哈考特工作室 [1] 的主要竞争对手。她的工作是提供艺术和设计建议，并

1　哈考特工作室（Studio Harcourt），巴黎摄影工作室，以拍摄电影明星和名人的黑白照片而出名，曾被视为法国中产阶级必去的地方。——译者注

负责推广限量版艺术品。埃米莉的生活总是围绕着艺术和创意，她先在伦敦瑞文斯博学院学习平面设计和市场营销，后来又到纽约的伯克利学院和巴黎 Mod'art 国际时装艺术学院深造。她的朋友也大都属于艺术圈，其中就包括年轻设计师塞巴斯蒂安·梅耶尔和阿诺德·瓦兰特，两人曾因帮助时尚品牌 Courrèges 重整旗鼓而声名鹊起。

埃米莉在工作之余喜欢去圣旺区的跳蚤市场淘宝，或者去逛博物馆，比方说会去她曾经实习过的马约尔博物馆，或在周末逛一逛马赛公寓的 MAMO 艺术中心。

在谈论自己的生活时，她总是带着孩子般的笑容，让你觉得这微微一笑能帮她扫清一切障碍。这也是一种只在巴黎女人脸上才能看到的微笑。这一点可不能告诉珍妮，因为她也同样有一种混杂着强悍的属于巴黎女人的魅力。

埃米莉的童年在巴黎和遥远的尼斯度过，这也解释了她为什么会热衷于回归自然并定期去南部。她小时候住在塞纳河畔讷伊的豪宅，有时也会去蒙特勒伊一个艺术家的庭院里和熟铁工匠混在一起。她的母亲是一位英国知识精英，因而也想把她培养成名模凯特·摩丝那样的人物。埃米莉有着多元化的家庭背景——继祖母是马提尼克岛人，自身也游历过很多地方，她在上海实习过，去纽约度过了一年间隔年，也迷恋历史悠久的巴黎郊区。她所理解的巴黎是躁动不安的，其范围包括布洛涅郊区以及更高端的迈松拉菲特社区、大雷克斯电影院和圣日耳曼德佩区。

全拜到处游走的游牧式童年所赐，埃米莉从小就养成了不在同一个地方连续睡上两个晚上的习惯。她是巴黎设计师伊莎贝尔·马兰特的侄女，这位阿姨富有传奇色彩，其设计作品经久不衰。与巴黎所有的时尚女孩一样，在谈论埃米莉的生活时，就不能不提到巴黎的夜生活。她还记得在 17 岁去过格兰兹大道一家名为 Pulp 的夜店，因当时受到歌

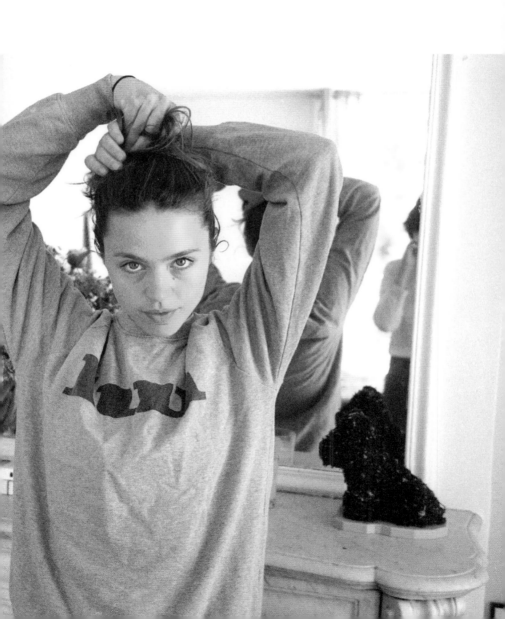

手小猫小姐和 DJ 克洛依的感染，她整夜都在跳舞。她还回忆说，那时晚上一般会和朋友先去圣马丁运河，然后再去夜店 Favela Chic；她的夜生活大概会让全世界的学生都羡慕不已吧。等到去伦敦艺术学院读完书后，她决定要安定下来，于是在巴黎找到了一个小小的居所（位于第三区的公寓，也是我们这次无缘造访的那间）。"我住的地方是一个交汇处，那里交织着不同风格的巴黎：比如有暗藏风险的巴黎——那里有我喜欢逛的圣丹尼街，还有波希米亚风格的巴黎——我会去布列塔尼街的红孩子市场购买新鲜的农产品。"

她说，无论到哪一家咖啡馆，每次站在咖啡馆外抽烟的时候，她就感觉自己是最有巴黎风情的人。而在我们看来，当她漫不经心地说自己从不化妆时，似乎已经是最有巴黎风情的人了。她只会步行或坐地铁去其他地方，因为按照她的说法，巴黎很小。"我的助手来自马赛，从来没有像在这里一样走这么多路。"她对巴黎女人做出了自己的定义："巴黎女人是活力充沛、同时过 30 个人的生活、努力工作、会自我学习和不断进步的人；也是会上下打量别人的人，但并非出于势利，而是因为喜欢观察——我们常常在巴黎观察别人，对不对？"是啊，我们确实是这样的人，因为我们此刻就在观察她的生活。我们不仅对她紧张刺激的生活很感兴趣，还发现她工作室里摆放的物品看起来很有个人特色：壁炉的花瓶里插着几束豌豆花，旁边有一尊小狗雕像和几本书。忽然之间，她停止了同时在做的三件事（回邮件、抽烟和与我们谈论），抓起一本艺术书翻了翻，给我们看了一张图片。在这一刻，她终于能喘口气消停一下了。

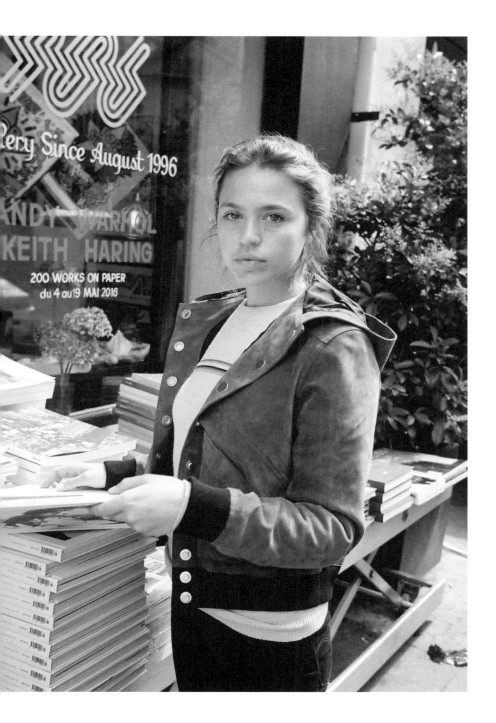

我们的巴黎
摇滚红唇

　　如果要用一个动作来概述巴黎女人，那一定就是巴黎女人在涂抹红色唇膏时的诱人姿态。在巴黎，你会看到很多女人虽然素面朝天，却不会忘记涂上红唇。不少巴黎女人都拥有令人羡慕的大红唇，以下是来自她们的唇膏小贴士。

海伦的唇膏：
品牌：植村秀
型号：柔雾唇膏 370（Matte 370）

摄影师萨斯基娅·拉瓦克的唇膏：
品牌：魅可
型号：Ruby Woo

妮的唇膏：
品牌：妙巴黎
型号：天鹅绒 08（Rouge Velvet 08）

影导演丽贝卡·兹罗托斯基的唇膏：
品牌：Rouge Baiser
型号：虞美人柔润显色口红 207（Le Coquelicot）

摄影师索尼娅·西埃的唇膏：
品牌：香奈儿
型号：卡门（Rouge Coco Carmen）

履设计师艾米丽·皮沙尔的唇膏：
品牌：Nars
型号：丛林红（Jungle Red）

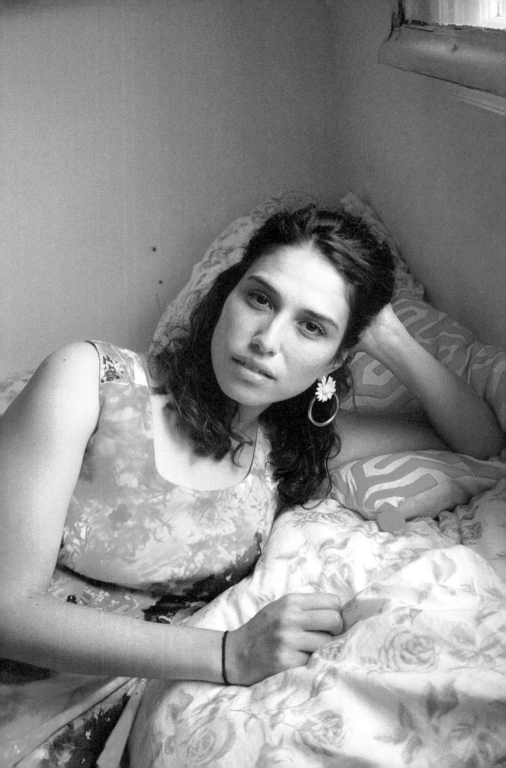

在贝黑广场

和**多拉·穆托**

分享她的"时尚坏品位"

网络怪论
勃肯鞋
公报
园丁

　　巴黎女人通常被认为是好品位的代言人，她们好像永远都穿着深蓝色毛衣和白色的斯坦·史密斯运动鞋。但这样的假设不完全正确，尤其是我们在网上遇到多拉以后。她是一名记者，创立了一个叫"坏品味公报"（The Bad Taste Gazette）的网站。通过这个网站，她终于有机会肆意表达自己对于媚俗事物的热爱。多拉的网站采用迷幻的色彩，常常会毫无顾忌地发布一些粗俗的视频和图像。她喜欢荒诞的事物，特别是那些闪闪发光的紫色的东西。她就像人类学家一样，喜欢探索人类心灵中最令人着迷的部分。因此，多拉穿一套完全不同于普通巴黎女人的装束来迎接我们也就见怪不怪了——她穿着一件古怪的荧光色扎染连衣裙、一双银色的勃肯鞋，手上还涂着闪亮的绿色指甲油。邀请我们进屋时，她有点面露难色地说自己已经受够了这个房子，并把这栋房子描述成"在柏林才能看到的一堆砖块"，不过我和珍妮在这里倒是感到莫名的舒适。我们坐在破沙发上一边喝外带咖啡，一边听这位曾经的非主流青少年回忆巴黎鲜为人知、怪异又美好的一面。

　　多拉从小生活在适合居家的社区，在位于第十七区中心位置的贝

黑广场附近度过了童年时光。但她明显对这个街区充满了厌倦，除了觉得有一点还不错：地方议会为园丁提供了很好的待遇。"我很迷恋鲜花，刚好这个区在花卉方面会投入可观的预算。我偶尔会带着相机去拍灌木丛和花坛，有时会走到远一点的地方，比如去勒瓦卢瓦、巴加泰勒或布洛涅森林。"

多拉和许多人一样，有自己的怪癖。但我们只能说，她比一般人更怪，而这种对奇异事物的钟爱或许起源于童年。她的母亲出生于以色列，父亲在阿尔及利亚出生，而她出生在华盛顿，后来也去巴黎郊区、法兰克福、伦敦和纽约生活过。多拉为我们简要介绍了自己的各个时期，但好像每个阶段都混在了一起，很难按照时间排序。不过，从这些故事可以看出，她的生活经历和住所一样独树一帜。"我父母的品位都很差。父亲会穿着袜子配凉鞋，母亲觉得自己太漂亮了以至于不太注重打扮，事实上也不太会打扮自己。母亲对时尚一点也不感兴趣，习惯背一个赛诺菲[1]促销时赠送的背包，不喜欢用手提包。他们教会了我何为讽刺。"此话不假，多拉真的特别喜欢使用委婉语气和双关语来表达讽刺的意味。"我的父母住在国外，姐妹在旧金山，朋友们在巴西或德国。但我认为巴黎最特别，是我最熟悉的城市。我四岁到七岁，十四岁到二十岁都住在这里。我老是回巴黎，和我关系亲密的奶奶和姥姥也生活在这里。"

她说自己从十七岁起就在巴黎独自生活了，接着还向我们描述了她眼中的巴黎：她有时去沙特雷—大堂地铁站做穿孔或染头发；有时会去一家叫 Grouft 的哥特式商店买衣服，或是去 Batofar 船上夜总会观看朋克摇滚的现场演出或是 Andrea Crews 富有想象力的时装秀；她还经常光顾理查德勒努瓦街和美丽城的二手店及路边摊，觉得在那些地方

1 赛诺菲（Sanofi），全球领先的法国医药企业。——译者注

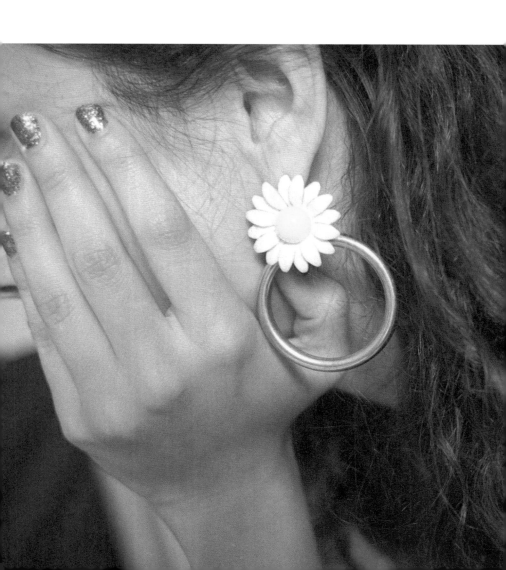

最容易淘到一些产自中国的奇异小摆设。

"在我还是个小女孩的时候，就特别喜欢粉红色的东西和彩虹小马，它们一直陪伴我长大成人。我从十几岁就开始探索各式各样的亚文化，包括朋克、EMO 情绪硬核、赛博哥特等。在读书的时候，我喜欢把自己打扮得很可爱，到处都绑着丝带，但我的老师们更像是马丁·马吉拉[1] 那种类型的人，他们总是说：'多拉，你的品位太差了！'于是，我在创立网站时就借鉴了这句充满讽刺意味的话。"

多拉的轻佻和幽默让我们想到了作家西蒙娜·波伏娃、漫画家克莱尔·布勒特谢尔等伟大又有智慧的巴黎女人。她和这些巴黎女人一样专注于时装，仿佛她的万种风情与自己的雄心壮志相伴而生。事实上，对于纺织品的痴迷还促使她创立了一个新项目：用纪录片来展现新兴国家的传统和当代服装，让观众通过服饰文化了解一个国家。目前，

1 马丁·马吉拉（Martin Margiela），比利时服装设计师，以解构及重组衣服的技术而闻名。——译者注

她已经在摩洛哥完成了先导片的拍摄。多拉本人并不畏惧用穿着打扮来制造视觉上的冲击感，而且她也尝试过很多次了。和她居住在同一街区的人们早已熟悉她的奇装异服和那些稀奇玩意儿：比如带猫耳朵的雨帽，还有那辆荧光色的荷兰自行车。"我和来自不同国家的男性都约会过。第一个男朋友是我在CaraMail[1]上认识的。他是一个滑板运动员，但后来因为他留了脏辫，我就把他甩了。后来，我又结识了一个脸上有很长一条银白色文身的男人。"

多拉谈到自己的爱情生活时，我们发现她好像突然变了一个人似的，而这种情况在巴黎人中很常见。一旦人们开始谈论爱情，他们的语调就会发生变化，并且开始挥舞双手，试图打断别人的谈话。这时候，气氛似乎变得紧张起来，人们好像必须参加这场辩论，发表意见和讲述自己的经历，最后寻找到一个答案。不过，多拉的感情观其实相当传统。"我是个浪漫的人，但对于夫妻的看法很老派。我不想没有结婚就生孩子，因此时常觉得自己与当下的交友文化格格不入。我们这一代人很难一步一步地发展感情，有时候太快就和别人发生关系了。我觉得，大家应该先用一段时间来互相了解，再进行下一步。"

1　CaraMail，法国以前的一个电子邮件及社群门户网站。——译者注

我们的巴黎
一起跳舞

　　巴黎女人喜欢小型夜店,但那种地方要排好几小时才能进去。最后她们会说,那里只适合星期四女士之夜的时候去,或者根本就不值得去。

　　在其余时间里,我们会随时随意地起舞。

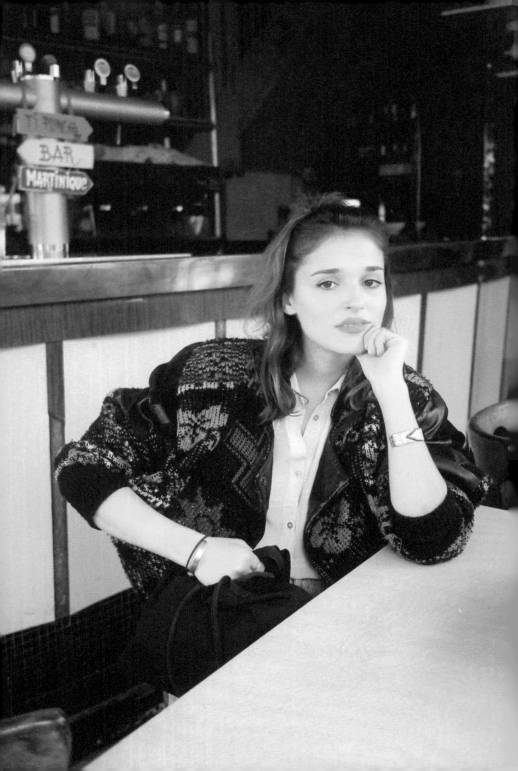

在美丽城

听**洛拉·贝西**聊电影

里科塔奶酪菠菜馅饼
背带牛仔裤
导演约翰·卡萨维茨
咖啡馆

　　许多电影表明：很多人喜欢拍与巴黎相关的电影，而巴黎同样也是一个热爱电影的城市。这些电影都和巴黎有着千丝万缕的联系：《断了气》《五至七时的克莱奥》《红磨坊》《天使爱美丽》《天堂的孩子》《北方旅馆》《扎齐坐地铁》《婚姻生活》《当猫不在家》，甚至还有《料理鼠王》。因此，如果我们不谈论电影产业，就很难把巴黎的全貌描绘得一清二楚。在冬天的时候，我们遇到了一位年轻的女演员、编剧兼深受影评人好评的导演——洛拉·贝西（Lola Bessis），从而有机会和业内人士谈一谈电影。她执导的电影曾在电影节亮相，而她本人顶着凌乱不已的头发、以一种非常巴黎化的方式出现在电影节的红毯上，这让我们对她的生活产生了好奇，因此很想让她出现在这本书里。

　　洛拉在第十四区出生，父亲是突尼斯人，母亲是意大利人，而她在蒙梭公园附近长大。她在19岁的时候认识了现任男朋友，目前和他生活在一起。她的男朋友也是一名电影制作人，三年前他们一起创作剧本并执导了处女作《游走的小鱼》。这是一部预算极少的独立电影，但拍得迷人又高雅。电影中的故事发生在纽约，那也是他们生活了五年的地方，因此两人得以追逐共同的电影梦。

"对我们来说，在巴黎拍电影可能会更困难一些。相比之下，在纽约剪辑和制作独立电影更为容易。那是我作为导演和演员制作的第一部电影。纽约为我提供了非常好的学习机会。不过，当我回到巴黎，在这里得到了大家的认可！"这部电影获得了许多奖项，讲述了一个签证有问题、又不想离开纽约的年轻法国女人的故事。女主角借住在一对夫妇家中（睡在沙发上），后来和一位才华被埋没的艺术家发展出一段恋情——这段故事听起来有点像洛拉本人的经历。她在离开出生地巴黎后，才开始明白这座城市之于自己的意义。"当我回来的时候，才发现自己并不了解巴黎。我在第十七区度过了童年，在卡诺中学读书，但这一切让我忽略了这座城市更五彩斑斓、更充满矛盾性的一面。还好，纽约帮了我，让我以一种不同的方式重新看待巴黎。"

当我们和洛拉见面时，她刚刚搬到美丽城——这是一片广阔的坡地，既有现代建筑，也有传统的狭窄街道、时尚的餐馆以及更为主流的酒吧。从历史来看，这个街区以向移民提供住房而出名，一直都是巴黎最有活力、拥有最多元文化的地区。伊迪丝·琵雅芙[1]曾住在这里，维利·罗尼[2]也曾在这里拍摄作品，罗曼·加里甚至将他的小说《来日方长：如此人生》的故事发生地设定在这里，而西蒙·西涅莱主演的电影《金盔》也在这里取景拍摄。如今，越来越多的巴黎"波波族"（不得不承认，我们俩也属于这个行列）梦想搬到这里来，这样他们离美丽城艺术文化中心更近，去那里观看文化演出也更方便。另外，这个街区离肖蒙山丘公园里的大草坪也不远。看来洛拉和男朋友已经实现了这个梦想，因为他们搬来了这里。不过，他们觉得这间公寓有点像阁楼，所以计划要拆掉所有墙壁，让家里的采光更好。我们造访他们

1　伊迪丝·琵雅芙（Édith Piaf），法国著名女歌手。——译者注
2　维利·罗尼（Willy Ronis），法国纪实摄影大师。——译者注

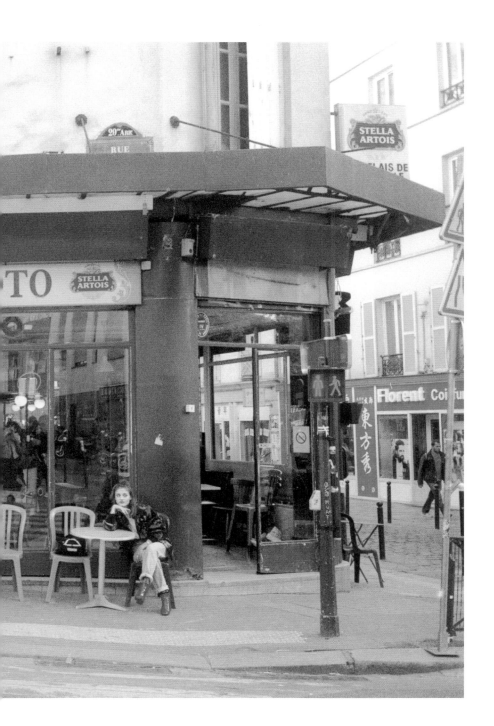

的公寓时，发现还有一些箱子没拆封，而她的男朋友正睡在床上。这里没有椅子和咖啡，所以我们决定到位于美丽城大道的一家咖啡馆进行访谈，那里的一小杯意式浓咖啡卖一欧元。

洛拉感到有点尴尬，因为她刚搬回巴黎，还没有太多关于巴黎的事情可以和我们分享。对她来说，像自己手背一样熟悉的地方位于塞纳河的另一边——位于第六区、靠近圣米歇尔电影院的地方，他们昨天还住在那里。"我们住的地方和圣安德烈艺术电影院在同一栋楼里，影院就在我们家休息室的正下方。这算是一个征兆吧！我们有时会在信箱里发现寄往电影院的信，后来还和剧院的负责人取得了联系，有时会组织影迷来观看我们的作品。我曾经梦想在那里举办夜间电影展，播放一些鲜为人知的美国独立电影，晚上再邀请大家来我们家边喝酒边吃素食。"她向我们列举了一大堆电影，包括萨弗迪兄弟拍摄的《去采些迷迭香》《天知道》、马瑟·波特菲尔德执导的《菩提山》等。"我喜欢跟我的意大利祖母学做饭，从七岁开始就不再吃肉和鱼了。我经常在家做饭，里科塔奶酪菠菜馅饼是我的拿手菜，在整个巴黎都很有名哟！"说到这里，我们感觉她似乎有点怀念在电影院楼上的旧居。"那是间老旧但很漂亮的公寓，铺着凡尔赛镶木地板。家里的所有物品都是二手货，很多东西都是我们从艾玛于斯（一家二手店）买回来的。在我们电影里出现过一个20世纪70年代的黄色旧沙发，那是我们特意从纽约搬回来的。"除了家具摆设，洛拉的穿着打扮同样充满了浓浓的复古风格。采访当天她穿了一件十分合身的粗棉布连衣裙，并且把在雅典、洛杉矶等地的二手店里淘来的古着单品搭配在一起，由此形成了一种酷酷的波希米亚风格。

洛拉和男朋友从纽约搬回巴黎已经有四年了。因为两人都萌生了想要改变生活的想法，所以决定搬到美丽城。新公寓就像是他们的世界中心，他们俩总是待在一起，不仅在家里办公，还会邀请编剧来家里聊工作。她承认，他们"在用一种相当与世隔绝的方式经营事业"。

不过，最近这一次搬家并不是洛拉生活中发生的唯一变化，因为她的艺术生涯也开始在法国发展得越来越好。"我把作品整合在一起，开始结识一些圈内人士，也有一些工作邀约主动找上门来。"

如果事业发展一切顺遂的话，那么她下一步就不得不克服对走红毯的恐惧了。"在我小的时候，父母为了拍全家福，必须强迫我摆造型才行。但我不能忍受那样做，所以老是闷闷不乐。后来，我才慢慢对这件事产生兴趣。约翰·卡索维茨[1]是我在创作电影时最大的灵感源泉。

1　约翰·卡索维茨（John Cassavetes），美国导演、编剧、制片人、演员，是美国独立电影的先驱。——译者注

他在大型电影制片厂做演员，用赚来的钱制作自己的电影，而这种方式为他带来了很多自由。"洛拉说。她会在自己的工作中注入对这座城市的爱。"我正在为接下来要拍的电影写剧本。这部戏将在巴黎取景，但只会在晚上进行拍摄，因为我们真的想去了解午夜巴黎会发生什么样的故事。"

我们的巴黎
偏执的风衣控

　　我们好像有一个心照不宣的秘密：这本书里的每个女人似乎都有一件风衣，而且通常是一件从夏天到冬天都会出现在衣架上的二手风衣。她们好像在任何时候都会穿着它，比方说：下雨的时候，一年四季的大部分时候（每年大约有十个月），晚上外出的时候，星期天出去玩的时候，穿着随意的时候，精心打扮的时候，工作或放松的时候，想看起来有魅力的时候，想和别人打成一片的时候，状态好的时候，情绪低落的时候，搭配牛仔裤的时候，搭配裙子的时候，想要展现女人味儿的时候，想看起来像"女汉子"的时候，跳舞的时候，拼命工作的时候……

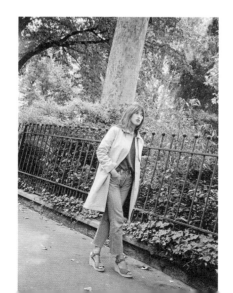

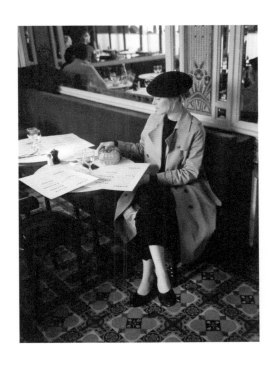

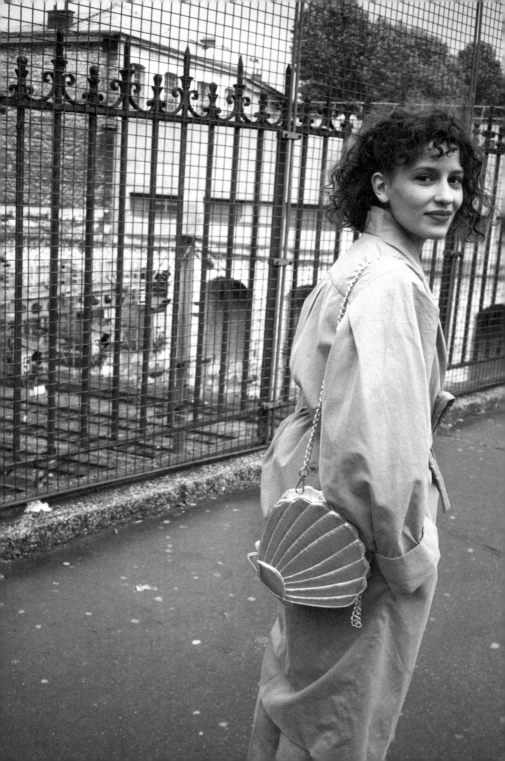

在巴黎东站

听**多琳·阿圭勒**聊舞蹈

波尔多区
男朋友
一辆小汽车
复古装

正当我们采访多琳的时候，她的男朋友埃利奥特突然闯进了公寓，她吓得脸色都变了。"我告诉过你，不要过来！"她尖叫着，脸也涨得通红，男朋友却在一旁笑。埃利奥特和多琳都非常可爱，一看就是正处于热恋中的人。如果我们的书是关于巴黎情侣的话，他们俩肯定能登上封面。他们在 Myspace 网站（如果你还不到 20 岁，应该不会知道有这样一个古老的社交网络）上相识，在一起已经十多年了，多琳为了能和埃利奥特在一起，七年前离开波尔多区来到巴黎。

对于埃利奥特而言，多琳也可能主要是为了跳舞才搬家的。巴黎和舞蹈总是密不可分，似乎也没有什么地方比巴黎更加重视舞蹈了，无论是芭蕾、嘻哈，还是诸如电影《一个美国人在巴黎》或巴士底歌剧院，全都少不了舞蹈的元素。舞蹈这种艺术形式既是一门学科，也是一种生活方式，在未来应该还会继续发展壮大。在巴黎的各个地方，包括郊区都开设有舞蹈学校。多琳就在一间舞蹈学校教学。每天晚上，她都会教年龄在 6 岁到 66 岁之间的业余舞蹈爱好者跳舞。她还在塞纳 – 圣但尼省加尼市的郊区为教残疾人士开设 handidanse 的课程，而这也是她拥有一辆福特迷你车（Ford Ka）的原因。巴黎是一个几乎找不到

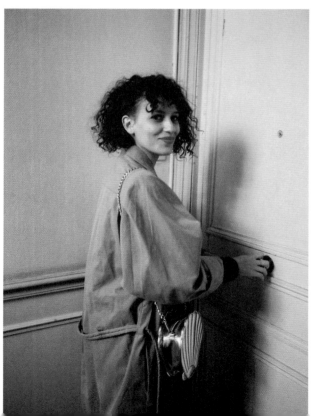

停车位的城市，在这里，车子真的是一项不寻常的财产。

"我晚上很晚才下课，也不想坐 RER 大区快铁列车回家。我们住在印度街区（Quartier Indien），人们在这里工作，但不会在这里睡觉，所以我总能在晚上找到停车位。"

多琳在十岁的时候就明确了自己未来愿意投入热情的职业。"对于一个专业舞者来说，那时候才意识到这一点，已经太晚了。"她说。不过，这样的觉醒让她茅塞顿开，为人生找到了新方向。她开始一个接一个地上舞蹈课，无论是教古典舞的夏季班，还是嘻哈舞，她都跑去学习。这天早上，我们到位于印度街区的小公寓里和多琳见面时，她表情严肃地捧着一杯茶。我们很容易就能想象出她以前肯定是一个自觉、专心且行为端正的青少年。她居住的地方离巴黎东站只有一步之遥，因此在家里总能听到公交车的隆隆声和交通拥堵时刺耳的喇叭声。此刻，五月的大雨正猛烈地拍打在窗户上，而多琳的猫跑到我的笔记本上蹭来蹭去。我们还看到有纺织商推着装满闪亮布匹的手推车，沿着街道蜿蜒前进。她公寓外面的杂货店在卖香料和熏香，而在拐角处有巴黎当下最时髦的素食餐厅 Sol Semilla。多琳又给我们倒了一杯茶，然后继续讲述自己的故事。

她在 17 岁的时候获得了参加专业舞者培训的机会，但同时对法律也有点兴趣，所以她进入大学一边学习，一边练习舞蹈。一年后，她被挑中参与一个叫"城市芭蕾"（Urban Ballet）的演出活动，跟随莫里斯·拉威尔[1]的《波莱罗舞曲》（Bolero）表演嘻哈舞。这场演出获得了空前的成功，她也因此有机会多次到世界各地演出。巡回表演三年后，她来到最终站——巴黎，在这里她仿佛悟出了生活的真谛，开始真正地面对现实生活。埃利奥特住在巴黎北站，而多琳的父母住在圣马丁

1　莫里斯·拉威尔（Maurice Ravel），法国著名作曲家，印象派作曲家的最杰出代表。——译者注

运河附近，因此在选择住处时，他俩毫不犹豫地选择了第十区。像大多数巴黎女人一样，多琳无法想象要搬到其他街区去生活。只要熟悉的街区还在，她就不会离开。

多琳说她喜欢早起，"否则我会感到内疚"。起床后，她会喝一些咖啡和橙汁，吃几片涂上能多益巧克力酱的烤面包（要知道她每周都要跳 17 个小时的舞，还要做 3 小时的瑜伽）。早上，她会为即将到来的试镜演出做排练。她笑着告诉我们，在等待为音乐剧试镜时，舞者之间会弥漫一种紧张的气氛，而舞蹈指导在这时候会发表一些无厘头的言论，比如会说"当没有舞蹈的时候，我喜欢跳舞"。

多琳喜欢骑着自行车沿圣马丁运河的堤岸疾驰而下，然后穿行在人来人往的小巷。每当这时候，她就感觉自己最像巴黎女人。"每当看到身穿纱丽的印度妇女，还有那些推着手推车的爸爸，我就觉得这样的场景非常有巴黎味道。在 11·13 巴黎恐怖袭击事件发生以后，这座城市不仅展现出更多元的文化，变得更加有活力，人们也更加重视家庭幸福。"每当夜幕降临时，多琳喜欢邀请朋友来家里做客，品尝她男朋友做的意大利面。

我们走到屋外，想在这个街区拍一些照片。多琳把风衣系在腰间，即便是在下雨天，她也展现出一个巴黎女孩所拥有的强大气场。不过，她在不经意间讲述的一些事情表明她这些年在不同省份生活过——比如她说有些地方的商店在中午仍然会关店休息，直到下午两点。"在巴黎总是有事可做。"说着她向我们列举了一些日常会去的地方，比如有圣日耳曼德佩区的电影图书馆、朱西厄区的 Le Champo 电影院等。此外，多琳还会去"漫游"（Wanderlust，位于塞纳河畔的一家大型露天夜店）参加嘻哈之夜，每周至少要参加三次全天都开课的热瑜伽。她在提到要去波尔多过周末的时候，仍然用到了"回家"这个说法，但毫无疑问，几年后她就不会再这样讲了。

我们的巴黎
逛古着店的艺术

十件你应该拥有的复古单品：

风衣
斜纹软呢外套
丝绸衬衫
水桶包
美国大学校服卫衣
费尔岛（Fair Isle）牌毛衣
李维斯牛仔裤
印花长裙
连身衣
印度风格的长袖衬衣

巴黎最棒的古着店：

Kiliwatch
地址：提科图尼街（Tiquetonne）
邮编：75003

lo Shop
址：圣日耳曼大道
编：75006

ierissol
址：克利希大道（Clichy）
编：75018

Coffre
址：梅尼蒙当街
编：75020

ag
址：圣马丁街
编：75004

tchup
址：当库尔街（Dancourt）
编：75018

ose Market Vintage
址：希波里特 - 勒巴斯（Hippolyte Lebas）
编：75009

Mode Vintage
址：罗切布鲁恩街（Rochebrune）
编：75011

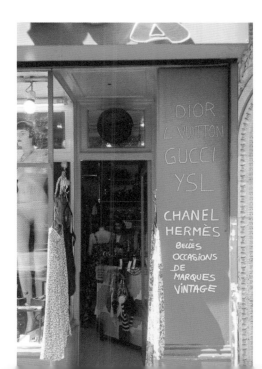

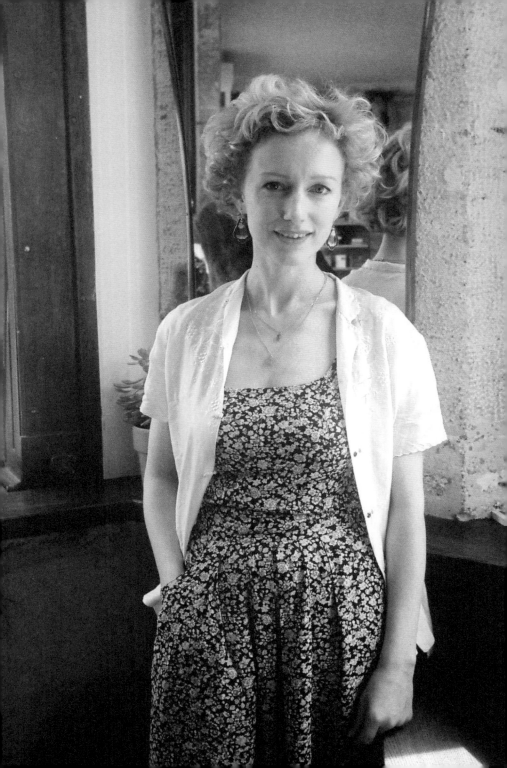

在巴黎圣母院旁

和**西尔维娅·惠特曼**

谈论如诗歌般的生活

书店

威廉·巴勒斯

苏格兰寄宿学校

两岁半的儿子加布里埃尔

　　西尔维娅·惠特曼（Sylvia Whitman）在塞纳河畔的莎士比亚书店门口迎接我们，她看上去不仅容光焕发、活力四射，还充满亲和力。我们相约在一个秋日见面，此刻的巴黎就像镀上了一层红色和橙色。我们坐在邻近书店的小咖啡馆里享用苹果梨奶昔和牛油果吐司，看着圣母院大教堂下方的塞纳河上的小船缓缓驶过，水面泛起层层涟漪。西尔维娅有一双蓝眼睛，身穿一件印花连衣裙。从她在吧台点茶的方式、彬彬有礼的举止、说话时喜欢运用反讽的习惯，看得出她整个人非常英式。她用美妙的口音为我们讲述了她的小狗科莱特的故事——每天晚上她都会带着小狗在堤岸上散步。

　　我们不得不旧话重提：在我们见过的所有女人中，西尔维娅可能是最有巴黎风情的。她的血管里好像从小就流淌着巴黎的血液，而她本人就像是小说中的女主角一样，生活中经历了一连串离奇又曲折的故事，有的不同寻常，有的浪漫，而有的仿佛悲剧一样。巴黎似乎为所有难以预料的际遇提供了舞台背景，让这些故事一幕接一幕地在城市中上演。她目前在经营从父辈那里继承的书店，在店内摆放了一些

自制的巴黎明信片（她和丈夫共同管理着一个近 40 人的团队，员工在书店和隔壁的咖啡馆工作）。

走进西尔维娅·惠特曼的书店，就好像进入了艾米丽[1]和艾丝美拉达[2]的奇幻世界：这间如同绿色金属盒一般的二手书店矗立在塞纳河岸边，从这里可以看到双桥、西岱岛和圣母院大教堂上方高耸入云的塔尖。"圣母院每天都让我觉得惊艳，塔尖上的风景从来没有重复过。"她认为自己的生活就像是一部小说的开篇，而这座城市就像是一首诗。即使身为一个书店老板，她也能将特有的巴黎生活方式娓娓道来。

"我在对面西岱岛上的主宫医院出生。当年母亲开始宫缩的时候正在书店里，她赶紧从塞纳河这边冲过桥去岛上的医院准备分娩。后来，她把年幼的我也送进了岛上的幼儿园。我在巴黎留下了很温暖的童年回忆，至今都还记得从公寓窗户里透过来的斑驳阳光，还有从地铁和面包店传出的味道。"西尔维娅·惠特曼的父亲乔治·惠特曼是一位学识渊博的美国人，他在第二次世界大战后爱上了巴黎，于是决定搬来这里。"因为他想住在一个人人都是诗人的城市，过上如诗歌一般的生活。"父亲最初于 1951 年在布彻希街（Bûcherie）开了一家书店，然后在 1964 年把书店改名为莎士比亚书店——这个名字取自西尔维娅·毕奇于 20 世纪初在奥德翁大街开办的同名老书店。西尔维娅·毕奇当年和詹姆斯·乔伊斯、欧内斯特·海明威、弗朗西斯·斯科特·菲茨杰拉德等文坛大腕经常在她开设的书店里谈天说地。而在 20 世纪 50 年代，要是在乔治·惠特曼的书店里偶遇艾伦·金斯伯格[3]和威廉·巴勒斯[4]，

1　艾米丽（Amélie），电影《天使爱美丽》的女主角。——译者注
2　艾丝美拉达（Esmeralda），《巴黎圣母院》中美丽又热情的吉卜赛女郎。——译者注
3　艾伦·金斯伯格（Allen Ginsberg），美国诗人，堪称美国当代诗坛和整个文学运动中的一位"怪杰"。——译者注
4　威廉·巴勒斯（William Burroughs），美国作家，"垮掉的一代"文学运动的创始人之一。——译者注

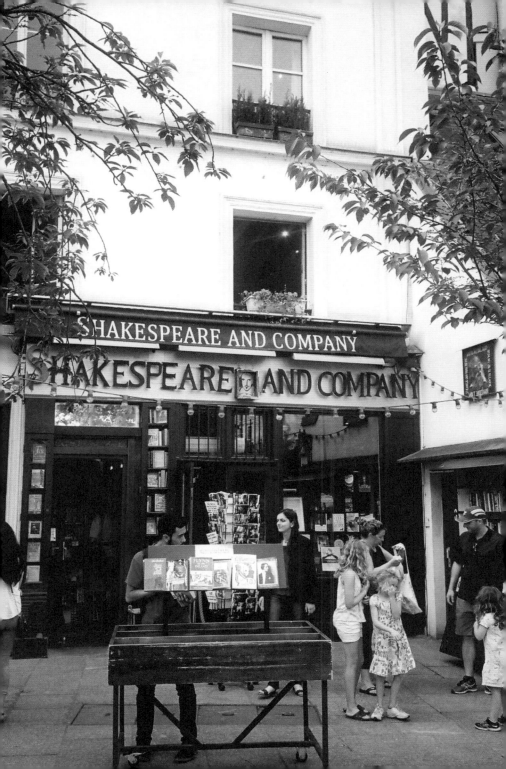

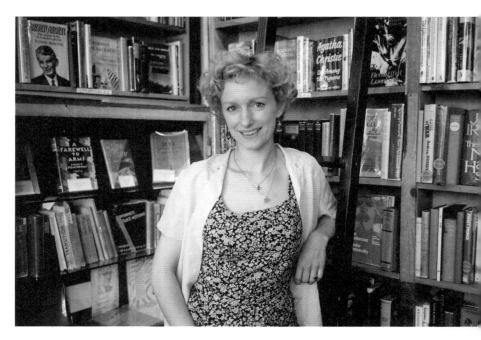

也不是什么稀罕事。"我的父亲性格古怪，有点像堂·吉诃德。如果他在读书时感到无聊了，就会烧掉自己的头发。对他来说，书店以外的世界是不存在的，所以他总是敞开书店大门，似乎想让外面的世界直接闯进书店里。正因为如此，他遇到了很多小偷。"

"在我们书店的横梁上写着这样一句话：'不要对陌生人冷漠，他们也许是伪装的天使。'这也是我父亲觉得非常重要的一句座右铭。当目睹这世界所发生的一切，这句话在我眼里也变得越来越有分量。父亲经常旅行，特别喜欢去南美洲。他在 38 岁时开了这家书店，在 70 岁才有了我。"

父母在西尔维娅很小的时候就离婚了，她和母亲后来一起去了伦敦。从那时候起，她就几乎和父亲断了往来。她自豪地告诉我们，她去了苏格兰的寄宿学校，在那里每天都穿着格呢褶裙。因为之后选择在伦敦继续学业，她差不多在十年里都没有见过父亲。"在我 21 岁的时候，突然意识到父亲已经 91 岁了，我觉得自己要在一切还来得及之前去看望他。"乔治以一种轻松随意的方式迎接她的到来，但在每个人面前介绍她时都说这是一位名叫埃米莉的英国女演员。"他带我去了书店，把这里的一切都传给了我。我们变成了最好的朋友。我以前不是书虫，但就在那个时候，我爱上了书店和巴黎。"

西尔维亚带领我们参观了由木头和石头组成、如迷宫一般的莎士比亚书店，但在很久以前，巴黎的魅力就在于这些低矮的天花板、凹凸不平的地板和摇摇欲坠的楼梯间。她一边为我们当向导，一边继续讲述书店的故事。原来，布彻希街的历史可以追溯到 12 世纪。自 1951 年书店在这条街上开业以来，书店的长椅和书店楼上的老乔治公寓陆续接待过许多作家。按照父亲订立的传统，每一位在书店睡觉的作家都必须为书店写大概一页纸篇幅的小自传。西尔维娅向我们展示了一本厚厚的活页夹，里面全是各个文学家留下的文字。"这里装满了巴黎

人的梦想。"她说道。

西尔维娅还讲了一些我们以前从未听过的巴黎轶事。例如，她知道巴黎境内最古老的树生长在勒内·维维亚尼广场（square René Viviani）里，而简·柏金和赛日·甘斯布是在距离这里只有一步之遥的艾丝美拉达酒店相识的。不过，西尔维娅一点也不羡慕那些传奇眷侣，因为她和丈夫的邂逅本身就像极了经典爱情小说里的情节。"他当时正在写一篇关于莎士比亚的文章，为了找一本罕见的书走进了这间书店。我说会记下他的电话号码，但这还真是我从没做过的事情！我现在依然在帮他找书……"如今，他们的儿子加布里埃尔已经两岁半了。就在刚刚，他从书架上拿下五本书"推荐"给一位正在为孙女买书的祖母，算是完成了自己第一次荐书活动。西尔维娅一家子住在蓬图瓦兹街附近，就在巴黎最美的游泳池对面。"我本来打算每天早上 7 点都去那里游泳，但这个计划显然没有实现过。"她笑着说。不过，她现在每天都徜徉在书海中，已经是精通巴黎艺术的专家了。

"我有一辆自行车，喜欢骑自行车去看望住在第十一区、第二十区或第九区的朋友。"她喜欢在城市中独享私人时光，会在早上独自去塞纳河畔散步，也喜欢在夜深人静的时候和一位作家穿过塞纳河去探索一些比较破旧的地方。在经过某条街时，她会回想起亨利·米勒[1]。"在伦敦的时候，满脑子想到的都是买衣服或汽车，但在这里就不会想到那些。在伦敦，所有都以金钱为中心，而在巴黎，一切都是诗歌至上。"

1　亨利·米勒（Henry Miller），美国作家，代表作有《南回归线》。——译者注

我们的巴黎

成为一名文化热衷者

巴黎以丰富多彩的文化活动而闻名，在这里随处可见艺术、戏剧、文学、诗歌或摄影作品。这里有极具地标性的卢浮宫、波堡区、沙特莱剧院和路易·威登基金会艺术中心。不过，巴黎文化还有更为神秘的一面，因此我们想协助你去探索一个范围远不止环城大道以内的巴黎。

Le Bal 展览中心
推荐理由：以举办摄影和影像展览而出名。
地址：拉德芳斯区 6 号
邮编：75018

Le 104
推荐理由：文化创意空间。
地址：奥贝维埃街 104 号
邮编：75019

亨利·卡蒂埃·布列松基金会
推荐理由：著名的摄影艺术中心。
地址：档案街（Archives）79 号
邮编：75003

巴黎第八大学图书馆
推荐理由：法国最大的大学图书馆。
地址：圣但尼省自由大街 2 号
邮编：93526

Le MacVal
推荐理由：当代艺术博物馆。
地址：塞纳河畔维特里自由广场
邮编：94400

杰拉·菲利浦剧院
地址：圣但尼省茹尔·盖得大道（Jules Guesdes）59号
邮编：93200

伊夫里剧院
地址：伊夫里省皮埃尔戈纳广场（place Pierre Gosnat）1号，
剧院位于 La Manufacture des Œillets 艺术中心内
邮编：94200

Le 116 当代艺术中心
地址：蒙特勒伊巴黎大道（Paris）116号
邮编：93100

Mains d'œuvres 当代创意艺术机构
地址：圣旺区查尔斯·加尼叶街（Charles Garnier）1号
邮编：93400

奥贝维埃实验室
推荐理由：新兴艺术形式的实验展览中心。
地址：奥贝维埃市雷圭叶路（Lécuyer）41号
邮编：93300

在梅尼蒙当
和新一代巴黎女孩
克丽丝特尔·默里闲聊

棒球夹克
马文·盖伊
Régal'ad 水果软糖
Silencio 会员俱乐部

　　克丽丝特尔喜欢发出无忧无虑的笑声，在人行道上还会拖着运动鞋走路。除了这两点，从她的神态举止来看，完全看不出她是一个刚刚进入青春期的青少年。克丽丝特尔只有 14 岁，但她的自信，还有拍照时直视镜头的姿态都足以让你误以为她已经成年了。她住在美丽城，距离耸立着现代化高楼的马克斯·恩斯特街不远，街对面就是阿曼狄公园（square des Amandiers），但她家所在的街道不如附近的梅尼蒙当街那么华丽。克丽丝特尔从小就和家人住在这里。"这里是超级中心区，可以步行去共和国广场。"因为父亲是美国人，所以她练就了一口独特的"英式法语"——即法语中充斥着诸如"don't ask"（不要问）或"so strange"（太奇怪了）等英文短语。当然，她也会在讲话时大量使用青少年喜欢说的法式流行语，比如意思和"je ne sais pas"（我不知道）差不多的"chais ap"，又或是代表"完全正常"的"archinormales"等。

　　克丽丝特尔的神韵有点像某部电影里一个著名角色：一位巴黎少女。这个角色出自电影《初吻》，由备受推崇的法国女演员苏菲·玛索饰演，而这部电影备受 80 后法国女人的推崇，被她们奉为集体回忆。

克丽丝特尔就像是女主角的 21 世纪版本。克丽丝特尔和四个十五六岁的朋友们在巴黎东部很出名，甚至在全城的时装派对中都小有名气。尽管他们和奢侈品牌古驰完全扯不上关系，但被人称为"古驰帮"。他们会让人想起法国电影里的一些孩子，比如《薄荷苏打水》里喜欢恶作剧的女孩，还有瑟琳·席安玛执导的《女孩帮》里那群个性独立又叛逆的青少年。"其实我不知道我们到底是什么。我们好像被赋予了一种奇怪的恶名，*Public* 这样的八卦杂志会报道我们，在德国甚至也有关于我们的文章。不过我们都只是非常普通的朋友，虽然个性不同，但喜欢相同的事物，尤其是在古着店闲逛和买衣服的时候。"他们确实是这种普通朋友，从穿着一样的 Champion（冠军）牌运动衫就能看出来。他们都挺时髦的，会大胆娴熟地把亮片与街头服装结合在一起，这不仅让他们成为新一代巴黎造型师的灵感源泉，也被 Pigalle、Études Studio、Vêtements 等服装品牌视为灵感缪斯。

我们在找到合适的采访地点之前，跑去克丽丝特尔和父母的住所走马观花地参观了一遍，看到这个小女孩的卧室地板上乱七八糟地堆满了衣服。她的房间里有一台唱片机，里面放着歌手马文·盖伊的旧唱片，随时都可以播放。床上有一本法国编剧维吉妮·德彭特的电影同名小说《掰了金发妞》，正翻到她昨晚读完的那一页。后来，我们决定去附近一家咖啡馆的户外座席区做采访。克丽丝特尔点了一杯茶，把一个无法上网的老式三星手机放到桌上，这让我们感到惊讶无比：首先，因为我们一直认为年轻一代比我们更沉迷于科技；其次，我们是从 Instagram 上找到的她。这就是克丽丝特尔，总带给人惊喜，但整个人又充满了矛盾，也许一个天生有偶像气质的巴黎青少年理所当然就该这样吧。她带着狡黠的微笑开始回忆起童年，虽然那并不是很久以前的事情。

克丽丝特尔说自己度过了一个"完美的童年"，家境优渥的她从小

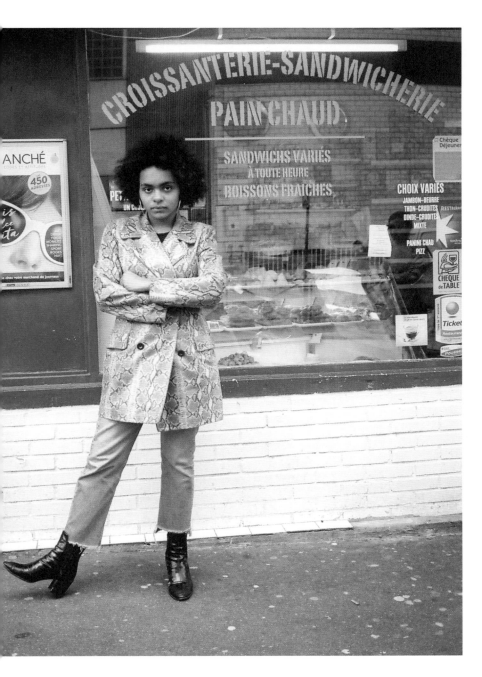

便生活在这座大都市里，还有机会到处旅行。她的父亲是一位音乐家，家里除了她还有三个兄弟，喜欢冲着她大呼小叫，相比之下，她说自己和母亲"非常亲近"。在她很小的时候，父母就带着她在墨西哥、日本等地东奔西跑。"受到 19 岁的哥哥影响，我 11 岁的时候就已经把自己打扮得很好看了。我以前常常模仿他的穿着，会学他穿飞行员夹克。事实上，我穿的就是他的夹克。"

　　自从苏菲·玛索的《初吻》上映后，许多巴黎年轻人就把在 14 岁的时候要去翻墙和去夜店当作必要的成人仪式。显然，克丽丝特尔也在私底下混迹在 Social Club、Silencio 和 Le Carmen 等夜店举办的派对中。不过，有一点让她觉得很诧异，因为就算"每个人都知道我的年

龄"，竟然也没有任何人阻止她出入夜店。说这话时，她露出嬉皮笑脸的表情。她还笑着告诉我们，不久前，就算是刚参加完国家文凭考试，她也有胆量去参加 Pigalle 品牌办的夜间时尚派对。我们发现，她和这本书里其他巴黎女人一样，浑身散发着一种勇敢又神秘的气质。在交谈中，克丽丝特尔会冷不丁地放出一些隐藏真相的烟幕弹，让人在她的叙述中有点摸不着头脑。比方说，她在前一分钟会悲伤地皱起眉头，重温在天主教私立学校上学时所面对的困难。"我过得一点都不好，"她大叫道，"他们要我剪掉头发。当得知不能留在那里读高二时，我真的很难过。不过我就要转去普通学校了，这样也许会更好吧。"但接下来的一分钟里，她会用略带炫耀的语气说："我对自己很有信心，也很

喜欢现在的自己。我觉得巴黎女孩应该是自由的，不用在乎他人的眼光，想做什么就做什么。"

　　克丽丝特尔喜欢做自己感兴趣的事情，我们不确定这是不是他们这代人的特征，或者是巴黎年轻人的共性。与此同时，我们还留意到，她在做事的时候不会遵循任何具体的计划。在聊到如何树立自我时，她说："不必成为一个为所欲为的人。"在谈到个人风格时，她说："我每天都穿同一条李维斯 501 牛仔裤，有时还会从父亲那里偷 XXL 号的美式足球衬衫来穿。但在隔天，我又会穿妈妈给我的缎面睡衣。"关于美食，她会说："每到午餐时间，我都会买一份便宜的 Sodemo Roma 沙

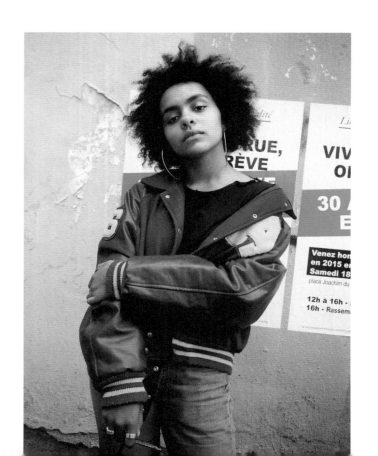

拉，有时我们会去文森森林野餐，或者去绿色小径（Chemin Vert）找母亲吃越南煎蛋卷。要不然，我就会随身带很多 Régal'ad 水果软糖。"说到美容护肤，她说："我经常觉得很累，所以几乎不化妆。外出的时候，我唯一会做的就是在眼皮上涂一点亮粉，让它看起来更亮一点。如果'熊猫眼'看起来比较明显，我会把化妆棉先放在洋甘菊化妆水中浸泡一下，然后再敷在双眼下面。"在谈到爱情的时候，她打死也不愿承认自己尚缺乏这方面的经验，或是还不够成熟。相反，她有自己的爱情观："每当谈到男人的时候，巴黎女人总会有点失去理智。但我不会这样，因为我反对爱情。"

　　如果克丽丝特尔看起来没这么坚强和自信的话，我们会觉得她是个柔弱的小女孩。我们平日里老在关注手机上弹出的新闻，也在时刻担心法国民众当下受到的威胁和动荡的国际时局，所以我们想问问克丽丝特尔，从一个年轻人（采访时只有 14 岁）的角度如何看待 11 月 13 日发生的恐怖袭击。"太可怕了，那天晚上我在共和国广场和朋友聚会，母亲正在参加一场音乐会。事件发生后，我在家里待了几个星期都不愿出门。我知道这个世界很可怕，但不想一直都处于惊慌失措中，也不想总是想到唐纳德·特朗普和玛丽娜·勒庞 [1]。我知道，如果一切都如他们所愿，那简直糟糕透了。但是，新世代也正在崛起，他们注定将改变世界。"听到此话，我们不敢反驳她，但希望她对未来抱有信心，能够长江后浪推前浪。

1　玛丽娜·勒庞（Marine Le Pen），法国政治人物。——译者注

我们的巴黎
花房姑娘

我们经常光顾的花店：

Arom
地址：勒德吕－罗林大街73号
邮编：75012

Variations végétales
地址：吉扬将军街（Général Guilhem）18号
邮编：75011

L'artisan fleuriste
地址：圣殿老妇街95号
邮编：75003

Les succulents cactus
地址：特伦娜街（Turenne）111号
邮编：75003

Debeaulieu
地址：亨利莫尼耶街（Henry Monnier）30号
邮编：75009

如果没有在巴黎公寓里的花瓶中插满鲜花，那么对于一个巴黎人来说这个公寓就是不完整的。时令鲜花是最好的选择，所以我们喜欢去买冬天的含羞草，春天的黄水仙和丁香花，夏天的吊钟花和向日葵，还有秋天的大丽花。在巴黎，送花代表"谢谢"或"干得好"，或者代表什么都行。每个巴黎女人都有专属于自己的花店，她们总是无法离开它们。

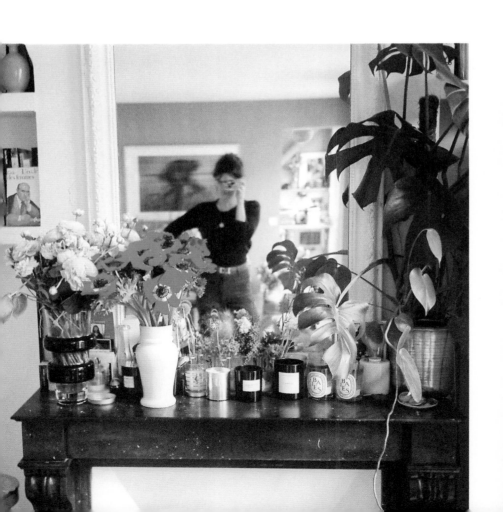

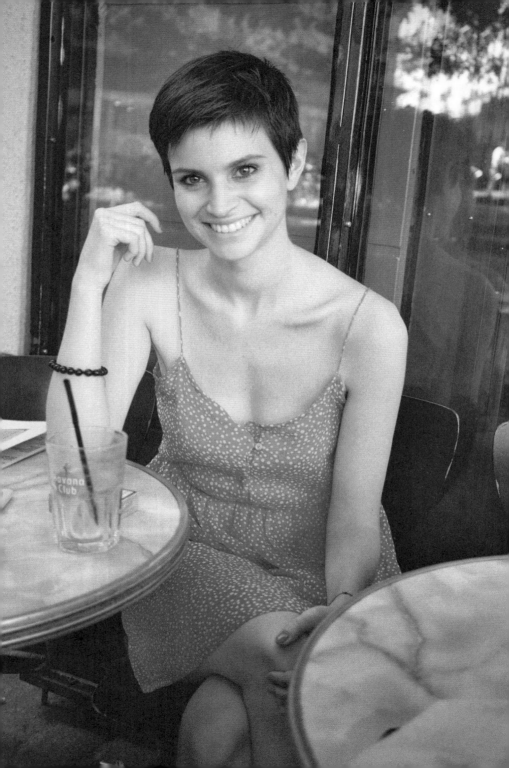

在南皮加勒

感受**露西 · 豪特林**

对正义的渴望

"黑夜站立"抗议活动
发型
素食主义
推特

 自从在推特上看到了露西的照片后，我就被她深深地迷住了。2016年春天，人们在共和国广场发起了一个叫"黑夜站立"的抗议活动，每天晚上抗议者都把广场挤得水泄不通，当中有年轻人，也有上了年纪的人，有的人充满愤怒，还有一些人则怀着想要改变世界的强烈愿望。我们去过那里多次，为的就是去广场上呼吸自由的空气，去和那些坚定的巴黎人交谈。他们宣扬的思想内容或多或少带有乌托邦色彩，而我们更愿意把那看作是一种富有远见的人道主义价值观。共和国广场是巴黎一个极具象征意义的广场，它代表了巴黎人心目中的政治理想。在过去几年里，巴黎人在那里举行过多次抗议活动。2015年1月7日，当《查理周刊》总部遇袭事件发生后，数百万人来到广场；同年11月13日发生恐怖袭击事件后，大家再次聚集在这里悼念遇难者。我们还曾经在这里一起向空中挥舞拳头，抗议巴黎社会对女性做出的种种暴行。每次穿过广场，我们的脑海中就会响起各种口号，首先出现的就是被刻在市政厅的国家格言："自由、平等、博爱。"

 我在那晚发的推特照片，正是露西在参加有关劳动法修订案的抗

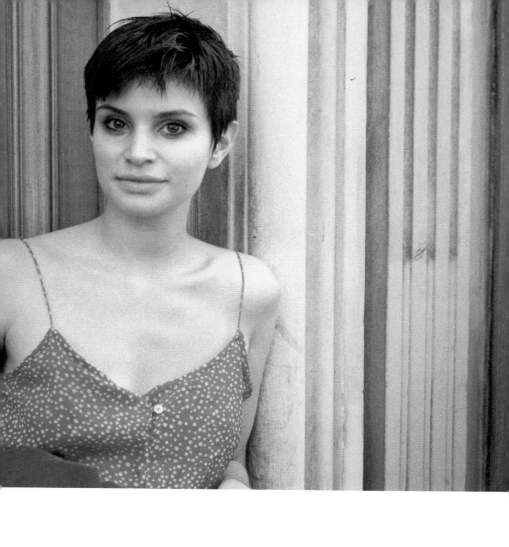

议活动时拍下的。她系着围巾，头上戴着护目镜，尽量保护自己免遭催泪弹伤害。她脸上坚定的神情让我想起了一些女性革命家，特别是18世纪末法国大革命时期的社会改革家兼作家奥兰普·德古热，还有在1871年与国民警卫队一起为保卫巴黎公社而对抗凡尔赛军队的"红色处女"路易丝·米歇尔。她还让我想到了20世纪初的妇女参政论者，还有1968年发生"五月风暴"以后，领导妇女解放运动的斗士们——她们使这场运动在巴黎造成了巨大的轰动。巴黎是一座充满革命精神的城市，一座抗议之城，也是不断取得社会进步的光荣城市。从露西的眼睛里，我们似乎看到了这一切。

经过几次询问后，我们设法与她取得了联系。露茜住在特律代纳大街附近，离我家不远。我们来到她的住所附近，看见她正在和一个坐在滑板上的男孩聊天，他们都是"黑夜站立"反物种主义[1]委员会的成员。露西是一位素食主义者，素食也是她所主张的"政治行动主义"中的一大基石。"其实，人们很容易就能发现动物权利和金融及生态危机之间的联系！"她激动地说道，"我不会食用任何动物制品，不穿任何带有皮革、毛皮和羊毛的衣服，也不使用会在动物身上做测试的化妆品。我以前一直都在喝牛奶，但有一天我去拜访了一位信誉很好的奶农，发现不停产奶的奶牛都处于精疲力竭的状态。目睹这一切后，我就不再食用乳制品了。"而后她笑着说，这个街区是素食主义者的完美选择（此话不假，这里有一家叫 Le Potager de Charlotte 的著名素食餐厅）。她告诉我们，最近参演了一部叫《解放的肉体》（*Chair Liberté*）的反乌托邦式短片，该片由德博拉·比顿执导，描绘了一个把人（而非动物）当成屠宰品的世界。

1 物种主义，澳大利亚哲学家彼得·辛格在1975年提出的一种有关于人类与其他物种间的关系的理论。该理论认为人类与其他动物有着本质上的区别，动物理应比人类得到更少权利。——编者注

露西是一名积极的社会活动人士，也是一名演员，但她说只会参与拍摄能够"传达意义"的电影。"作为一名女演员，我的终极目标是利用自身的名气来激励别人、改变世界。"她像许多初出茅庐的年轻女演员一样，依靠在餐馆打工的收入来付房租。"我的日常开销很少。我会回收被人丢弃的东西，从廉价二手店买衣服，而且只吃素食。我把所有的钱都存起来，这样就可以出去旅行。去年夏天，我带着500欧元去了秘鲁。"最近，露西开始在一家私人俱乐部当酒吧女侍应。"平时，我在反抗游说者，但到了周末，我在这里为他们调莫吉托鸡尾酒。"她说这话时，露出一种不太友善的表情。

我们来到位于罗什舒阿尔街和杜尔哥街之间的一个漂亮的广场上，坐在一家咖啡馆外面开始闲聊。我们所在的位置位于第九区的中心地带，这个区食肆林立，大街小巷内都有蛋糕店和面包坊。虽然这里街道狭窄，也缺乏绿植空间，但似乎并没有阻止有小孩的家庭选择在这里生活。这个地方通常被称作"南皮"（南皮加勒地名的缩写），和布鲁克林有很多相似之处。这里的男性大都留着胡子，最常见的交通工具是自行车，大多数餐馆都出售无麸质食物。今天，露西点了一杯与她的红色连衣裙相衬的番茄汁。

她一直是个积极的活动人士。在上高中的时候，她就参加过反对自由劳动市场改革的社会运动。她一直都痛恨不公平的现象，而这很可能和她在童年时期遭遇的不公正对待有关。露西不知道自己的双亲是谁，从小由卫生保健及社会福利事业局（该机构的职责之一是抚养孤儿）照顾，后来被别人家收养。虽然小时候受到了很多虐待，但那些经历让她变得更坚强。"我必须在世界上创造出属于自己的位置，因为从来没有人给过我这些。在21岁的时候，我穿着一双运动鞋，背上背包就去了加拿大。那次旅行是一次我个人的灵魂之旅，让我受益匪浅，也让我产生了向世界敞开心扉的愿望。后来，我在伦敦生活和工作了

一段时间，感觉自己好像失去了生活的方向。我意识到，自己好像不能生活在资本主义制度里。"露西向我们列举了一些激励她成为一名活动人士的书籍和电影，包括汉娜·阿伦特的《艾希曼在耶路撒冷》、肖恩·蒙森拍摄的纪录片《地球公民》、马克·德·拉·梅纳迪埃（Marc de la Ménardière）和纳塔内尔·科斯特（Nathanaël Coste）执导的电影《对于意义的探索》（A Quest for Meaning）。当然，她还看过西蒙娜·波伏娃的《第二性》，以及柯琳娜·塞罗执导的关于地球生态的电影《绿行星》。

露西以前没有把巴黎列入自己的未来人生蓝图中。"每一次回到这里，我都会觉得受到了侮辱，在地铁站里也经历过很多磨难。最近，我才开始觉得自己更像是巴黎人而非外省人，感觉找到了属于自己的路。无论是知识还是文化，这个时代的一切事物都发展得越来越快。"

在 4 月的某个晚上，露西在共和国广场被一枚刺鼻的烟幕弹击中。"警察在压制活动人士。"说这话时，她充满了愤怒，"在我看来，他们的压制比抗议者们的任何暴力行为都更无理。我在那晚认识了在独立媒体当记者的男朋友，他帮我处理了伤口。虽然我在当时是一身抗议者的行头——戴着安全帽、护目镜，手里还举着一块牌子，但我们的相遇还是很浪漫。"接着，她向我们描述了和其他"黑夜站立"的抗议者每天在共和国广场度过漫漫黑夜的感受。"我喜欢历史好像在注视着自己的感觉。我每天晚上都去那里，在那里颤抖和哭泣。我在反物种主义委员会的全体会议上做过一次演讲，让社交网络上的人们都听到了我们的声音。我们从中也认识到，社交媒体是一种可以用来表达诉求和举办活动的工具，所以我们创建了自己的网络，变得更加组织化。我们好像正处于一个临界点，已经达到了某种极限。"我们问："你在巴黎发展了自己的事业，如果在其他地方也会如此吗？"她笑了笑，然后叹了口气。"这下我可能没那么客观了，"她说，"我疯狂地爱着这座城市。对我来说，当年被收养是正确的。"

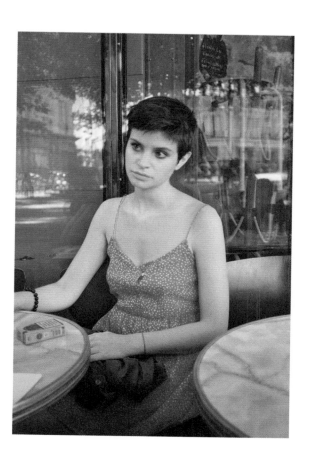

我们的巴黎
法国人的政治生活

当我们在写这本书的时候，正在巴黎举行的抗议活动可不止一个。其中，最令我们难忘的是唐纳德·特朗普当选美国总统后在法国发生的抗议活动。之所以要这么做，是因为大家发现，即使这位美国总统一再攻击女性，最后还是当选了。巴黎人迅速走上街头抗议，并且通过社交媒体和标语牌表达自己的不满。2017年1月21日，数千名抗议者还从巴黎的特罗卡德罗出发，声援同一天在华盛顿所举行的"女性大游行"活动。大约在同一时间，参选2017年法国总统的一些候选人也针对女性发表了令人担忧的讲话，因此大家还发起了反对堕胎的抗议活动。话说回来，我们应该通过阅读什么书籍和观看什么影片来强化自己的表达呢？如何才能把女性主义价值观融入日常生活呢？以下有一些小小的建议。

值得一看的书籍：

《女性的权利》（*We Should All Be Feminists*）
作者：奇玛曼达·恩戈齐·阿迪奇埃

《一间自己的房间》（*A Room of One's Own*）
作者：弗吉尼亚·伍尔芙

《选择的权利》（*The Right to Choose*）
作者：吉塞勒·哈利米

《致命的美》（*Beauté fatale*）
作者：莫娜·切利特

《第二性》（*The Second Sex*）
作者：西蒙娜·波伏娃

《女性、种族和阶级》（*Women, Race & Class*）
作者：安吉拉·戴维斯

《我不是一个女人吗：黑人女性与女权主义》
（*Ain't I a Woman: Black Women and Feminism*）
作者：贝尔·胡克斯

《世界的性化：关于解放的思考》
（*La Sexuation du monde: Réflexions sur l'émancipation*）
作者：吉纳维夫·弗雷斯

《盖雷耶尔》（*Les Guérillères*）
作者：莫妮卡·威蒂格

值得订阅的新闻网站：

Lenny（www.lennyletter.com）
Les Glorieuses（lesglorieuses.fr）
Quoi de meuf?

值得一看的电影：

《野马》
导演：蒂尼斯·加姆策·艾葛温

《女神们》
导演：侯达·本亚闵纳

《美好时节》
导演：卡特琳·科西尼

《假小子》
导演：瑟琳·席安玛

值得一听的播客节目：

La Poudre
Stuff Mom Never Told You
The Guilty Feminist
Génération XX

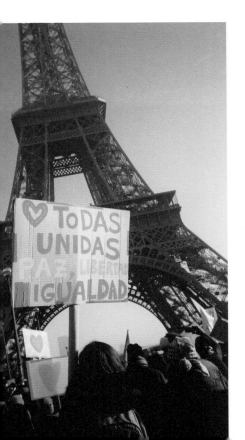

推荐追踪的 Instagram 博主：

@vscyberh
@payetashnek
@lallab
@causettelemag
@klairette

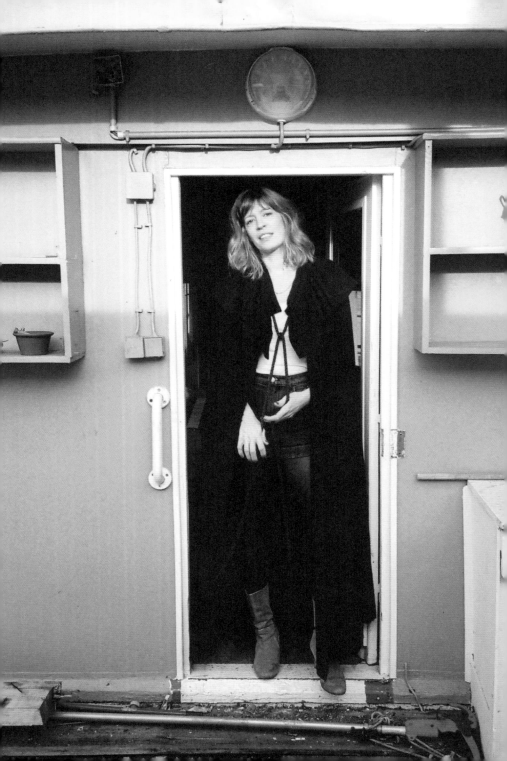

在塞纳河畔讷伊的驳船上

和**安娜·莱因哈特**

聊特立独行的生活

披肩
驳船
吉他
游泳课

　　安娜邀请我们到她的驳船上见面，她的船停泊在塞纳河边的一个码头。这艘驳船可不是那些厌倦了住在第九区的公寓、追求刺激的中产人士一时冲动购入的时髦物，而是她长大的地方。在四处漂泊了几年之后，她现在打算又搬回船上生活。

　　安娜是一位记者，也是一名音乐人。她和男友组建了一支叫"酒店"的乐队，她为这支独立乐队创作过不少充满怀旧风情的歌词。"之所以给乐队起这个名字，是因为我们觉得，在酒店里任何事情都有可能发生，人们可以在那里笑，在那里哭，可以在那里迷失自我，也可以做爱、做梦、跳舞、睡觉、独处一室或和别人在一起……"安娜身上有一种巴黎人的特质：在谈论事物时会不自觉地把一切都理论化。她让我们想起20世纪70年代富有哲学气息的巴黎，当时改革之风吹拂着这座城市，涌现了一批重要的思想家、学者、艺术家和活动人士，他们大都在咖啡馆聚会，渴望用他们的话语来改变世界。

　　采访时正值寒冬时节，塞纳河岸边的树木都是光秃秃的，河水也是一片灰色。我们看到拉德芳斯区的摩天大楼在对岸拔地而起，高达

40 层的法国之旅大楼（Tour France）更是直冲云霄。我们刚一踏上蓝色的旧驳船，整艘船就立刻左右摇晃起来，发出吱吱嘎嘎的声音。然而，我们被这里平静又富有诗意的氛围完全迷住了。安娜为我们演唱了一首名为《我的河流》的歌曲。"这首歌是在致敬这个地方和我的童年，父母过世以后我才完成这首歌，"她说道，"当我感到特别阴郁的时候，就会沿着塞纳河散步，即使不知道到底要走向何方。这条河的河水很清澈，它似乎在沉思。"

安娜裹着一条母亲留下的圣罗兰黑色羊毛披肩。她坦言："以前，我在上学路上都会把自己裹进这件披肩里。"她的回忆就像她本人一样，集合了创造力、优雅和神秘感，当然，也很巴黎。"我的父亲是一名学者，对这座城市的每一个角落都了如指掌。他曾经和雅克·布雷尔 [1] 以及他的乐队混迹在各大酒吧。"她回忆道，"我的母亲在巴黎第十一大学的奥赛校区当讲师和研究人员。我清楚地记得，社会党候选人弗朗索瓦·密特朗当选总统那天，他们简直高兴得手舞足蹈。我们应该是讷伊唯一一个左翼家庭吧！如果在我家举办聚会的话，我也会这样直话直说！"安娜的父母是真正的巴黎知识分子，他们也培养出她对不同文化的强烈好奇心，而其中最重要的，就是对音乐的热爱。"我对他们有一种令人难以置信的崇拜。多亏我接受过心理治疗，才学会了要用爱别人的方式来爱他们。我深知自己的身世背景，也明白自己继承了什么样的特质。"安娜本来可以选择继续轻松地当记者（她是法国一档最受欢迎的早间电视节目的记者），但为了能在音乐上投入更多时间，她选择退居二线。她往往会做出违背常理的选择，就像她的父母一样。

1968 年，"五月风暴"爆发之后，许多居住在巴黎的人都趁着河运事业方兴未艾，从荷兰购买了低价的驳船，并将它们停泊在第十六区

1　雅克·布雷尔（Jacques Brel），比利时歌手、作曲人。——译者注

和塞纳河畔讷伊。安娜的父母也不例外。"他们的驳船就像是一个避风港，似乎永远都有来自阿根廷的难民、日本的小提琴家，而一大群富有人道主义精神的艺术家和研究人员也会在此长期居住。我们的驳船大门几乎总是敞开着。这就是驳船上的真实生活。"

那是一种自由无拘束的生活方式，安娜的爱情生活也体现出这一点。几年前，她参加完"一场在南法的祖母家举办的美妙聚会"后就闪婚了，然后有了两个孩子。但在两年后，她离婚了。"对我来说，毫

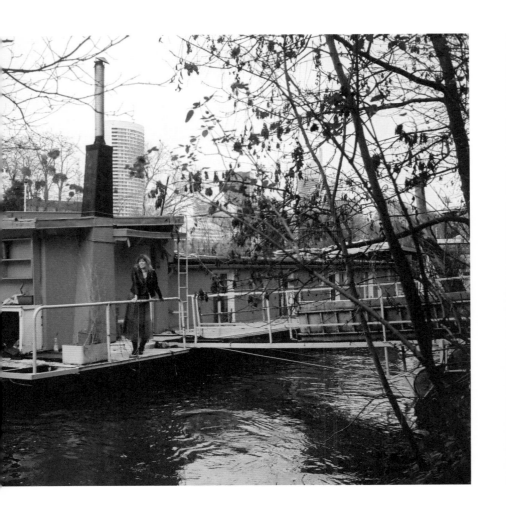

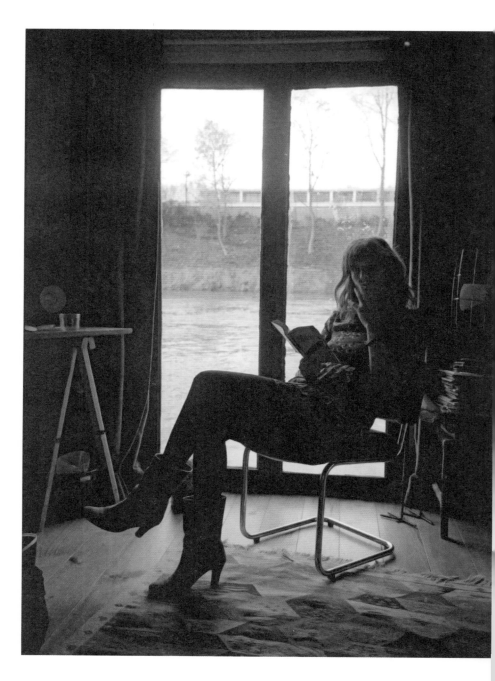

无遗憾。"现在，她和比自己年轻一些的男友生活在一起。当初他们在摩加多尔的滚石音乐会相识，而后共同成立了"酒店"乐队。"我递给他一把吉他，他就为我上了一堂吉他课，然后我们觉得必须要在一起创作歌曲才行。从此以后，我再也不指望让另一半来帮忙解决私人问题了。我现在拥有的恋爱关系，应该是和男性之间最明智的一种关系。"不得不再说一次，她有一种不自觉地将每件事都理论化的特质。

安娜正在对这艘驳船进行大规模的改造。在几个月后，她和男朋友、两个孩子（一个六岁，一个八岁半）会搬回船上生活。在过去的几个月里，基于安全方面的考虑，她一直在安排孩子们上游泳课。此外，她和男友决定要改造厨房，计划把休息空间也变得更大一些。修复老旧的驳船听起来是一件有趣的事情——她先把船运送到一个船坞，让工人们重新制作船体，然后才让驳船重新浮出水面。"工人们都认识我的父亲，他们像真正的船夫一样来迎接我，这让我觉得自己得到了他们的认可。"然而，驳船生活也会有一些不便，比方说需要每天清扫树叶和甲板。但是每当把船停泊在码头，远离岸上的喧嚣和汽车时，这样的生活就会带给人一种长久的宁静。"我无法住到那些停在巴黎市中心的驳船上，"接着她解释说，"有些人会一直盯着你看，游船上令人眼花缭乱的灯光也会照射过来。"

在我们走过摇摇晃晃的浮桥来到驳船入口时，发现这里放着一架蒙上了些许灰尘的大钢琴。这架钢琴属于一位著名的音乐家，他同时也是安娜的教父。她在钢琴前坐下来，为我们表演了几个和弦。就在她裹着披肩弹琴的那一刻，我们猛然发现，在 20 世纪 70 年代嬉皮士盛行之后，那个洋溢着波希米亚风情的巴黎或许并没有完全消失。

我们的巴黎

夏季固定搭配

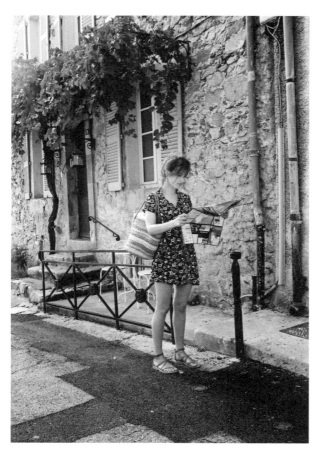

印花长裙、
凉鞋和草编包

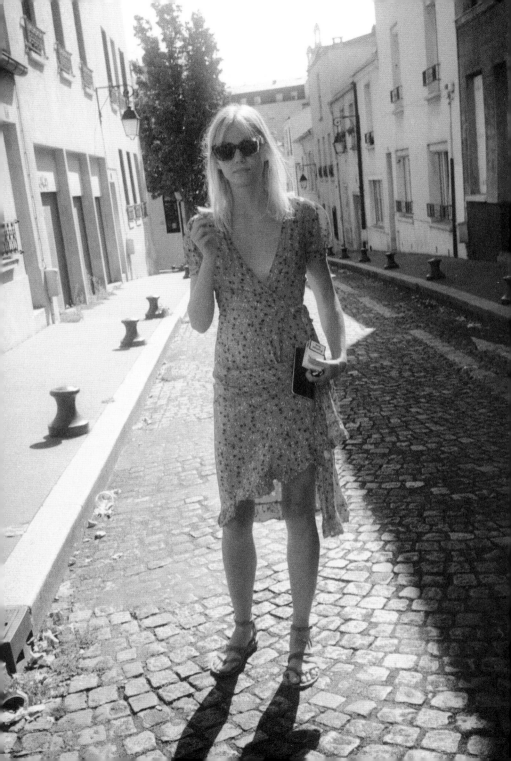

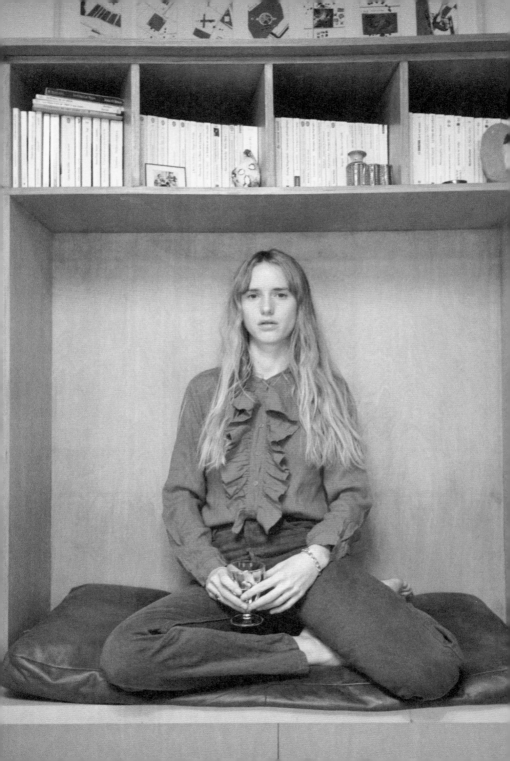

在圣日耳曼德佩区

听**佐薇·勒贝尔**

分享环球旅行趣事

波斯地毯
带褶边的衬衣
纱笼
黑咖啡

我们来到距离著名的巴黎政治学院仅有几步之遥的地方，而这里离圣日耳曼大道也不远。无论是人行道上正在吸烟的自命不凡的学生，还是带鹅卵石大庭院的豪华建筑上的白色檐口，这个街区的一切事物都给人留下了深刻的印象。想去佐薇·勒贝尔的住处，必须穿过一个仿佛能听到微弱马蹄回声的庭院和一段户外石阶，来到一扇高高的漆釉大门前，推开大门，还得再爬上另一条铺着红毯的大石阶，才能来到她的家门口。在爬这段石阶的时候，我们观察到阶梯下方的铁艺灯投射出柔和的灯光，感觉它们装扮这面墙已经有几个世纪了。

只要一脚跨过佐薇的公寓门槛，就仿佛远离了古老而繁华的巴黎，进入了一个可以环游世界的空间：在一个巨大书架的边缘，整齐地排列着各种贝壳；艾米莉·勃朗特与加夫列尔·加西亚·马尔克斯的著作被放在一起；扶手椅下方铺着一张波斯地毯，椅子上放着一张摩洛哥坐垫和一些非洲的布料。佐薇不仅是一名摄影师、电影人，还是经验丰富的环球旅行者。她在世界各地飞来飞去，为家里带回了大量迷人又充满异国风情、有时甚至令人感觉不适的照片。

　　佐薇经常为时尚品牌拍摄广告，也会执导音乐影片和制作纪录片，赢得了不同行业的赞赏。她最新的一部纪录片将在新闻频道 VICE 上播出，这部影片非常感人，记录了她在希腊科斯岛与移民一起度过的几个月生活。她认识的大部分移民都是为了逃离战争而背井离乡的阿富汗人，他们希望能够穿越巴尔干半岛去西欧。

　　佐薇从儿时就萌生了要去海外旅行的想法。"我的父母是巴黎人，但我还有俄罗斯、意大利和英国血统，"她说道，"当我还小的时候，父母决定要离开巴黎。所以，我在波克罗勒岛、布列塔尼和马赛这三个地方度过了童年。我们从未远离过大海。如果一个人小时候老看到海天一色的景象，想必日后在生活中也会拥有无穷无尽的可能性吧。对我来说，边界这个东西，从来就不存在。"佐薇今天穿着带褶边的紫红色衬衣和棕色的裤子。她的肤色很白，五官精致，有长长的金发，这样的外表和她大胆的个性形成了鲜明的对比。只要看看她发布在 Instagram 上的帖子，就会发现她的风格与传统的巴黎女人有天壤之别。从有些照片来看，她有时候会穿着毛茸茸的豹纹夹克，有时候头上会包着头巾。"我要为电影选材，所以经常游走在不同的国度。我总是在寻找不同的地方。身处他乡，会让我更有创造力。"

　　当我们问起她的童年教育时，佐薇有点含糊其词，似乎她的过去隐藏着某些秘密的伤疤。我们只知道，她和父母在全世界东奔西跑，而她在获得法律和政治学位后出演过不少电影，而后还当上了导演。"我通过观看别人的拍摄和阅读大量的相关书籍来学习，比如我会读约翰·特鲁比[1]的《故事的解剖》。"她喜欢在开放式厨房里为电影界的朋友烹制简单的菜肴。今天，她为我们俩泡了绿茶，热情地跟我们分享她的旅行趣事。"我刚结束了一段摩洛哥的公路旅行，去了马拉喀什和

1　约翰·特鲁比（John Truby），好莱坞著名的故事写作顾问。——译者注

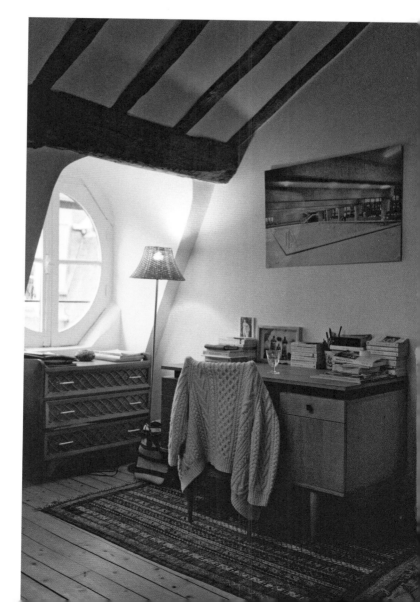

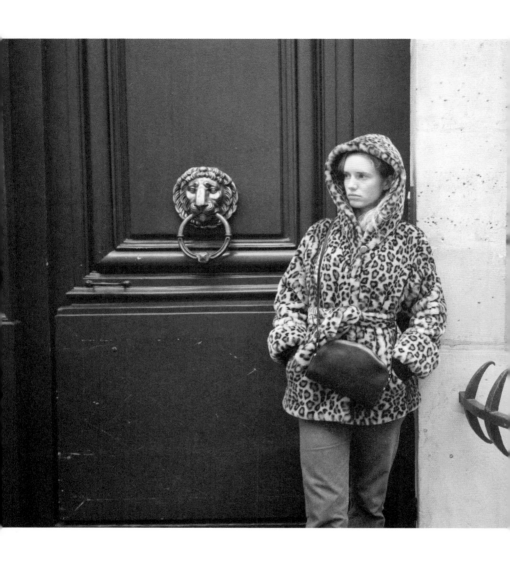

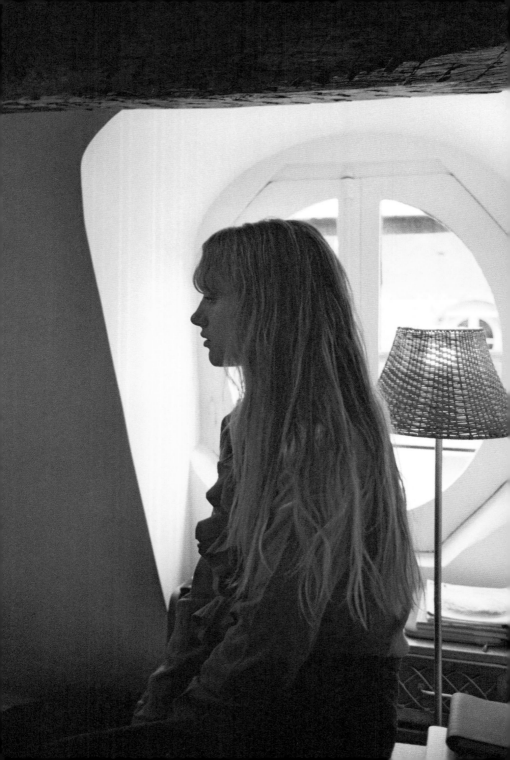

扎戈拉。"她还向我们描述了德拉山谷、塔鲁丹特、索维拉，还有美景和沙漠的日落景象。

佐薇钟爱独自旅行。"我会沉浸在造访的国家里，穿着和当地人一样的衣服，有时会在偏僻的街道里迷路，有时会去咖啡馆和本地人交谈，询问他们最爱的地方在哪里。我通常会拎着空空的手提箱出发，然后去各地的市场买布料。我喜欢穿不同的纱笼，或者往头上系一条头巾。我感觉自己就像变色龙一样，但这就是我的旅行之道。"在冰岛旅行时，她也采用了同样的方法，感觉"自己像是去了另一个星球"；她去过加纳，认为"非洲让我想起了童年，我以前和父亲一起去肯尼亚的拉穆旅行"；她还去过马达加斯加，觉得"那是一次疯狂又紧张的旅行，那一个多月好像和世界都断绝了联系"。每一次旅行完回到巴黎，她都会带回当地的布料、照片和一些不寻常的小物，而这些物品全都散落在她顶层公寓的各个角落。

像许多巴黎人一样，佐薇有时也会对巴黎人太过自我的一面颇有微词。"巴黎让我着迷，但它也很容易遭到批评：这里的人们有一种孤立自己的倾向。"然而在几分钟后，她又微笑着承认，"每次当我旅行回来也会觉得，没有什么事情比回到自己的小咖啡馆更让人开心了。我喜欢在圣佩雷斯街的 Le Comptoir 餐吧喝上一杯，听听那里的陌生人讲八卦。"或许，巴黎人只有在巴黎，才更像旅人吧。

我们的巴黎

冬季固定搭配

男式夹克或西装外
套、羊绒衫、直筒
牛仔裤和靴子

在巴克街

听**弗朗索瓦丝·戈洛瓦诺夫**

口述历史

爱马仕手袋

亨利四世

碧姬·芭铎

"Godasses"（俚语）

　　在一开始为这本书寻找女性受访者时，我们就非常笃定地认为，一定要把每天在巴黎街头看到的那些白发苍苍的巴黎贵妇囊括其中。我们希望找到一位戴着珍珠项链的年长女士，就像是从桑贝[1]的漫画里径直走出来的女士。她可能是一位毫不出奇的祖母，坐在卢森堡公园的长凳上一边照看她的猎狐梗，一边读有点儿偏激的政治类文章。

　　我们制定了如此具体的标准，以至于好像难以如愿。直到有一天，珍妮在 Instagram 上闲逛时发现了拥有天蓝色眼睛的弗朗索瓦丝。她和做时尚记者的女儿、身为法国女人代表人物的亚历山德拉·戈洛瓦诺夫一样让人惊艳。我们在开启壮阔的巴黎女子寻找之旅将近一年后才遇到弗朗索瓦丝，而她也是我们在写这本书时遇到的最后一位女性。她住在第七区，居住的地方离巴克街不远。我们来到她的公寓，室内设计令人过目难忘。我们看到屋子里满是新古典主义时代的物品和家具，还能闻到一股好像刚给木头打完蜡的味道。弗朗索瓦丝和她的丈夫都是古董商，所以把家

1　桑贝（Sempé），法国插画大师。——译者注

里打理成这样也不无道理。这对夫妻经营多年的古董店离公寓不远，那些热爱典型的巴黎式消遣活动的人都知道这个街区。他们喜欢来这里淘二手货，还喜欢把玩那些透着浓浓历史感的古董。博纳街上有几十家古董店，富人们经常去那里买枝形吊灯、地毯、家具、艺术品等，这些家居摆设能让他们的家里散发出地道的巴黎味道。弗朗索瓦丝的丈夫安德烈曾经是一名医生，在我们采访她时，丈夫从不远处时不时地看着她。

她开始向我们讲述自己的故事："我出生在战争时期的波城，亨利四世也在那里出生。我的家人都是巴黎人，但我们在'二战'时期德国占领巴黎的那段时间逃离了这里，直到'二战'结束才回来。我留着一些老照片，包括我一岁时在特罗卡德罗学走路的照片。"对于大多数人而言，弗朗索瓦丝算得上是一位纯正的巴黎人，她和巴黎早已融为一体，她的人生经历也呼应着这座城市的历史。她的故事始于第十六区，这个区以居住着众多富裕家庭而闻名，非常广阔，从埃菲尔铁塔一直延伸到布洛涅森林深处。她在这里长大并长期居住于此，直到大约 15 年前才搬走。"在以前那个年代，人们的背景更加多样化，不同社会阶层的人会住在同一栋楼里。但现在，你只能遇到一些精力充沛的年轻专业人士，"她笑着说，"我们以前住在拉涅拉附近，我很享受在那里把三个女儿抚养成人的时光。她们在庞贝街上学，而在周末的时候，我们会步行去布洛涅森林。每天我都会坐 63 路公交车去离家不远的博纳街开店。从奥斯特里茨站到犬舍站的这一路风景非常美！我们也在莫斯科住过一段时间，但巴黎是唯一让我真心着迷的城市。我喜欢巴黎的一切，包括这里的混乱，我不明白人们为什么老在抱怨这个问题。"她喜欢散步，常常牵着小狗穿过塞纳河去杜乐丽花园散步，或是到里沃利街的 BHV 百货公司逛逛。"散步真是太棒了。我还喜欢早上九点去森提尔区 ¹，那里的商品简直让人眼

1 森提尔区（Sentier quartier），曾经是巴黎最重要的纺织工业区。——译者注

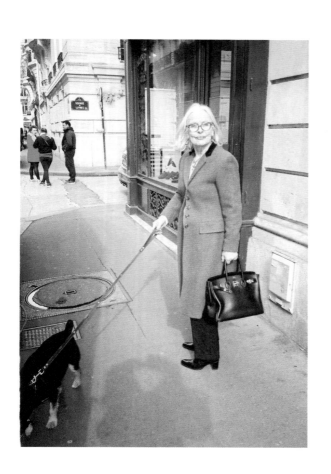

花缭乱。我无法想象住在巴黎以外的城市。虽然我并没有充分探索这个城市的一切，但现在的程度对我来说就已经足够了。"

我们很想听听她在十几岁时的故事，这样就能知道 20 世纪 60 年代的巴黎长什么样子。"我真的没去过俱乐部。对我来说，去参加派对或是去香榭丽舍大街的 Le Drugstore 餐厅更时髦——我会在下午的时候去那里喝苏打水。"

当我们问她过去流行穿什么款式的衣服时，她回头看了看安德烈。"碧姬·芭铎风格的衣服，"安德烈自信满满地说道。但弗朗索瓦丝耷

了耸肩，表示不太同意。她承认，那时候的确会把头发梳成像碧姬·芭铎经典造型中那样的华丽发髻，但她也坦言自己更喜欢艾娃·加德纳、奥莉薇·德·哈佛兰等漂亮的美国女星。"我以前在索邦大学文学院念书，"她回忆说，"当时的姑娘都很聪慧，我们会戴着手套，穿着高跟鞋，系着丝巾去上课。"

接着，弗朗索瓦丝说了一句可能只有在巴黎才能听到的话："我对时装感兴趣，但对时尚则不然。"我们要求她具体谈一谈这个话题。她说自己基本上不会刻意去购物，衣帽间里的衣服几乎都是一时兴起买的，她特别容易在外出散步或经过店铺橱窗的时候因为冲动而购物。此外，她还有很多衣服来自二手店。"我们在贝里有一栋乡间别墅，那附近有一家慈善性质的服装店，在那里经常能买到价格低廉的漂亮衣服。这件夹克是我在十五年前买的，后来被虫蛀坏了，但我把它修补好了。"弗朗索瓦丝会缝纫，"但我不知道怎么缝制图案"，她好像在特意澄清这一点。她会绣花、织毛衣（女儿亚历山德拉透露，如果没有妈妈的专业眼光，她永远不可能推出自己的羊绒衣系列），但她只会谦虚地说，自己只是"知道如何把东西拼凑在一起"。弗朗索瓦丝在提到郊外的第二个家时，用了"我的乡野"这个词。因为她的狗讨厌坐火车，她每个周末只能开车去郊外的别墅。她开玩笑地说："一旦你到了四五十岁，就想拥有属于自己的花园了。等着瞧吧！"弗朗索瓦丝使用了一个老式的法式俚语"godasses"来称呼鞋子，这个词从她嘴里说出来时显得很别致，好像被抹上了一层和她的古董耳钉一样微妙的粉红色。

现在，弗朗索瓦丝已经当了祖母，膝下有九个年龄介乎四岁到十七岁之间的孙辈。夏天的时候，她有时甚至会同时照顾他们九个人。孙辈们会来她的乡间别墅，而她也会带他们去打网球，教他们画画或是做法式甜点。"第一个孙辈出世的时候，我有一种奇怪的感觉。这种感觉类似于，我有了一个孩子，但这个孩子又不是我的。不过从那以后，我就开始习惯了。我和他们在一起的时候，会笑得很开心。"

我们的巴黎
外出用餐

珍妮从小就是个美食家，她精心挑选了以下最爱的巴黎餐厅。

Le Servan

推荐理由：从面包到葡萄酒，所有餐点都很棒。

地址：圣莫尔街（Saint-Maur）32 号

邮编：75011

Le Clown Bar

推荐理由：自然葡萄酒搭配西班牙餐前小吃很美味。

地址：阿梅洛特街（Amelot）114 号

邮编：75011

La pointe du Grouin

推荐理由：这间餐厅的家常菜和饮品很棒，是巴黎唯一一
家要先兑换店家自己的通用货币"grouins"（意即"猪鼻币"）
才能付钱的餐厅。

地址：贝尔赞斯街（Belzunce）8 号

邮编：75010

Le Petit Marché

推荐理由：夏季的吞拿鱼油酥千层糕（tuna millefeuille）和
冬季的焦糖鸭胸肉很不错。

地址：贝阿恩街（Béarn）9 号

邮编：75003

Chez Philou

推荐理由：珍妮父亲经营的餐厅，所以你有可能在那里会
遇到她。

地址：查安德大街（Richerand）12 号

邮编：75010

Le Comptoir

推荐理由：据美食家珍妮说，这里有巴黎最好的食物。

地址：加乐福奥德翁（carrefour de l'Odéon）59 号

邮编：75006

在蒙马特尔

听**拉米娅·拉哈**

讲述自己的巴黎梦

新浪潮
红裤子
阿尔弗雷德·德·缪塞
地上轨道

　　拉米娅在巴黎居住了七年半。她的小型单间公寓坐落在蒙马特尔一条斜斜的街道上。每天，旅游大巴都会载着游客一窝蜂地来到这里，大家都渴望一睹电影《天使爱美丽》女主角艾米丽所居住的复古街区。拉米娅十分中意这里。"我喜欢这里的乡村风情，"她笑着说，"有时候，我晚上会独自出门散步。如果向左转的话，就会到达皮加勒的红灯区，但再往前走两条街，就能看到更加富庶的巴黎，有许多餐馆和热闹非凡的户外酒吧。"

　　拉米娅是一位造型师，曾在著名设计师让·夏尔·德·卡斯泰尔巴雅克的公司和其他一些巴黎的大型时装公司工作过。她现在是新锐品牌 Jacquemus 的主力，该品牌由珍妮的密友西蒙·波特·雅克米斯（Simon Porte Jacquemus）一手创立。拉米娅身材苗条、穿衣品位优雅，珍妮对她的风格可谓赞不绝口。采访当天，容光焕发的她穿着一袭红衣，看起来就像 20 世纪 50 年代的时尚模特。她几乎让我们忘记了此刻窗外正下着细雨，二月巴黎的天空一般都会经历一段短暂的灰色时期。

　　拉米娅和许多成年后才搬到巴黎的人一样，来这里定居之前就有

一个巴黎梦。她出生在德国的多特蒙德，但大部分时间都在柏林度过。她的父母是突尼斯人。"我总觉得自己在两个世界里徘徊。在突尼斯的时候，我觉得自己像德国人，而在德国的时候，我又像突尼斯人。待在家乡的时候，我会尽量吸收当地的文化养分。父亲总是会鼓励我：'世界是你的！你可以做任何事。'虽然他让我拥有一种阿拉伯人特有的骄傲，但我觉得自己也很像德国人，柏林是我最爱的城市，尤其喜欢那里的夏天。"她对巴黎的迷恋可以追溯到小时候，那时候她就已经很痴迷服装了。她对 20 世纪 50 年代的文化充满着热情，梦想日后能够从事时尚工作。"我喜欢看雅克·塔蒂、让－吕克·戈达尔等导演拍摄的新浪潮电影。我有时候还会做白日梦，幻想自己是那个年代的法国女人。她们的穿衣方式简约又时髦，说话的方式也是如此。我觉得巴黎有一种难以置信的吸引力，而似乎只有巴黎才带有这种浪漫又怀旧的感觉。"在 17 岁的时候，拉米娅跟随学校旅行第一次来到巴黎。她当时就疯狂地爱上了这里，现在都还清楚记得当年的情景，仿佛一切都发生在昨天一样。"那天下着倾盆大雨，比今天更糟糕，让我心怀敬畏。我喜欢这里的街灯、奥斯曼风格的建筑，还有随处都能听到的法语。那些画面和声音都在深深吸引着我，从那个时候我就知道，总有一天会来这里生活。"

拉米娅从杜塞尔多夫的一所时装设计学校毕业后，决定要来巴黎展开自己的职业生涯。那一年，她 22 岁，在巴黎举目无亲。不过，她有一位朋友刚刚为巴黎东部的一户人家做了一年互惠生，朋友后来把这家人的情况告诉了她。于是，拉米娅以照顾小孩为条件换取了在那个家庭的住宿。

但在那个时候，拉米娅非常渴望找到一份实习工作，以便能尽快学会法语。说到这里，她趴在沙发上，从上方的小架子取出一本平装书——阿尔弗雷德·德·缪塞的《勿以爱情为戏》。她说，在那个时候

她完全沉浸在这本书里，并最终靠这本书学会了法语。

后来，她在 American Apparel 美国服饰找到了工作，随后也辞去了互惠生的工作，开启了全新的生活。

"突然之间，好像一切都变了。"她说，"我一直都是一个人。但从某一天起，我被邀请参加了很多时尚派对，几个月后，我似乎就认识了巴黎的整个时尚界。巴黎真的很有趣。头天你还孤身一人待在这座大城市里，但第二天，你发现整个世界好像都在自己手中。"拉米娅的事业从此有了起色，甚至还找到了和著名设计师克里斯·万艾思一起

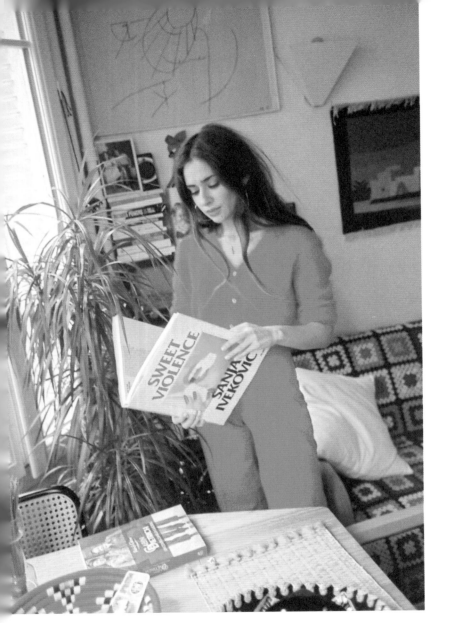

工作的实习机会。

那么，她现在觉得自己是真正的巴黎人了吗？"每次在回答这个问题时，我总会说自己是个世界公民。当然，现在法国是我的家。但如果你是一名穆斯林信徒，在这里生活就变得比较复杂了。我经常因为那次袭击事件而受到指责。我好像必须要表明自己的观点，必须为自己做辩护才行。这一点让我真的感到很难过。"她看到过很多不公正的事情，因此对巴黎的看法非常犀利。最令她感到震惊的是，在离这里不远的地方，许多移民都睡在地铁轨道上。这种凄凉的生活让她感到不知所措，而巴黎市中心和郊区之间的不平等问题也让她感到无比诧异。"我在一些支援难民和帮助无家可归者的机构里做志愿者，想为别人提供一些帮助。我在塞纳－圣但尼省的一个青年中心当志愿者。我想做更多的事情，但只要你想做点什么，就需要填写大量的文书。如果在柏林，绝对不会出现这样的问题！"她一直都被巴黎女人所吸引。"她们的眼里总是流露出一丝忧郁。刚开始的时候，我每次初到一个地方都会大声说'你好'，但想不到竟然没有一个人回应我。我以前认为巴黎人很傲慢，但现在才明白那只是表象。我在巴黎遇到过一些困难，但总能找到愿意帮助我的人。"

我们的巴黎
巴黎秘境

　　我们在这里列出了 20 个巴黎私密景点，有的与众不同，有的神秘或浪漫。每个街区都有一个我们心中的秘境，这样你们就不会错过巴黎的任何景致了。

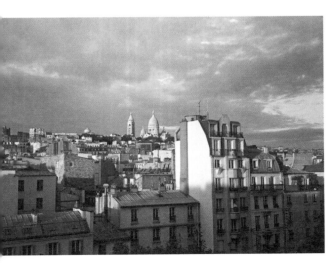

i. 盖琳亚尼书店
推荐理由：这里的高品质藏书令人过目不忘，店内的木地板会散发出美妙的味道。
地址：里沃利街 224 号

ii. 法兰西喜剧院
推荐理由：在正式开演前一小时售票，每张票 5 欧元。
地址：科莱特广场（place Colette）1 号

iii. 瑞典文化中心
推荐理由：这里有历史悠久的鹅卵石庭院，造访的时候不妨点一份腌三文鱼三明治。
地址：佩叶尼街（Payenne）11 号

iv. 巴尔耶广场
推荐理由：在圣路易岛的顶端位置，在垂柳下可以享受小憩时光。
地址：亨利四世大道（Henri IV）2 号

v. 蓬图瓦兹泳池
推荐理由：在这里可以享受到从泳池的私人换衣间俯瞰整个泳池的豪华体验。
地址：蓬图瓦兹（Pontoise）19 号

vi. 福斯坦堡广场
推荐理由：选一个春天的傍晚，去这里等待路灯亮起的一刻，灯光洒在粉色的泡桐树上很美。
地址：福斯坦堡街（Fürstenberg）

vii. 罗丹博物馆
推荐理由：在博物馆的花园里读一本书吧。
地址：梵伦纳街（Varenne）79 号

viii. 卢芹斋彤阁
推荐理由：这座令人惊艳的塔式建筑在 20 世纪初由一位华人艺术商修建，位于奥斯曼建筑群中。
地址：库尔塞勒街（Courcelles）48 号

ix. 浪漫生活博物馆
推荐理由：可以去这里欣赏小说家乔治·桑的珠宝，或去花园里漫步。
地址：莎布达勒街（Chaptal）16 号

x. 布雷迪拱廊街
推荐理由：在这里吃一餐咖喱，然后去迷宫般的店铺街买贡香或香米。
地址：圣丹尼斯郊区街 46 号

xi. Le Perchoir 咖啡馆

推荐理由：在这里可以一边享受红酒，一边眺望整座城市。

地址：克里斯潘都卡斯街（Crespin-du-Gast）14 号

xii. 绿荫步道

推荐理由：沿着这条步道，可以走到巴黎最新的西蒙娜·波伏娃行人桥。

xiii. 鹌鹑之丘街区

推荐理由：这里会让你忽然觉得自己来到了 16 世纪的乡村。

地址：五颗钻石街（Cinq-Diamants）

xiv. 暗箱画廊

推荐理由：这里会展出萨拉·穆恩、维利·罗尼、马克·吕布等摄影大师的艺术作品。

地址：拉斯巴耶大道（Raspail）268 号

xv. 骑兵网球馆

推荐理由：这个网球馆在 15 楼，位于一座艺术感很强的大楼内，不仅能够打网球，还能远眺埃菲尔铁塔。

地址：骑兵街（Cavalerie）6–8 号

xvi. 佛庙花园和吉美亚洲艺术博物馆

推荐理由：在这个安静的地方可以好好研究馆藏的 250 件日本艺术作品。

地址：耶拿大街（d'Iéna）19 号

xvii. 蓬斯莱市场

推荐理由：每日都开放的市场，出售异常美味的冻肉、奶酪和令人欣喜的法式甜品。

地址：蓬斯莱街（Poncelet）与巴扬街（Bayen）区域内

xviii. La Recyclerie

推荐理由：这间餐厅位于一个废弃的火车站内，有空可以去那里享受一顿食材新鲜的素食早午餐。

地址：奥尔纳诺大道（Ornano）83 号

xix. Bergeyre 高地

推荐理由：这是位于巴黎四大葡萄园之一的肖蒙山丘公园内的小丘地带。当心迷失在各种小街后巷里。

xx. 皮亚特街（La rue Piat）

推荐理由：这里拥有从美丽城公园的观景台看到的最美街景。

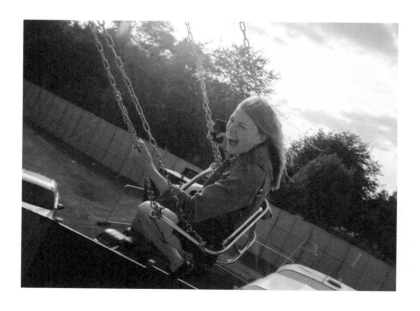

致谢

感谢这本书里所有接受我们采访的巴黎女人：艾米丽、纳萨莉、帕特里夏、夏洛特、范妮、索菲、吉泽斯、诺埃米、瓦伦丁、埃米莉、多拉、洛拉、多琳、西尔维娅、克丽丝特尔、露西、安娜、佐薇、弗朗索瓦丝和拉米娅。感谢你们的加入，我们备感荣幸。

感谢以下朋友积极地为这本书做出的诸多贡献：米夏埃拉·汤姆森、亚历山大·吉尔金格、斯蒂芬妮·索科琳斯基、萨斯基娅·格吕亚特、玛丽克·格吕亚特、杰茜卡·皮耶尔桑蒂、让·皮肯、乔丹·昂里翁、萨比娜·索科尔、奥克塔夫·马萨尔、西蒙·波特·雅克米斯、巴尔塔扎尔·彼得勒斯、艾丽诺·杜隆、弗洛伦丝·泰捷、克莱尔·玛格丽特、克洛依·迪普伊、埃马努埃莱·丰塔内西、瓦伦丁娜·莫雷诺和尼恩、艾利斯·奥弗雷和阿瑟、伊纳·梅利亚、阿格妮特·哈沃德·克里斯滕森、路易丝·达玛斯、莉拉·卡多纳、洛拉·帕尔默、莫娜·瓦尔拉芬斯和皮埃尔－路易斯·勒克莱尔。

感谢我们最爱的编辑克洛依·德尚，在这次巴黎之旅中一直陪伴我们左右。感谢马蒂厄·洛克里的精心设计，充分展现出我们的个性。感谢尼娜·科尔奇特斯卡亚，带着相机陪我们走过巴黎的大街小巷。感谢于尔根·莱勒提供诚恳有用的建议。

感谢两个朋友咖啡馆、花神咖啡馆和圣佩雷斯酒店，为我们提供了舒适的开会场地。

感谢我们的母亲帕斯卡尔·达玛斯和布丽吉特·巴斯蒂德，还有我们最爱的巴黎女人们。

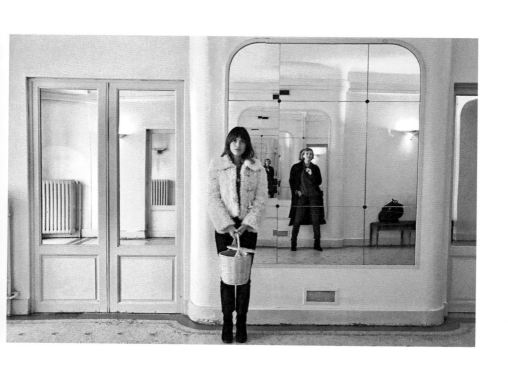

我是
我自己

Word
管阿姨

"我渴望人生变得更有意义更有价值。"

很早之前看过一部梅姨和妮可·基德曼主演的电影《时时刻刻》，电影描绘了三位女性在面对平庸生活时内心的挣扎与抗争，让我知道其实直面自己需要经历漫长的思考和一定的勇气。所谓的"自己"也不是一成不变的，这不单单指一个人年龄的增长，更多的是意识、心智以及感悟有效能量能力上的变化。

小时候，受原生家庭的影响，自己身上或多或少总会有父母的影子。再长大一点，我有了自主选择的能力，每天遇到的人、接触的事、慢慢塑造着我的自主意识。在慢慢摸索独立的过程中，我也知道了自己想要的生活和自由是什么样的。我们面对的是一个充满偶然性和不确定性的世界，我渴望人生变得更有意义更有价值，但我很清楚这需要不断地去思考，去努力，去进步，这样才能更好地了解自己，或者说了解有价值的自己。

当我认识并接纳了自己之后，再去独立，这时候我就有了更大的勇气和决心。首先，我一定要做到经济独立。当我做到不依附别人生存之后，再去谈精神独立，我才能在任何情况下都拥有自己的话语权和决定权。

"独立女性"其实是一个蛮敏感的概念，很多人认为这意味着和男性的对抗，但我不喜欢把男性放在对立面的观点。虽然社会上难免会遇到这种问题，但从宏观的角度去考虑，我认为"独立女性"应该更多意味着由内而外的能量的散发，或者是自我价值的实现。

其次，自我认可是实现自我价值非常重要的一环，人要学会自我认可和自我鼓励。很多时候我们可能更多地是在乎外界对自身的看法，但这些远远比不上自我认可带来的能量。自我与外界的评判很多时候是不匹配的，所以这也是我们生活在这个社会中的必修课。当我们慢慢知道如何正确地肯定自己时，会活得更加快乐。

自我是不变的，却又一直在变。我希望每位女性朋友在面对生活的庸俗不堪而倍感无力时，能平静下来，去了解自己，倾听自己内心深处的声音，发掘自己的人生价值和意义，从而更加幸福和坦荡地生活。

Profile
服装品牌主理人、时尚博主

Location
杭州

Photography
@ 管阿姨

管阿姨

INTERVIEW

去尝试
人生的
各种可能性，
你总会
发现你热爱
的方向

● 和我们讲一下你的日常生活还有工作吧。

管阿姨： 我的日常生活很简单，除了工作就是陪家人。

因为我的工作室和我的住处在一起，所以这种状态到底是好还是坏对我来说是模棱两可的。但是以我的性格，觉得生活和工作在一起比较适合。因为我的职业属性，本来生活跟工作就很难分开，所以我就顺其自然地将工作和生活揉在一起，并且把尽量把它打理好。

● 现在的生活状态对于你来说是否是"最理想的状态"呢？

管阿姨： 不是最理想的，因为我想规划出更多

的私人空间去学习和沉淀。现在工作把生活填
得比较满，所以缺一点充电和自我提升的时间。

● 最喜欢的地方是哪里？为什么？

管阿姨： 我喜欢冰岛，因为那块地方地广人稀，
无人问津，整个冰岛让人感觉孤寂却不孤独。
总感觉在那里可以静下来好好看书，本地人也
很友好，长期看这雪山冰川湖泊，应该心胸也
会变得更开阔吧。

● 不同的年龄阶段需要面对的事情也不同。如
果以 20 岁为起点做一个时间轴，将恋爱、工作、
学习、婚姻、育儿、个人生活或是你想到的要
素在这个时间轴上做排列，你认为应该如何排
列？

管阿姨： 其实我是个比较喜欢规划自己人生并
按部就班执行的人。因为我觉得这样不容易出
差错，给自己固定的时间排期做一个规划性的
人生课程表进行学习、恋爱、创业、结婚生子，
这样对于我来说心里会比较有安全感。所以我
其实很矛盾，内心里想着顺其自然、随遇而安，
实际落在行动上时又是一板一眼。如果按时间
轴排列顺序的话，我会按学习、工作、恋爱、
婚姻、育儿，最后享受个人生活这样去给人生
排序。

● 对于现在的中国女性有着怎样的印象？

管阿姨： 我周围的女孩让我感觉现在的女性从
身到心都在"崛起"，生活和事业上大家都很努
力很拼并且异常独立，对于精神世界也有自己
的追求。如果一定要给大家提建议，应该就是
希望现在的女孩们多注意身体，养成良好的生
活习惯。

● "美"的女性应该是什么样的?

管阿姨: 美是需要内在和外在综合起来探讨的, 我认为善良真诚就足够称之为内在美, 而外在应该就是一个人的谈吐气质, 还有她自己的个性以及在艺术文化上的审美。

● 我们常会听到:"女人就应该……"大众对女性附加了很多定义和要求, 面对这些定义与要求, 你想如何回应?

管阿姨: 反驳他们!

反之,"男人应该怎样……"的说法也是不对的。因为《你生而为人就应该怎样》, 这句话就带着指令性, 所以在我这里不太成立, 面对定义和要求, 基本上我在上面描述过的那种女性都会对这种说法嗤之以鼻吧。

● 你觉得日常生活中必不可少的一件道具(化妆品、包包、小物、配饰、生活用品等)是什么?

管阿姨: 我的化妆包。

● 给我们推荐一部电影和一本书吧。

管阿姨: 电影的话就是《时时刻刻》, 书的话应该是《奥丽芙·基特里奇》。

● 你在什么时候觉得真正找到了自我, 那是在什么情景和背景下呢?

管阿姨: 我从小就比较有独立思考意识了, 印象里我小时候就知道自己喜欢什么, 知道自己想要什么, 我会为此做很多尝试, 年纪小时去尝试各种多样性, 你会很容易发现自己热爱的方向。而且个人意识、爱好之类的其实也在不断变化, 我会不断去调整自己的状态。■

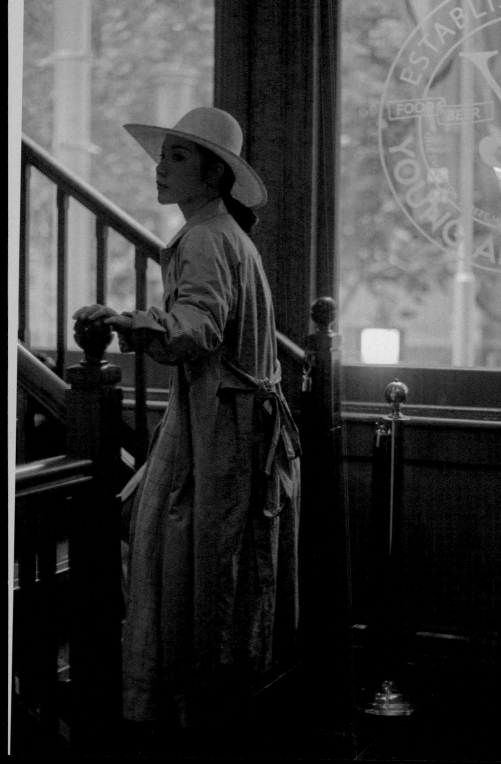

不管恋爱工作，
还是家庭生活，
最终的目标都应该是"到
更远的地方去"

Profile
摄影工作者、时尚博主

Location
北京

Photography
@ 斯诺依花姑娘

斯诺依花姑娘
（下文简称"斯诺依"）

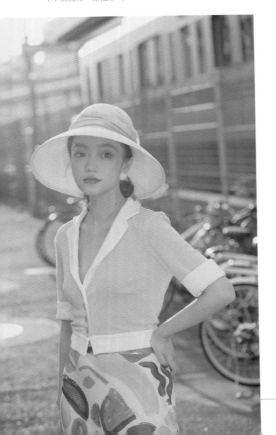

INTERVIEW

● 和我们讲一下你的日常生活还有工作吧。

斯诺依：有一个长期活跃的微博账号，分享穿衣打扮，记录心情。还有个属于自己的影像工作室，承接一些拍摄业务。让自己保持思考，每日研究时尚、拍好看的照片、读书写东西，这些都算是我的日常工作。

● 现在的生活状态对于你来说是否是"最理想的状态"呢？

斯诺依：不是太理想，觉得自己的生活还可以更好。有时候会觉得自己的生活会略显松散没有主心骨，需要培养更多的兴趣才好，让自己已经有的爱好兴趣更加专业化。我不是那种很盼望正能量并擅长自我鼓励的人，相反，对自己的否定和不满，这些才更能推动我前进。

● 最喜欢的地方是哪里？ 为什么？

斯诺依：东京。

混乱、美丽、自由的同时整个城市却又并并有条。

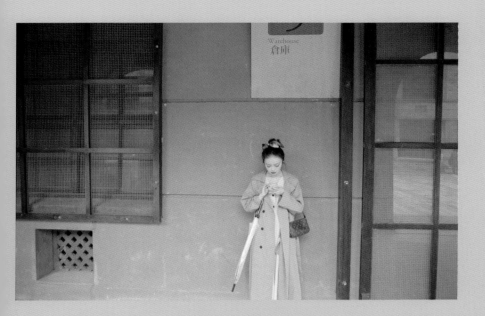

其实一切有着丰富物质文明的城市我都很向往，但日本尤其好买好逛，很多上世纪遗留下来的好东西还没有被消耗完。

● 不同的年龄阶段需要面对的事情也不同。如果以 20 岁为起点做一个时间轴，将恋爱、工作、学习、婚姻、育儿、个人生活或是你想到的要素在这个时间轴上做排列，你认为应该如何排列？

斯诺依：我其实不太赞成把自己的人生区间划分得太细，很容易陷入无意义的焦虑和与同龄人的盲目攀比之中。诚然，"什么年纪干什么事"有它的主流合理性，但人的路应该越走越宽，没必要一定让自己融入某个狭窄的坐标轴中。不管是恋爱工作，还是家庭生活，最终的目标都应该是"到更远的地方去"。

● 对于现在的中国女性有着怎样的印象？

斯诺依：中国女性尤其是都市里的女性都很精明，也很有欲望。这些从她们的眼神还有肢体行为中都能看出来，我有时候会害怕面对她们"审时度势"的目光。或许我们可以放松一下，不用过多地困囿于"成为更好的自己"这种命题，不用那么和自己、和生活较劲。

● "美"的女性应该是什么样的？

斯诺依：标准很多，绝不仅仅局限于面容。甚至我觉得过了一定的"水平线"，各人容貌的美很难区分高下。"美"最终指向的是更模糊的气氛、格局和经年累月沉淀下来的东西。女性偶像里作家偏多，波伏娃、萨冈、向田邦子，能活成自己的作品中的形象这点让我很羡慕。

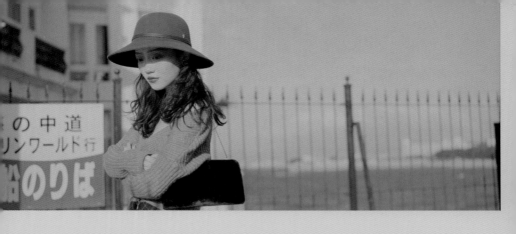

●我们常会听到："女人就应该……"大众对女性附加了很多定义和要求，面对这些定义与要求，你想如何回应？

斯诺依：只能用铁石心肠、不为所动来回应这些话语。越早摆脱他人的目光，人生越容易豁然开朗。

●你觉得日常生活中必不可少的一件道具（化妆品、包包、小物、配饰、生活用品等）是什么？

斯诺依：带一面小镜子的粉盒。不管去哪儿都会在包里塞一块，既能快速补补妆又能随时随地"自我审视"。毕竟我的签名就叫"我再照会儿镜子"。

●给我们推荐一部电影和一本书吧。

斯诺依：《穆赫兰道》——描述内心世界最宏大而微妙的电影。看完之后你可能会对自己更加诚实，对人和人的关系、命运有更深刻的理解。《回忆，扑克牌》——向田邦子这本短篇小说集描述了异常真实的家庭关系和人情伦理，或许会让每个曾因为敏感多思而苦恼的人感到一种连接。细腻是天分，不要责备它。

●你在什么时候觉得真正找到了自我，那是在什么情景和背景下呢？

斯诺依：在身心全面自由的情况下。换言之你摆脱了家庭、学校，真正要探寻自我实现的时候，过程或许艰难而漫长，但总有一击即中的时候。

■

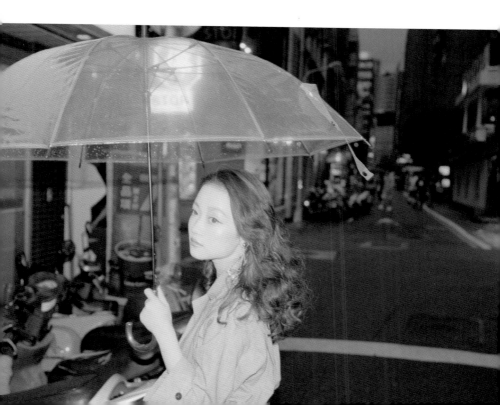

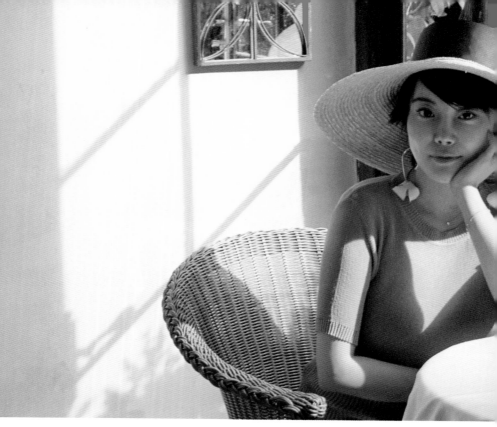

Profile
作家。
曾出版《世界从不寂静》《时光不老，我们不散》
等多本畅销书。

Location
上海

Photography
@ 祝羽捷

祝羽捷

我希望
像她们一样，
一辈子
眼睛里有光

INTERVIEW

● 和我们讲一下你的日常生活还有工作吧。

祝羽捷： 我现在每天生活比较简单，就是看书、写东西，自由安排。

● 现在的生活状态对于你来说是否是 "最理想的状态" 呢？

祝羽捷： 现在的生活是我很理想的状态。我经历过那种高压高强度的工作，超快速的生活节奏，也经历过辞职什么都不做的闲散阶段，

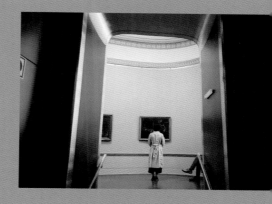

富感"。大概是因为我比较恋旧吧，加上这两座城市确实像宝藏一样永远挖掘不完，永不停息的马路，流动的江河，生生不息的人群，这两座城市仿佛总在酝酿着什么。上海和伦敦都是让你永远不会感到厌倦的地方，这种深情并非是我在此地原地不动的时候发现的，而是，每次在从某地回到上海或是伦敦的时候我都会有一种强烈的幸福感，那一刻我就在心底确认了热爱。比起出发，我也更享受回家的感觉。任外面光阴流转，有家可回，有人等待，靠这些就足够我气高胆壮，拔地倚天。总觉得背后有肯定的眼神，人生可进可退。

现在的生活就是一种完美的平衡。我理想的生活就是手中有活，心中有爱，那种接近手艺人的生活方式是我一直很迷恋的状态。

●最喜欢的地方是哪里？为什么？

祝羽捷：我喜欢的地方肯定是我生活时间最长的地方，上海和伦敦。虽然有很多地方自己也很喜欢，但是日积月累的感情还是战胜了一个陌生地方给我带来的新奇感和异文化带来的"丰

●不同的年龄阶段需要面对的事情也不同。如果以20岁为起点做一个时间轴，将恋爱、工作、学习、婚姻、育儿、个人生活或是你想到的要素在这个时间轴上做排列，你认为应该如何排列？

祝羽捷：我觉得用年龄做规定是非常粗暴、懒惰的事情。何况每个人的物理年龄、心理年龄又不是靠时间计算的。 我在伦敦见过女艺术家

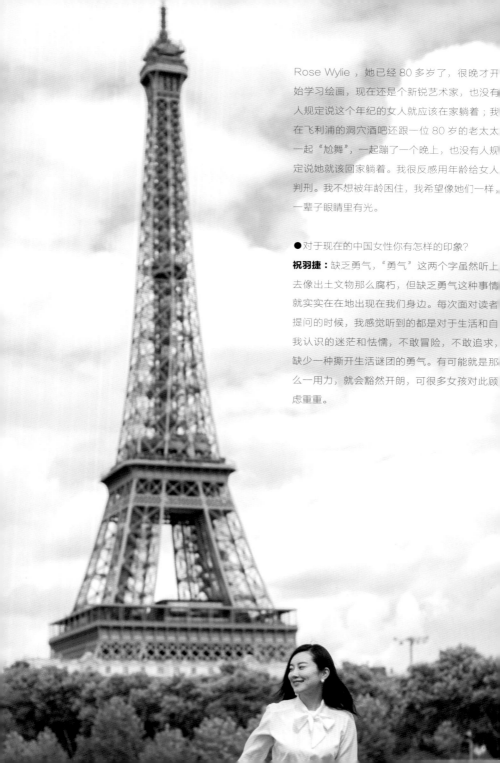

Rose Wylie，她已经 80 多岁了，很晚才开始学习绘画，现在还是个新锐艺术家，也没有人规定说这个年纪的女人就应该在家躺着；我在飞利浦的洞穴酒吧还跟一位 80 岁的老太太一起"尬舞"，一起蹦了一个晚上，也没有人规定说她就该回家躺着。我很反感用年龄给女人判刑。我不想被年龄困住，我希望像她们一样，一辈子眼睛里有光。

●对于现在的中国女性你有怎样的印象？
祝羽捷：缺乏勇气，"勇气"这两个字虽然听上去像出土文物那么腐朽，但缺乏勇气这种事情就实实在在地出现在我们身边。每次面对读者提问的时候，我感觉听到的都是对于生活和自我认识的迷茫和怯懦，不敢冒险，不敢追求，缺少一种撕开生活谜团的勇气。有可能就是那么一用力，就会豁然开朗，可很多女孩对此顾虑重重。

●"美"的女性应该是什么样的?

祝羽捷: 我喜欢的女作家法拉奇说:"女人从来都不是一种特殊的生物,我不明白为什么还要在报纸上为她们专门开一个版块,就像运动、政治还有天气预报一样。"我想这正是我心中的话,就是不要总是强调"我是女人,我如何如何"。我最讨厌听到这样的论调,而说出这样论调的总是那些标榜自己是"独立女性"的人,一旦强调就说明内心就是持有男女不平等的观点。对我来说,独立意味着不被世俗压垮意志,不会一味接受外界强加的价值观,懂得审视内心,认可自我并实现自我价值。

●我们常会听到:"女人就应该……"大众对女性附加了很多定义和要求,面对这些定义与要求,你想如何回应?

祝羽捷: 我一听到"女人应该"四个字,脑海中浮现的是跪在地上擦地板,抱着啼哭的婴儿喂奶,穿着围裙刷碗,让生活牵着鼻子走的各种刻板的"劳动主妇"形象。"女人应该"应该是一种高级别魔咒吧,把我们牢牢框住,变成男权世界的顺臣,变成一个知书达礼却没有个性的没头脑。

●你觉得日常生活中你必不可少的一件道具是什么?

祝羽捷: 我每天出门必带的是口红,口红简直就是我的一把手枪,我可以什么妆都不化,就是不能忍受嘴唇苍白。其他的东西伺机而定,尊重场合。

●给我们推荐一部影视剧吧。

祝羽捷: 配合今天讨论的主题,我推荐《使女的故事》。

●你在什么时候觉得真正找到了自我,那是在什么情景和背景下呢?

祝羽捷: 应该是第一次为自己做重大决定的时候,不考虑别人的意见,自己衡量得失,真正地去实践"后果自负"这句话的时候。■

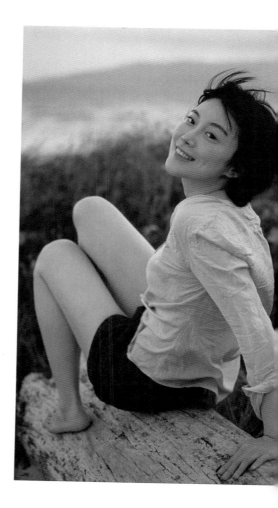

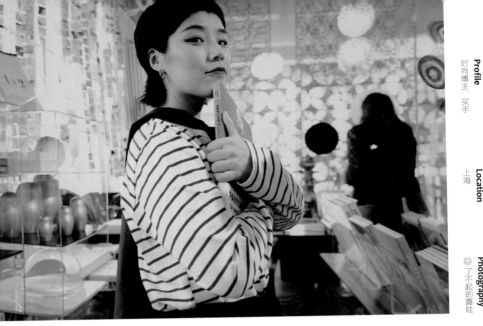

Profile

时尚博主、买手

Location

上海

Photography

@了不起的喜娃

我觉得给自己树立太多风格或个人偶像一类的明确的参考对照，是挺没意思的事儿

了不起的喜娃（以下简称"了不起"）

● 和我们讲一下你的日常生活还有工作吧。

了不起：日常生活的几大板块：写稿、健身、看戏、出席活动和睡觉。博主工作的时间相对自由，没有固定的什么时间点做什么事的约束，反正有这么一些项目，把一天 24 小时塞满。上面说的通常是周一到周五，周末是家庭日，因为老公工作也比较忙，我们陪伴孩子的时间通常就只有周末两天。

INTERVIEW

● 现在的生活状态对于你来说是否是"最理想的状态"呢？

了不起：不能算最理想，但总体来说已经足够自由。如果能更自律，那生活可能会更理想和"轻松"一些。因为长年养成的深夜写稿的习惯，生物钟比较反常规，通常在凌晨两三点入睡，次日 11 点左右起床，因此也错失了一些亲子和家庭时间。理想的生活状态就是现在的状态，

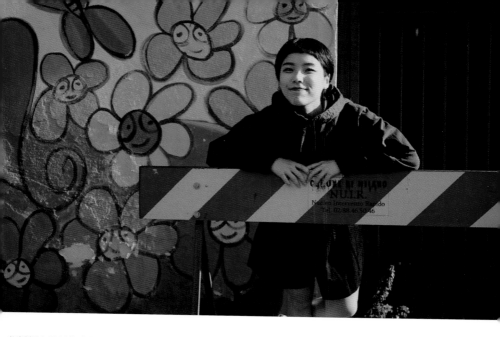

但希望自己的作息能更规律吧。

●最喜欢的地方是哪里？为什么？

了不起：非常喜欢西班牙的塞维利亚，那是我第一次一个人去一个地方旅行。也是第一次因为喜欢一个地方，临时改变了行程，在这个地方多待了好几天。

可能因为和我的生物钟和散漫的性格很符合吧，每天一两点才开始提供午餐，在此之前就懒懒地晒晒太阳。太阳下山了，八九点才有晚饭吃，人手一杯红酒，吃到十一二点，吃饱喝足回家睡觉，太开心了。这个城市也没什么需要你去赶的景点，没有压力，就特别放松。

●不同的年龄阶段需要面对的事情也不同。如果以 20 岁为起点做一个时间轴，将恋爱、工作、学习、婚姻、育儿、个人生活或是你想到的要素在这个时间轴上做排列，你认为应该如何排列？

了不起：我 20 岁左右的时候，把自己规划得特别好，24 留学 26 结婚 28 生小孩。我觉得这是很多中国女生被父母和社会潜移默化植入的一个最优化的时间轴。当然我也没有特别去赶着这个时间点去生活，只是恰好这些事都按时发生了。

●你是否认同"女孩子在什么年纪就该做什么事"这种观点？

了不起：不认同，但同时觉得如果有这样的想法和计划，也没有任何不妥。最关键的是顺自己的心意、顺当下的环境，如果你就是一个计划性特别强的人，那就按计划去实施你的生活好了。

●对于现在的中国女性有着怎样的印象？

了不起：缺不管不顾、我行我素的那种做自己的胆儿吧。

但我也很反感用"做自己"去否定其他生活方式。

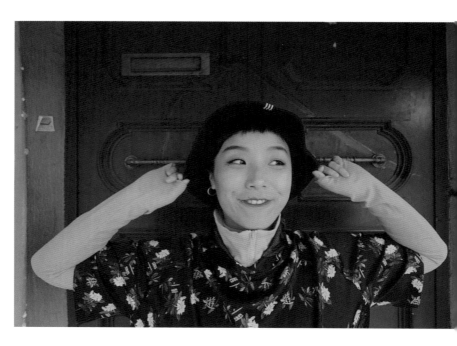

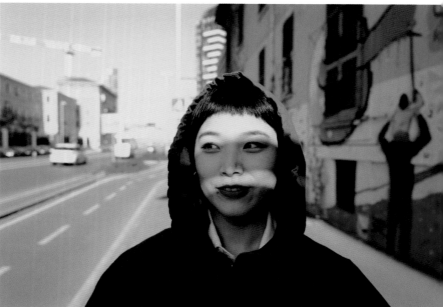

就像我上面说的，如果你认为结婚生子就是一个女生该做的事情，不代表你思维落后，只要是你打心眼里这样想的。扛着"做自己"的旗子去反抗一些来自家庭、交际圈或社会的压力，看着好像理直气壮，私下却并没有享受当下自己的状态的人，才最可悲。事实上，这样的女孩还不少。真正的"做自己"不是非要反抗、非要反传统，而是真的，自己怎么想，自己乐于什么样的生活，就去过，并且享受它（别违法就行）。

● 你对于"独立女性"是如何界定的？"美"的女性应该是什么样的？

了不起：这个问题太庞大了，特别容易回答得假大空。比如说什么自信、独立的女性就是美的一类的。首先俗气地说，经济独立是首要的。腰杆子都不硬，其他免谈。
再说美，撇去内在美这种基本道德要求不说；在当今社会，把自己打理干净、自律地管理身材和皮肤，展现力所能及的外在美，是一种对于自己和他人的礼貌和尊重。虽然自信的确会提升人的气质和气场，不过我觉得这是建立在将自己收拾得体的基础上的；而不是说自信就可以完全不做皮肤、妆容、身材的管理了。

● 我们常会听到："女人就应该……"大众对女性附加了很多定义和要求，面对这些定义与要求，你想如何回应？

了不起：大众对男性也附加了很多定义和要求啊。一边想着男人就应该赚更多钱，一边还想着大众不能定义我的女性，才是最可笑的。从我个人理解来说，过分强调女权也是性别歧视的一种。如果每个人都能正视和接纳男性和女

性生理上的差异，但不用性别为由去限制自己和他人的行为，就足够了。

● 你觉得日常生活中必不可少的一件道具（化妆品、包包、小物、配饰、生活用品等）是什么？

了不起：没有，没有什么离不开的东西，非得说一个那可能是家里的钥匙吧，但马上要换电子锁了，所以最重要的东西，还是你这个人本身。

● 给我们推荐一部电影吧。

了不起：《搏击俱乐部》吧，看自我和本我，看毁灭和重生，看"我到底是谁"。

● 你在什么时候觉得真正找到了自我，那是在什么情景和背景下呢？

了不起：当你可以掌握自己的决定权，并且为此负责的时候……
很庆幸生活在一个开明的家庭，从填报大学志愿的自由度，高考完我说要去打唇钉爸妈完全没有干扰的自由度来说，我应该在 18 岁的时候就找到了自我。

● 最近关注的服装品牌和博主是哪位呢？

了不起：没关注什么新的博主，因为最近一期公众号做了坎普的内容，搜索资料的时候关注了 KINGKONG Magazine（《金刚》）。很喜欢坎普这种无法被清晰定义的不能叫风格的风格。我觉得给自己树立太多风格或个人偶像一类的明确的参考对照，是挺没意思的事儿。■

Profile
插画师

Location
北京

Photography
@ 张小溪 -Nancy-Zhang

张小溪

无论
何时何地，
我就是我

INTERVIEW

●最喜欢的地方是哪里？为什么？

张小溪：没有最喜欢的地方只有最适合的地方。
情感上我对柏林感情深刻，但似乎巴黎永远最
适合我的性格。柏林是彼得·潘，巴黎是维纳斯。
我爱柏林是因为内心里我不希望长大，我爱巴
黎是因为这座城市更符合我现在的心态。举个
例子来说，柏林的文化气氛有种很重的"套路"，
人们的生活习惯也是如此；巴黎这个城市和巴
黎人在文化层面的探索上还是比柏林更为前卫
和自由一些。

●和我们介绍一下自己吧。

张小溪：一名每天都有新经历的创作者。

●现在的生活状态对于你来说是否是"最理想
的状态"呢？

张小溪：现在算是理想的心理状态吧。其实我
觉得最理想的生活状态永远是无限接近但不会
达到的状态。我不是完美主义者，生活永远是
有缺憾的。

●不同的年龄阶段需要面对的事情也不同。如
果以 20 岁为起点做一个时间轴，将恋爱、工
作、学习、婚姻、育儿、个人生活或是你想到
的要素在这个时间轴上做排列，你认为应该如
何排列？

张小溪：学习和个人生活贯穿整个人生啊。其
次主张 20 岁时多恋爱，然后是 25 岁后开始专

主自己的事业构建。其他两个属于自由选择项目，随缘。

●你是否认同"女孩子在什么年纪就该做什么事"这种观点？

张小溪：这话本身没问题，女人在不同阶段所需求的东西不同，追求的东西也不同，同理，男性们也一样。

●对于现在的中国女性有着怎样的印象？

张小溪：如果一定要说的话，可能一些轻熟女们在面对自己的生活和社会的声音时可能有些缺乏主见，这种主见会体现在方方面面，随着时代的推进肯定会发生改变。相较之下，年轻的女孩儿们较有主见但审美还尚未沉淀。不用着急，时间会改变一切。

●"美"的女性应该是什么样的？

张小溪：美人是有自己一套美学概念，知道什么适合自己，也知道自己想要什么的女性。

●我们常会听到："女人就应该……"大众对女性附加了很多定义和要求，面对这些定义与要求，你想如何回应？

张小溪：左耳进右耳出，或者完全忽略。

●你觉得日常生活中必不可少的一件道具（化妆品、包包、小物、配饰、生活用品等）是什么？

张小溪：钥匙。

●给我们推荐一部电影和一本书吧。

张小溪：那就推荐我最近刚看的电影——成濑已喜男的《女人步上楼梯时》；还有最近翻阅的

中文版《阿尔比恩的种子》。

●你在什么时候觉得真正找到了自我，那是在什么情景和背景下呢？

张小溪：无论何时何地，我就是我。

●这种意识其实在我们社会中很难得，您是在何时形成这种"自我认识"呢？跟风、抄袭、山寨等个人现象和社会现象其实都可以归咎于"自我认识"的问题。

张小溪：可能因为从小家里的教育比较自由的原因，自我意识形成得也比较早。其实有没有主见可以说成是一种选择：个人主义色彩鲜明的人和愿意去配合并遵循集体意志的人所做的事情是不同的，就好像选择职业一样。不同的性格、思想的人在社会中呈现出不同的样态，也就出现了别人所谓的"有没有个人主见"。■

Profile
时尚博主

Location
上海

Photography
@ 搞艺术一横

只有更好，没有最好
THE BEST IS YET TO COME

搞艺术一横（高老师） INTERVIEW

● 和我们讲一下你的日常生活还有工作吧。

高老师： 我算是自由工作者，所以日常生活与工作会时时纠缠在一起。这样的好处是掌控自己时间的自由度会比上班族更多一些，弊端是缺少固定的休息放松时间。

我会尽量将写文章、拍照以及学习的时间均匀分摊到每个星期中，也会尽力让自己在工作日做完手边的工作，并把周末留给自己。

● 现在的生活状态对于你来说是否是"最理想的状态"呢？

高老师： 姑且算是吧，经历了毕业后长达好几年的迷茫以及无所事事的时期。欣慰的是，那时候所做出的"无意义"的消遣，到今天成为我博主事业的第一份基石。现在回想起来，还是因为这份好运气而深感受宠若惊。

我的工作性质和我的爱好息息相关，物质层面上也能尽力满足自己的欲望，达到一个理想

的生活状态。但是我会谨慎避免使用"最"这个比较量级,因为需要安慰与鼓励自己:The best is yet to come.

另外,如果想要在时尚博主的领域保持甚至有所提升,它还需要饱和的工作量,甚至有些时候还会让人疲惫。这时候就要打起精神,督促自己不要懒怠。

● 最喜欢的地方是哪里?为什么?

高老师:伦敦。因为以前的生活学习经历,再加上毕业后也维持着每半年回去旅行一次的频率,所以对我来说,伦敦是最为熟悉以及喜爱的城市。

我喜欢伦敦人对于时尚以及穿衣风格的态度,他们很有自己独到的见解,足够包容,最重要的是有一种幽默放松的精神。

● 不同的年龄阶段需要面对的事情也不同。如

果以 20 岁为起点做一个时间轴，将恋爱、工作、学习、婚姻、育儿、个人生活或是你想到的要素在这个时间轴上做排列，你认为应该如何排列？

高老师： 哈哈，我认为不应该去排列。

● 你是否认同"女孩子在什么年纪就该做什么事"这种观点？

高老师： 以我自己的经历来说，并不认同什么年龄段就该做什么事的刻板观念。但我不是完全鼓励大家都按照我的观点来，每个人的性格经历所处的背景都是大相径庭的，没有唯一正确的选择。在这件事上，别人的意见永远是次要意见。

● 对于现在的中国女性有着怎样的印象？

高老师： 我认为如果非要说的话，就是缺乏一定的"包容度"。比如时尚、如何穿衣打扮、对美的理解，很多人都喜欢过分强调自己的喜好，主张"排他"。但我觉得比以上这些更为重要的是，要克制住这种倾向，因为我们每个人都可能是"他者"。

● 你对于"独立女性"是如何界定的？

高老师： 如果将地理范围缩小至本国，那么过分强调"独立女性"的定义就显得有些不接地气了。我认为"独立女性"是那些，不是只在品牌促销互动中才会被称呼为"独立女性"的女性。

●我们常会听到："女人就应该……"大众对女性附加了很多定义和要求，面对这些定义与要求，你想如何回应？

高老师：在字面上回应这些是很容易的，每个人都会说要拒绝，要打破刻板观念，这样隔空喊话是轻松的，也无需付出任何代价的。

但是，如果我们把自己代入到这个现实的对话环境呢？我们会发现跟你谈到这种观念的人其实就是你一位"语重心长"的长辈，你很难每一次都决绝、果断地提出反抗的观点。

抱歉，我并没有想到一个优雅、足以说服所有人的回应。我只能鼓励大家，尽可能地做好自己手边可以做的每件事，并期望终有一天，我们的动作不再是空洞的隔空喊话。

●你觉得日常生活中必不可少的一件道具（化妆品、包包、小物、配饰、生活用品等）是什么？

高老师：手机。

●给我们推荐一部电影和一本书吧。

高老师：电影：《法外之徒》。书：《银河系漫游指南》。

●你在什么时候觉得真正找到了自我，那是在什么情景和背景下呢？

高老师：我从未有一刻觉得自己真正找到自我。也许在某些时候，可能无限接近，又可能相隔一个银河系。■

喜好时装的人，
永远生活在别处

Word
高老师

那是我在多伦多的最后一个下午，意外地无所事事，于是决定在这个城市再给自己一次体验时尚的机会——顺着谷歌地图逛逛荣获高分推荐的本地时装商店。

本来没抱多大希望，但结果却是出乎意料地让人惊喜。在市中心边缘著名的住宅区的古着店及寄卖店，从二十世纪五十年代的伞裙到近现代的奢侈品，应有尽有。试衣的中间闯进来一位五十岁左右的女士，偌大的商店里，她隔着二十米远，目不斜视地盯住我放在沙发上的包，直问我这是否来自 Hunting Season。宾果！问题是就算是痴迷于消费的年轻女孩，都不一定能够迅速辨认出这个刚成立两年的小众品牌，而这位看似与时尚完全无关的女士是如何做到的？而这个问题，就像那些我本来以为根本不会出现在多伦多的精品店一样，也许指向的是同一种答案——时尚对某些人来说是一个出口，是将你导向另一种生活的一个入口，也是找到志同道合者的渠道。

超模辛迪·克劳馥说过："Women do makeup for other women, not men."（女为同性者容。）那么喜欢时尚的人也是如此，大家抱着小众爱好，始终期待着来自同好者的欣赏。

从这个意义上讲，喜好时装的人，永远生活在别处。

我们一定有过这样的经验，在巴黎、伦敦、纽约或东京这样的大都市，路过居民区时会对那里的日常生活图景产生不可遏制的艳羡，你会想为什么他们可以与此处同呼吸共命运，可以享受在你自己的城市里所无法企及的生活。

但这样的幻想往往是海市蜃楼。等到你自己某一日真的搬去了这个地方，从忙于探索新生活的前三个月冷静下来后，你内心会感到不可遏止的迷惘。因为当憧憬褪成了日常的琐碎，生活似乎才向你展露它最真实的模样。此时你和这个城市是一对已经互相懒于矫饰的夫妻，凑合着过呗，还能如何？

于是我们又展开新一轮的幻想，将自己寄托在遥远的地方。

在许多人心中，巴黎可能是最终寄托，否则不会有加州女孩们所倡导的"法式风情"。只是我还持少许的保留意见：以公式来拆解effortless chic（轻松的优雅），是否将"effortless"（轻松）学得本末倒置？又或者"chic"（优雅）本身就是来自欧洲的自我陶醉，需要被毫不留情地拆穿？

无解。

但人人心中都有自己的巴黎。我的白月光是铁塔，夜间顺着楼梯从最高处慢慢往下，惊叹于人类违抗自然的意志后所迸发的璀璨华章。这光芒万丈会永远封存在巴黎，从蒙马特高地枝繁叶茂的树影间望过去，铁塔是支撑天地的孤独。

因为人人心中有巴黎，所以也难免惋惜圣母院的大火。长居于巴黎的朋友说起火的瞬间才惊觉巴黎之美，我当然理解她这种醍醐灌顶般的醒悟——日常生活的消耗一叶障目，只有绕到背后，才会意识到自己曾多幸运才能伴这一切安眠。

自在
FEEL COMFORTABLE
IN ONE'S SKIN

86.11.08

Profile
从事奢侈品行业的时尚撰稿人。一个有幸与巴黎有过一段
爱恨交加的不健康感情的普通可爱女孩。

陈彤

Location
巴黎

INTERVIEW

Photography
@ Pas_de_Panique

●和我们讲一下你的日常生活还有工作吧。

陈彤： 典型的一天：早上起床煮杯咖啡，下载好要听的专辑或者播客，坐地铁，观察路人，工作，生产数据和漂亮的PPT。晚上下班，运动，看书看剧，听歌写稿，不是单身的时候就和对象聊聊天，单身的时候就网上购物。单身的时候很容易控制不住购物欲，不知道对于这种现象有没有什么心理理论可以支撑。

现在夜生活凋敝，一年去两次夜店，简直比男人去海澜之家的次数还少。周末会约朋友去吃brunch（早午餐），但是巴黎好吃的brunch都至少要排一个小时的队，这种时刻就会觉得什么都市人忙碌、生活节奏快，通通是个骗局。没事的时候可以去看很多展览，我想这大概是住在巴黎最大的好处，巴黎的展览无论是展品本身还是策展水平都是第一流的。因为买了电影院无限次卡，想要拥有自己的独处时刻时就会一个人在电影院来一场电影马拉松。我还有一个兴趣爱好是漫无目的地在街上走，主要是巴黎比较适合步行，天气好的时候一步一景。

●现在的生活状态对于你来说是否是"最理想的状态"呢？

陈彤： 不是最理想的状态，我甚至怀疑是否存在最理想的状态一说。人总是贪心的，到达了一个阶段目标又会向往下一个。现阶段来讲，希望自己事业上能更进一步，更加勤奋，开发出自己更多的潜力；感情上能稳定下来吧，现在对约会生活比较厌倦了。不过这都是我的一些很朴素的愿望。

●最喜欢的地方是哪里？为什么？

陈彤： 对我来说的话应该是东京。那里是一块

混乱与秩序并存的地方。我觉得在那里每一个人的个性都会被尊重，再小众的爱好都能找到属于自己的族群。我记得第一次去歌舞伎町的时候，站在闪烁的霓虹灯招牌下，看着周遭来来往往的人群，有一种无数故事线平行展开的感觉，什么事都有可能发生，而我在这里也可以拥有无限奇遇。同时在东京生活也很舒适便

利，人与人之间也保持客气和（至少表面上的）温柔。

●不同的年龄阶段需要面对的事情也不同。如果以20岁为起点做一个时间轴，将恋爱、工作、学习、婚姻、育儿、个人生活或是你想到的要素在这个时间轴上做排列，你认为应该如何排列？

所以我们也敢于去违背这套陈规。

● 对于现在的中国女性有着怎样的印象？

陈彤：我感觉中国女孩同质化比较严重吧。好像大家脑海中都有同一个理想女性模板，比较容易一窝蜂赶同一波潮流。比如之前网络上风靡的"A4腰""空气刘海""红色眼影"什么的，随便数数就能数出不少这种压倒性的时尚趋势。但其实我觉得参差多态才是幸福的本样，我觉得不要去追求某种定式吧，胆子大一点，多承担一点"时尚风险"，毕竟穿衣打扮多大点事呢，不合适再换就是了。其实我觉得新一代95后甚至00后的中国女孩就已经开始展现出更加多元化的风格了。有时候在网上看到一些年轻小女孩，也不是博主，但穿得就已经很有自己的想法了，时常感觉后生可畏。

陈彤：这些东西我都想要啊，但我不觉得这些事能在时间轴上排列，工作学习还比较可控，顺着升学系统走就是了。恋爱结婚和育儿这就不是我能控制的了，毕竟还涉及另一半。试图给这些事情安排一个恰当的时间节点是一个比较自大且以自我为中心的想法吧。

● 你是否认同"女孩子在什么年纪就该做什么事"这种观点？

陈彤：我爸妈一直这么和我说！我就回答说："如果你要我在该结婚的年纪结婚，我就有可能在该离婚的年纪离婚；你要我在该生小孩的年纪生小孩，我可能就会在该产后抑郁的年纪产后抑郁。"哈哈哈，当然这是开玩笑啦。我觉得父辈会产生这种想法是因为他们不知道除此之外别的活法，所以就理所当然地把他们自己的这种"什么年纪做什么事"的想法，当作唯一的正解。我们这一代人有幸见证过一些别的可供选择的生活方式，

● 你对于"独立女性"是如何界定的？

陈彤：经济独立很重要，拿人家手短吃人家嘴软，能自己养活自己是还比较关键的一点，经济独立会给你比较大的自由度。除此之外，做事情或者发表看法的时候不要有表演心态，不要抱着取悦、迎合或者炫耀的想法，努力保持一种比较真诚的姿态，确保一切声音发自本真，这对我来说是一个独立女性应有的品质。

● "美"的女性又应该是什么样的？

陈彤：应该是自在的女性。

自在其实很难啊，英文里有一个挺有意思的表述："Feel comfortable in one's skin."意思是"穿着自己的皮肤时感觉舒适"。自在就包含了对自己的包容，优点同缺点一并接受，本我自我超我和谐共处。有几个人能做到？很多

看上去光鲜的女性其实和自己的关系都并不稳定，自尊心很飘忽，所以她们可能外在很漂亮，但性格骄矜又脆弱。但有些女性五官并不特别精致，穿得也并不特别出挑，但是却有种潇洒飘逸的气质，我觉得可能就是因为她们状态特别自在舒展的缘故吧。这个回答听上去挺鸡汤的，但我观察下来的确是这样的。

●我们常会听到：「女人就应该……」大众对女性附加了很多定义和要求，面对这些定义与要求，你想如何回应？

陈彤：麻烦先管好你自己吧。

●你觉得日常生活中必不可少的一件道具（化妆品、包包、小物、配饰、生活用品等）是什么？

陈彤：香水。因为我对气味比较敏感。我用的香水通常都比较淡，所以只有自己和亲近的人才能闻到，是给自己和亲近的人一个平凡生活里的诗意细节。最常用的一瓶是阿蒂仙的香杉雨藤，给人感觉是雨后森林的味道。可惜已经

停产了，二手市场炒到了天价，有点惆怅，这瓶用完之后可能不得不寻觅替代品了。

●给我们推荐一部电影和一本书吧。

陈彤：电影的话那就推荐《色·戒》吧，看过很多遍，比较厚脸皮地说，觉得自己性格有点像王佳芝。书的话前阵子看了《繁花》，是沪语写成的，看下来让人感觉故事表面上姹紫嫣红、荤素不忌，但底色又是悲凉的，既有时代变迁也有个人际遇，算是最近读到的大师之作。

●你在什么时候觉得真正找到了自我，那是在什么情景和背景下呢？

陈彤：我好像并没有经历过什么醍醐灌顶的时刻。我的自我意识一直都比较强烈，但是我觉得自己像是个乒乓球吧，球被球拍击出之后遇到了别的环境或是人，被反弹回来，那时我才真正明白自己是什么样的人。我觉得自己是在和他人、外界的碰撞和比对之中才更了解自己，是通过回声来找到自己的位置的。■

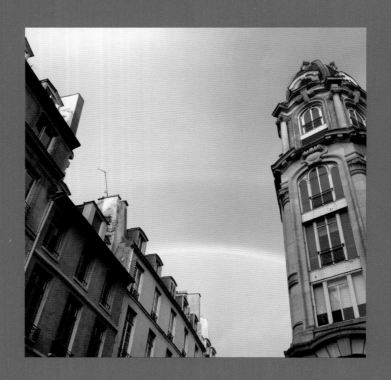

巴黎女孩的虚荣心

Word
陈彤

"很抱歉，我天生就那么时髦。"

其实接到约稿的时候我有些犹豫，因为巴黎女孩在时尚的语境下已经成为一个意象。无数的时尚杂志都在告诉你，巴黎女孩吃什么穿什么化什么妆，巴黎女人可能是唯一一个以集体形式存在的时尚标签。所以接到约稿之后我就开始思考：还有什么关于巴黎女孩的事情是没有被写过的呢？思来想去，不如写写她们的虚荣心好了。

巴黎女孩是很虚荣的。但这种虚荣又不是普通意义上攀荣附贵的那种虚荣。相比于物质财富来说，"有品位"这件事更值得她们去炫耀。所以走在这个以奢侈品和高品位而闻名的地方，你却会发现街上那些看起来潇洒时髦的巴黎女人，她们十有八九背的是帆布包。在人们的印象里也许巴黎女孩就该香奈儿，帆布包貌似和"时髦"二字毫不相干。但她们的帆布包也不是全然没有讲究。仔细观察，其实如果你懂点门道就会发现：巴黎女孩帆布包上印的图案才是她们"虚荣之战"的硝烟战场。要么是某个小众时髦又价格不菲的品牌附赠的袋子；要么是城中知识分子圣地——Ofr 书店的周边图案；再不济也要是蓬皮杜艺术品商店里买的限定展览纪念帆布袋。总之，把帆布袋想作是一个 insider joke（同一圈子的人才懂的笑话），是时髦巴黎女孩之间心照不宣的暗号。这是她们辨认同类，排斥异类的交流方式：如果你能看出来我背的那款看似平凡的帆布袋有多不凡，那么或许你的眼光也不算太差劲，我们之间也许有一点微小的建立友谊的可能性。

这种虚荣同时还体现在巴黎女孩一个被说烂的特点上：她们总是看上去毫不费力。这种毫不费力的表象不如说恰恰是她们极其精心设计外表的佐证。不过似乎全世界的女人的确需要佩服她们在这方面的审美天赋。一个亚洲女孩在出门前多半会仔细审视自己，看看身上还有什么不精致的地方、妆还需不需要再补补、能不能再往身上加点"时髦单品"。而巴黎女孩出门前是要审视自己看上去是不是太过精致了，要不要减掉几件东西，留出两三个破绽。所以当你看着巴黎女孩乱糟糟的头发、素净的短指甲或是脸上完全不经修饰的雀斑，可别被骗了，十有八九，这些破绽都是她们花了不少心思设计好的。

她们意在营造出一种没有刻意打扮，只怪自己"天生丽质难自弃"，一不小心就时髦了的感觉。不是我在赶时髦，实属时髦不放过我啊。这种心思就跟彻夜复习的学霸转天告诉同学自己昨天看了一晚上电视一样，是一种无害，甚至让人觉得有些可爱的虚荣心。相比被各大杂志吹捧万千、仿佛是被供奉在时尚神坛的泥塑金身的巴黎女孩，现实生活中有着自己的虚荣和弱点的她们不是更有趣吗？